CANO
EOS 7

THE EXPANDED GUIDE

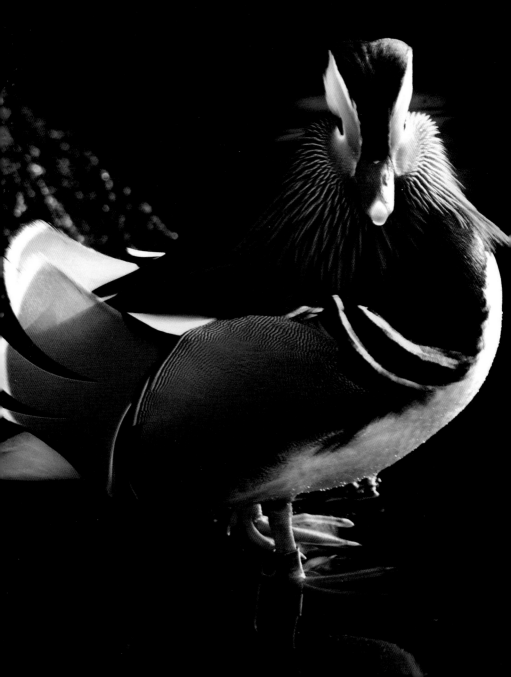

CANON
EOS 7D

THE EXPANDED GUIDE

Andy Stansfield

AMMONITE
PRESS

First published 2010 by
Ammonite Press
an imprint of AE Publications Ltd
166 High Street, Lewes, East Sussex, BN7 1XU, UK

Reprinted 2011

Text © AE Publications Ltd, 2010
Images © Andy Stansfield, 2010
Product photography © Canon, 2010
© Copyright in the Work AE Publications Ltd, 2010

ISBN 978-1-906672-72-0

While every effort has been made to obtain permission
from the copyright holders for all material used in this
book, the publishers will be pleased to hear from anyone
who has not been appropriately acknowledged, and to
make the correction in future reprints.

The publishers and author can accept no legal
responsibility for any consequences arising from the
application of information, advice, or instructions given
in this publication.

British Library Cataloging in Publication Data: A catalog
record of this book is available from the British Library.

Editor: Tom Mugridge
Series Editor: Richard Wiles
Design: Fineline Studios

Typefaces: Giacomo
Color reproduction by GMC Reprographics
Printed and bound in China by Leo Paper Group

《 PAGE 2
The Mandarin duck
is one of the world's
most striking, colorful,
and photogenic birds.

» CONTENTS

Chapter 1
OVERVIEW

1 OVERVIEW

The EOS 7D is the latest offering in Canon's semiprofessional range of digital SLRs. This outstanding camera evolved from the EOS D30, picking up technical developments from the EOS-1 range along the way.

» EOS HISTORY

First announced in 2000, the EOS D30 offered just over 3 megapixels, 3-point autofocus, 3 frames per second (fps), and a burst of three JPEGs. Its monitor was just 1.8in (4.5cm) in size. Things have come a long way since then.

Back in the mid-1980s, when camera and lens designers were suddenly making huge inroads in forging new links between

HISTORY IN THE MAKING ⌄
Those interested in the evolution of camera technology are advised to visit Canon's web site at www.canon.com/cameramuseum.

electronic and optical components, Canon designers were preempted by autofocus SLRs from first Minolta, then Nikon. An intense two-year period of research and development followed for Canon, who saw that these new cameras would ultimately form the basis of an extensive and flexible system, so every aspect of the camera needed to be stylish as well as practical.

The early Canon EOS models were designed with three criteria in mind: first, the introduction of an AF system should not increase the price point; second, the camera should be capable of shooting sports events handheld with a 300mm f/2.8 lens or similar; and third, autofocus capability should match exposure sensitivity in low-light situations.

In March 1987, Canon put its ideas to the test with the launch of the first EOS model, the EOS 650, which was soon to receive the accolade of European Camera of the Year. EOS stood for Electro Optical System, but Eos was also the Greek goddess of the dawn, described by the ancient writer Hesiod as "Eos, who brings light to all the mortals of this Earth."

Fanciful perhaps, but appropriate for the camera that heralded the most successful series of developments in the history of photography. Ironically, the goddess Eos was the daughter of two Titans. Minolta and Nikon, maybe?

During the next two years, new models appeared in the form of the EOS 620 and the EOS 630, but the most significant launch was the Canon EOS-1, which was specifically designed to lure professionals away from other manufacturers' models.

To support this drive to attract the high-end user, Canon also had to develop its lenses, and the company worked hard to reach the forefront of lens technology. In particular, Canon needed to develop a superfast autofocus system that would work in all lighting conditions with the large-aperture lenses favored by press and sports photographers.

In late 1994, Canon introduced a new top-of-the-range model in the form of the EOS-1N, which featured much quieter operation, 5-point AF, and a 16-zone evaluative metering system. Its high-speed sister, the EOS-1N RS, boasted a drive rate of 10 fps, a figure that other manufacturers still find hard to beat. While Canon continued to improve its amateur SLRs with innovations such as eye-control focusing, the EOS-1N served professionals well for half a decade.

A new flagship model, the EOS-3, was launched in November 1998, by which time the key areas of metering and autofocus were undergoing rapid development, and Canon was about to embark on a decade of regular upgrades.

The EOS-3 utilized a 21-zone metering system that was linked to AF points, of which there were eventually 45. This increased the speed of operation further, especially when combined with the eye-control system. It had a top shutter speed of 1/8000 sec., along with a claimed lifetime of at least 100,000 shutter operations.

A PERFECT MARRIAGE �
Canon's DSLRs marry sophisticated electronics to complex optics, plus a tough bodyshell. The model shown here is the EOS-1D Mk IV.

1

The EOS-1V was introduced in the spring of 2000, with high-speed continuous shooting of up to 9 fps and 20 Custom Functions that could be tailored to each user's individual requirements. The EOS D30, also launched in 2000, brought into play an affordable digital SLR aimed at the nonprofessional enthusiast. With its Canon-developed CMOS sensor, the EOS D30 could boast the smallest and lightest body in this sector of the market.

The EOS D30 also heralded a new approach to photography in which those with little experience could access the capabilities of a complex tool using the now-familiar Basic Zone settings indicated by symbols on the Mode dial. Additional foolproofing was added in the form of a 35-zone evaluative metering system and E-TTL (electronic through-the-lens) metering for its built-in flash. Canon RAW image files could also be selected instead of JPEG files.

The EOS-1D was introduced in 2001, followed by the EOS-1Ds in 2002. These digital versions of the renowned EOS-1 series of professional film cameras took specifications and speed to staggering new levels. Recent models have continued the trend, with the EOS 1D Mk IV offering a maximum ISO of 102,400; Dual DIGIC 4 processing; and a 45-point AF system that incorporates 39 cross-type sensors for improved speed and accuracy.

Canon has positioned the EOS 7D as a faster partner to the EOS 5D Mk II, just as the 1Ds is partnered by the faster 1D version. The EOS 7D may not have the built-in drive or the same degree of weathersealing as the professional series, but its specification is still very impressive: 18 megapixels; 8 fps; a new 19-point AF sensor that offers both Zone and Spot AF selection; a new 63-zone metering system that analyzes focus, color, and luminance; built-in wireless Speedlite Transmitter; Dual DIGIC 4 processing; and full 1080p high-definition movie recording.

DIGIC 4 PROCESSOR ⌄
The heart of any camera is its processor, and the EOS 7D's heart beats much faster than those of its predecessors.

» MAIN FEATURES

Body

Dimensions: 5.8 x 4.3 x 2.9in (148.2 x 110.7 x 73.5mm).
Weight: 28.9oz (820g).
Construction: magnesium alloy body covers.
Lens mount: EF and EF-S.
Caution: operating environment 32–104°F (0–40°C) at maximum 85% humidity.

Sensor & processor

Processor: Dual DIGIC 4.
Sensor: 22.3 x 14.9mm CMOS self-cleaning sensor.
Effective pixels: approx. 18Mp.
Total pixels: approx. 19Mp.
Color filter type: Primary color.

File types and sizes

JPEG file sizes range from 5184 x 3456 pixels to 2592 x 1728 pixels, with a choice of Fine or Normal for each of the Large, Medium, and Small settings. RAW files are recorded as 5184 x 3456 pixels, M-RAW files as 3888 x 2592 pixels, and S-RAW as 2592 x 1728 pixels. The EOS 7D can record RAW/M-RAW/S-RAW and JPEG files either on their own or simultaneously. Both sRGB and AdobeRGB color spaces are supported. Movie clips are recorded as .MOV files with a maximum duration of 29 min. 59 sec. and a maximum file size of 4GB. Files can be recorded at HD 1920 x 1080 format at 30, 25, or 24 fps; at 1280 x 720 format at 60 or 50 fps; or at 640 x 480 format at 60 or 50 fps.

Shutter

The EOS 7D uses an electronically controlled focal-plane shutter, providing shutter speeds from 1/8000 sec. to 30 sec. in ½- or ⅓-stop increments, plus Bulb. Drive options include single-frame; high-speed continuous shooting at up to 8 fps with up to 94 Large/Fine JPEGs in one burst (126 shots with 4GB Ultra DMA card); low-speed continuous shooting; a 10-sec. self-timer/remote control; and a 2-sec. self-timer/remote control. Shutter life is quoted as 150,000 actuations.

Focusing

A newly designed 19-point AF sensor with Zone and Spot AF modes offers new ways to select AF points, all of which are "+" type, increasing sensitivity to both the horizontal and vertical characteristics of the subject. The center AF point has both f/2.8 and f/5.6 sensors. Three different autofocus modes, including predictive autofocus, can be selected to suit static or moving subjects: One Shot, AI Focus, or AI Servo. Single AF points, Spot AF, AF point expansion, and Zone AF are all selectable manually. In Live View mode, Manual focus and three AF modes are provided: Quick mode, Live mode, and Live Face Detection mode. In Live View mode, two different grid overlays can be selected. The AF system's working range is from EV -0.5 to EV 18 at 68°F (20°C) at ISO 100. Autofocus lock is possible in One Shot mode, and,

1

when using flash, an AF-assist beam is triggered if it is enabled via the Custom Functions. AF Microadjustment enables minute focus corrections for to up to 20 lenses. Autofocus is not possible on lenses slower than f/5.6, or effectively slower than f/5.6 when using an extender.

LCD monitor

The Clear View II high-resolution 3in (7.6cm) monitor, with its 920,000 dots and dual antireflection coating, provides 100% coverage with a 160° viewing angle. It provides seven manually selectable levels of brightness in addition to auto brightness determined by an external ambient light sensor. This makes it easy to review captured images and is also used in Live View mode for composing and checking fine detail. Magnification of x5 and x10, plus vertical and horizontal scrolling of the magnified portion of the image, assist this process.

Display options: Shooting Settings, Camera Settings, and Dual Axis Electronic Level for accurate leveling and horizons.

Exposure

A completely new iFCL 63-zone dual-layer metering sensor incorporates focus, color, and luminance information in its analysis, providing improved accuracy and consistency of metering. *Four full-aperture TTL metering modes:* Evaluative (linked to all AF points), Partial (9.4% at center), Spot (2.3% at center),

and Center-weighted average metering. The metering range is EV 1 to EV 20 at 68°F (20°C) at ISO 100 using a 50mm f/1.4 lens. *Exposure compensation:* maximum of +/-5 stops using ½- or ⅓-stop increments. *Auto exposure bracketing:* Three shots with a maximum of +/-3 stops using ½- or ⅓-stop increments. Exposure compensation and bracketing can be used together.

ISO: Automatic ISO setting between ISO 100 and ISO 3200, or manual ISO settings can be used between ISO 100 and ISO 6400 in ⅓- or 1-stop increments, expandable to 12,800 (H).

Flash

Built-in flash: With a Guide Number of 12 (meters/ISO 100), the built-in flash provides coverage up to 15mm focal length (24mm full-frame equivalent) with a recycle time of approximately 3 sec. *Integrated Speedlite Transmitter:* In addition to the built-in flash, the EOS 7D includes an Integrated Speedlite Transmitter with the ability to control multiple Speedlites without an ST-E2 or 580EX II acting as master unit, enabling easier wireless flash photography with full E-TTL II metering. The built-in flash can be incorporated into the wireless setup or it can be disabled. *Flash modes:* Auto, Manual, MULTIflash, Integrated Wireless Speedlite Transmitter. *Flash synchronization:* 1/250 sec., first-curtain, second-curtain.

Flash exposure compensation: +/-3 stops in ½- or ⅓-stop increments.
Flash exposure bracketing: available with compatible Speedlites.
Flash exposure lock.
External flash control: operated via camera menu screen.
PC terminal.

Image processing

Picture Styles: Standard, Portrait, Landscape, Neutral, Faithful, Monochrome, User-defined x2.
White balance: Auto, six WB presets, Custom, Color temperature, WB correction, WB bracketing.

Noise reduction: Long-exposure, High-ISO.
Other: Auto Lighting Optimizer, Highlight Tone Priority, Lens peripheral illumination correction.

Custom Functions

27 Custom Functions are supported, with a total of 70 different settings.

Software

ZoomBrowser EX/Image Browser; PhotoStitch; EOS Utility (including Remote Capture, WFT Utility, Original Data Security Tools); Picture Style Editor; Digital Photo Professional.

ZOOMBROWSER »
Canon's own software is provided with the EOS 7D to help you explore the camera's potential to the full.

1 » FULL FEATURES & CAMERA LAYOUT

FRONT OF CAMERA

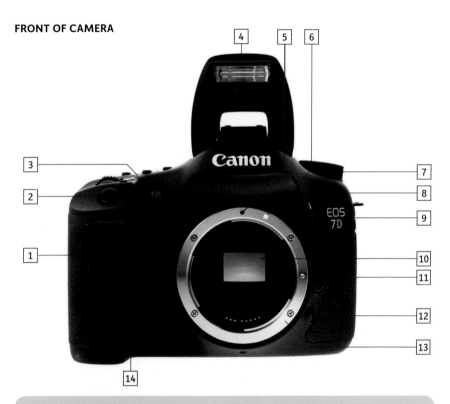

1	Remote-control sensor	8	Microphone
2	Shutter-release button	9	Flash button
3	Red-eye reduction/Self-timer lamp	10	Reflex mirror
4	Built-in flash	11	Lens-release button
5	EF lens mount index	12	Depth-of-field preview button
6	EF-S lens mount index	13	Lens mount
7	Mode dial	14	DC coupler cord hole

BACK OF CAMERA

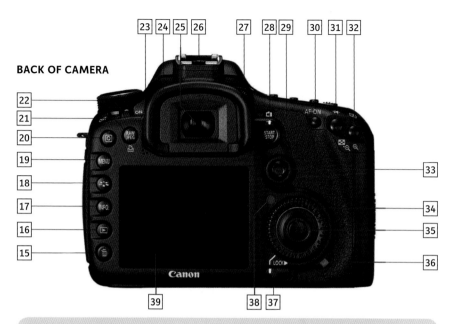

15	Erase button	28	Live View shooting/Movie shooting switch
16	Playback button	29	Movie start/stop button
17	INFO button	30	AF•ON button
18	Picture Style selection button	31	AE lock/Index/Reduce button
19	MENU button	32	AF-point selection/Enlarge button
20	Quick Control button	33	Multi-controller
21	One-touch RAW+JPEG/Direct print button	34	Quick Control dial
22	Power switch	35	Setting button
23	Speaker	36	Access lamp
24	Eyecup	37	Quick Control dial switch
25	Viewfinder eyepiece	38	Light sensor
26	Accessory hotshoe	39	LCD monitor
27	Diopter adjustment dial		

1 » FULL FEATURES & CAMERA LAYOUT

TOP OF CAMERA

LEFT SIDE

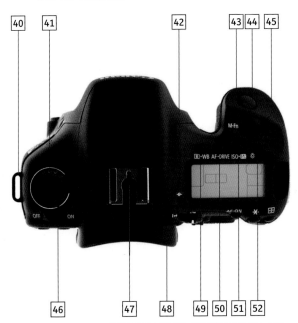

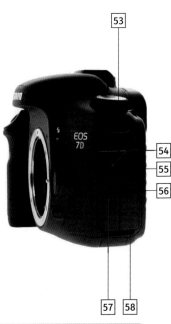

40	Camera strap eyelet	**48**	Diopter adjustment dial	
41	Mode dial	**49**	Metering mode/White balance selection button	
42	Focal plane mark			
43	Multi-function button	**50**	AF mode/Drive mode selection button	
44	Shutter-release button	**51**	ISO speed/Flash exposure compensation selection button	
45	Main dial			
46	Power switch	**52**	LCD panel illumination button	
47	Accessory hotshoe			

53	Camera strap eyelet
54	PC terminal
55	External microphone in terminal
56	AV out/Digital terminal
57	Remote control terminal (N3 type)
58	HDMI mini out terminal

BOTTOM OF CAMERA

RIGHT SIDE

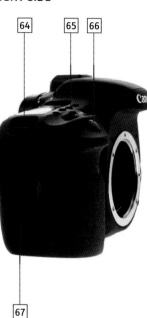

59	Expansion system terminal
60	Tripod socket (¼in)
61	Camera serial number
62	Battery compartment
63	Battery compartment release

64	Camera strap eyelet
65	Main dial
66	Shutter-release button
67	Compact Flash card compartment

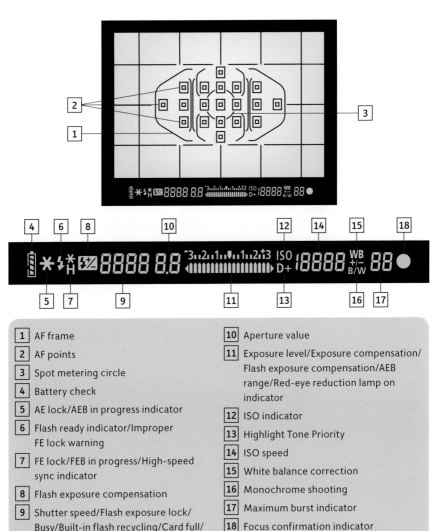

1 AF frame	**10**	Aperture value
2 AF points	**11**	Exposure level/Exposure compensation/ Flash exposure compensation/AEB range/Red-eye reduction lamp on indicator
3 Spot metering circle		
4 Battery check	**12**	ISO indicator
5 AE lock/AEB in progress indicator	**13**	Highlight Tone Priority
6 Flash ready indicator/Improper FE lock warning	**14**	ISO speed
	15	White balance correction
7 FE lock/FEB in progress/High-speed sync indicator	**16**	Monochrome shooting
	17	Maximum burst indicator
8 Flash exposure compensation	**18**	Focus confirmation indicator
9 Shutter speed/Flash exposure lock/ Busy/Built-in flash recycling/Card full/ Card error/No card indicator		

» LCD CONTROL PANEL

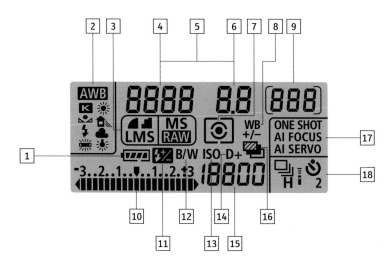

1 Battery check	**10** Exposure level/Exposure compensation/ Flash exposure compensation/AEB range/Card-writing status indicator
2 White balance preset	
3 Image format, size, and quality	**11** Flash exposure compensation
4 Shutter speed/Busy/Built-in flash recycling indicator	**12** Monochrome shooting
	13 ISO indicator
5 Card full/Card error/No card/Error code/Cleaning image sensor indicator	**14** Highlight Tone Priority
6 Aperture value	**15** ISO speed
7 Metering mode	**16** Auto exposure bracketing
8 White balance correction	**17** AF mode
9 Shots remaining on card/Shots remaining during WB bracketing/Self-timer countdown/Bulb exposure time	**18** Drive mode

1 » SHOOTING INFORMATION DISPLAY

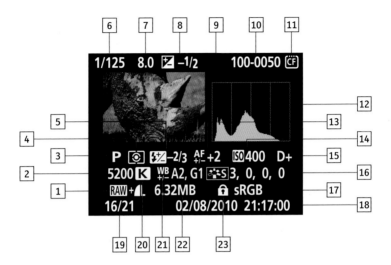

1	Image recording quality/Movie recording size	**13**	AF microadjustment
2	Color temperature when K is set	**14**	ISO speed
3	Shooting mode/Movie mode	**15**	Highlight Tone Priority
4	Metering mode	**16**	Picture Style and settings
5	Flash exposure compensation amount	**17**	Color space
6	Shutter speed/Recording time	**18**	Shooting date and time
7	Aperture	**19**	Playback number/Total images recorded
8	Exposure compensation amount	**20**	White balance
9	Protect	**21**	White balance correction
10	Folder number-File number	**22**	File size
11	Card indicator	**23**	Image verification data appended
12	Histogram		

» MOVIE INFORMATION DISPLAY

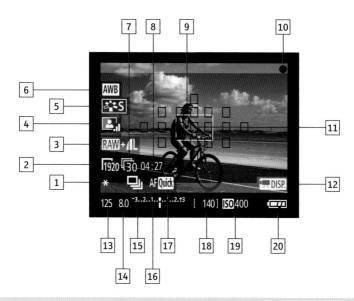

1 AE lock	11 AF point (Quick mode)
2 Movie recording size	12 Exposure simulation
3 Image recording quality	13 Shutter speed
4 Auto Lighting Optimizer	14 Aperture
5 Picture Style	15 Drive mode
6 White balance	16 Exposure compensation amount
7 Frame rate	17 AF mode
8 Movie shooting time remaining/ Elapsed time	18 Shots remaining
9 Magnifying frame	19 ISO speed
10 Recording movie	20 Battery check

» QUICK CONTROL SCREEN

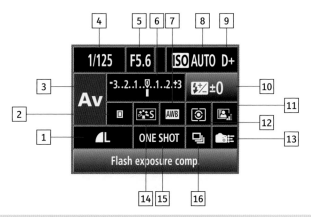

1	Image recording quality	9	Highlight Tone Priority
2	AF area selection mode	10	Flash exposure compensation
3	Shooting mode	11	Auto Lighting Optimizer
4	Shutter speed	12	Metering mode
5	Aperture	13	Custom Controls
6	Exposure compensation/AEB setting	14	Picture Style
7	White balance	15	AF mode
8	ISO speed	16	Drive mode

» SHOOTING SETTINGS DISPLAY

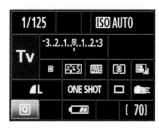

The Shooting Settings screen is almost identical to the Quick Control screen. When the Shooting Settings screen is displayed and **Q** is pressed, the bottom line changes to a function description and the most recently viewed function icon is highlighted in green.

» CAMERA SETTINGS DISPLAY

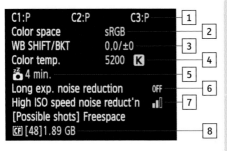

1	Shooting mode—Mode dial C1, C2, and C3
2	Color space
3	White balance shift/bracketing
4	Color temperature
5	Auto power-off
6	Long exposure noise reduction
7	High ISO speed noise reduction
8	Number of shots/space remaining

» MENU DISPLAYS

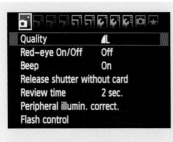

Shooting menu 1 📷
> Quality
> Red-eye On/Off
> Beep
> Release shutter without card
> Review time
> Peripheral illumination correction
> Flash control

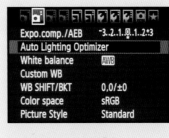

Shooting menu 2 📷
> Exposure compensation/AEB
> Auto Lighting Optimizer
> White balance
> Custom WB
> WB shift/bracketing
> Color space
> Picture Style

1 » MENU DISPLAYS

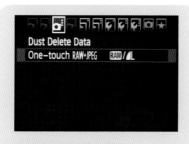

Shooting menu 3 📷
> Dust Delete Data
> One-touch RAW+JPEG

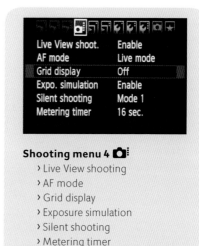

Shooting menu 4 📷
> Live View shooting
> AF mode
> Grid display
> Exposure simulation
> Silent shooting
> Metering timer

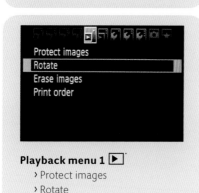

Playback menu 1 ▶
> Protect images
> Rotate
> Erase images
> Print order
> External media backup

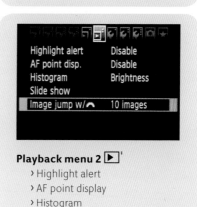

Playback menu 2 ▶
> Highlight alert
> AF point display
> Histogram
> Slide show
> Image jump with ⌒

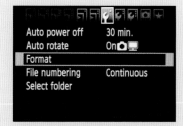

Set-up menu 1 🛠️

> Auto power-off
> Auto rotate
> Format
> File numbering
> Select folder
> WFT settings
> Recording func+media select

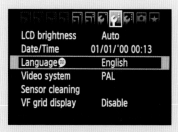

Set-up menu 2 🛠️

> LCD brightness
> Date/Time
> Language
> Video system
> Sensor cleaning
> VF grid display

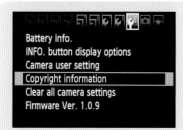

Set-up menu 3 🛠️

> Battery info.
> INFO button display options
> Camera user setting
> Copyright information
> Clear all camera settings
> Firmware version

Custom Functions menu 📷

> C.Fn I: Exposure
> C.Fn II: Image
> C.Fn III: Autofocus/Drive
> C.Fn IV: Operation/Others
> Clear all Custom Functions

Note: for My Menu, see page 85.

Chapter 2
FUNCTIONS

2 FUNCTIONS

If you are making the transition to the EOS 7D from a compact digital camera, or even from an entry-level DSLR, you may at first feel slightly daunted by its large array of buttons and dials. Fortunately, Canon offers Full Auto and Program modes that you can work with while you're getting to know the camera's functions better.

If you are upgrading from other Canon digital SLR cameras, you will be familiar with many of the 7D's design concepts, if not the actual placement of the controls—Canon tends to change the functions of certain buttons and the order of the menu options with each new model.

This chapter will explore the camera's full potential, step by step, by presenting basic information first and examining more complex issues in subsequent sections.

CANON EOS 7D ⌃
It takes time to explore the 7D's full range of features, but it's well worth the effort.

» CAMERA PREPARATION

› Attaching the strap

Use a camera strap at all times to ensure the safety of your camera. To attach it, pass the end of the strap through either the left or right eyelet at the top of the camera. Pass the end of the strap through the buckle under the length of strap that is already threaded through the buckle.

Repeat the operation on the other side of the camera. Pull the strap lightly to remove most of the slackness, position the buckle as desired, and pull more firmly so that the strap will not loosen within the buckle. The eyepiece cover is also attached to the strap.

› Fitting and removing a lens

Remove the rear body cap of the lens to be fitted, along with either the camera body cap or the lens already fitted to the camera. This is done by depressing the lens-release button while turning the cap or lens anticlockwise as it is facing you.

Canon EF and EF-S lenses can be used on the 7D. Align the lens to be fitted, using the red dot for EF lenses and the white dot for EF-S lenses *(see image, right)*. Insert the lens into the lens mount and turn it clockwise until you hear a faint click. Check that the AF/MF switch on the lens is set to the desired position.

After removing a lens, ensure that the lens cap is fitted and put it down safely with the rear end up. Fit the rear lens cap as soon as possible. Avoid touching the lens contacts, as dirty contacts can cause a malfunction.

Common errors

Before you attempt this operation, always make sure that the risk of dropping either camera or lens is minimized. Make certain that dust or sand will not be blown into the camera while changing lenses.

› Inserting and removing a memory card

1) Make sure that the camera is switched **OFF** and that the access lamp on the back of the camera is not illuminated.

2) With the camera facing away from you, the memory card slot cover is on the right side of the camera body. To open it, slide the cover toward you with firm finger pressure and it will swing outward on its hinges.

Warning!

Inserting the memory card incorrectly may damage the camera.

3) To insert a memory card, slide it into the camera's slot with its label side facing you and the two parallel rows of tiny holes along the edge of the card to your left. When the card is almost fully inserted, you will feel a slight resistance. Push a little harder and the card will slide fully home. The eject button will spring out slightly.

4) To remove a memory card, press the gray memory-card eject button located at the bottom of the card slot and slide out the card.

5) Press the cover shut and slide it forward until it snaps into position.

Tip

To enable shooting without a memory card inserted, see 📷 *Shooting menu 1. This facility can be used for remote shooting, when you are saving images direct to the computer.*

Common errors

When the red access lamp on the back of the camera is lit or blinking, it indicates that images are being processed—this may include being written, read, erased, or transferred to another device. Do not remove the battery or memory card when the red access lamp is illuminated or blinking. Either of these actions is likely to damage image data and may cause other camera malfunctions.

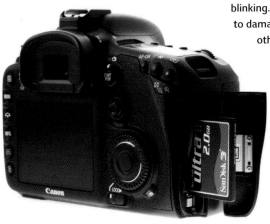

› Inserting the battery

Turn the camera upside down and locate the battery compartment on the right side. Using a fingernail, release the catch and open the compartment. With the projecting battery contacts downward, press the battery against the hinged white plastic catch on the left of the compartment and insert the battery until it locks in position. Shut the compartment cover until there is an audible click. To remove the battery, ease the white plastic spring-loaded retaining clip to the side. Once it is removed, a battery should have its protective cover attached to prevent shorting.

Tip

*Select **Battery info.** in ᵀᵀⁱ Set-up menu 3 to register each battery and check its remaining capacity, usage history, and recharging performance.*

› Using AC power

Use the AC Adapter Kit ACK-E6 (not supplied) to connect to an AC power outlet instead of using battery power.

1) Connect the DC coupler's plug to the AC adapter's socket.

2) Connect the power cord to the AC adapter and then to the power outlet.

3) Open the battery compartment, remove the battery, and insert the DC Coupler until you feel it lock in position.

4) Flick back the small rubber DC cord cover and press the cord into the notch. Close the battery compartment cover.

Warning!

Never connect or disconnect the power cord while the camera is switched on.

› Battery charging

The dedicated Battery Charger LC-E6E (or LC-E6 where supplied) should be used to charge the battery provided with the camera. Remove the battery cover and insert the battery into the charger. With the LC-E6E charger, connect the power cord to the charger and insert the plug into an AC outlet. With the LC-E6 charger, flip out the prongs and plug the unit directly into the AC outlet.

Recharging is indicated by a blinking orange lamp. A constantly illuminated green lamp indicates full charge. A fully discharged battery will take approximately 2.5 hours to recharge at 73°F (23°C).

Warning!

Do not touch the prongs of the charger's plug for at least three seconds after unplugging.

› Battery life

Battery life depends on many factors, especially the use of Live View, image review, built-in flash, and focus tracking. Lens operation is powered by the camera battery, so your choice of lens and use of Image Stabilization will also affect battery usage. Select an Auto power-off setting that suits the shooting situation.

The battery-charge symbol indicates the gradual depletion of power. When the symbol flashes, capacity is down to 10 shots or fewer. As a rough guide, without using the built-in flash or Live View, a fully charged battery will provide approximately 1000 shots at 73°F (23°C). This is reduced to 900 shots at 32°F (0°C).

Tips

The battery charger can be used abroad (100–240v AC 50/60 Hz) with a commercially available travel plug adapter. Do not attach any form of voltage transformer as this may damage the battery charger.

If your camera battery runs out quickly and needs frequent recharging, check the settings for **Auto power-off** *(Set-up menu 1) and* **Review time** *(Shooting menu 1) to see if you can save power.*

› Date/Time battery

The EOS 7D is fitted with a CR1616 lithium battery to retain date and time settings when the main battery is removed. With normal usage, this should last around five years. To change it, remove the main battery. The CR1616 battery holder is not immediately obvious, but can be found between the main battery compartment and the hinge of the battery compartment cover. Use a fingernail to slide it out.

› Diopter adjustment

Using the camera without spectacles or contact lenses is facilitated by the eyepiece diopter adjustment to the right of the viewfinder *(shown top left in the image above)*. To use it, turn the knob so that the AF points in the viewfinder appear sharp. (Removing the eyecup makes this easier.) If this does not provide enough adjustment, various different versions of the Dioptric Adjustment Lens E are available separately.

› EF and EF-S lenses

The EOS 7D accepts both EF and EF-S lenses. The latter are designed exclusively for Canon DSLRs with APS-C sensors, while EF lenses are designed for their full-frame counterparts, but can also be used with the smaller APS-C sensors.

The image projected by any lens onto a camera's sensor is circular rather than rectangular. A full-frame sensor is large enough to accommodate the maximum amount of the projected image circle of an EF lens. However, the smaller APS-C sensor covers a smaller proportion of the image circle projected by an EF lens, giving rise to what is referred to as the 1.6x "crop factor" to describe the reduced angle of view. However, an EF-S lens projects a smaller image circle, once again maximizing the sensor area.

(Left to right) Full-frame sensor plus EF lens; ❯❯ APS-C sensor plus EF lens; APS-C sensor plus EF-S lens.

2 » BASIC CAMERA FUNCTIONS

› Switching the camera on

The power switch is incorporated into the Mode dial on the top of the camera and provides a simple on/off switch. Care should be taken not to accidentally change the Mode dial setting when switching the camera on or off.

Sensor cleaning is performed automatically each time the camera is turned on or off. A message to this effect is displayed briefly on the LCD monitor on the back of the camera. Automatic sensor cleaning can be disabled in ⌂ Set-up menu 2.

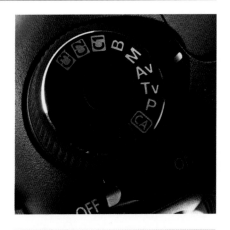

Common errors

The self-timer setting (indeed any Drive mode setting) is not canceled when the camera is switched off.

Always check your battery's charge level before setting out, especially if you anticipate making extensive use of flash. Even better, take a fully charged spare battery with you.

Tips

*If the camera is set to power-off automatically after a set interval (**Auto power-off** in Set-up menu 1), partially depressing the shutter button will fully reactivate the camera.*

*If the power switch is turned to **OFF** while an image file is being written, the camera will finish recording the image before turning off.*

› Drive mode

The EOS 7D provides three frame-advance modes and two self-timer settings. Single-frame advance is suitable for most situations, while Low-speed continuous (up to 3 fps) and High-speed continuous (up to 8 fps) are suited to shooting action. Low-speed continuous is also useful when bracketing a set of three exposures.

Auto mode restricts your choice to Single-frame advance or ☉ Self-timer. Creative Auto offers slightly more flexibility, adding Low-speed continuous to Single-frame advance and ☉ Self-timer.

The two self-timer options are ☉ and ☉₂, providing a 10-second delay and a two-second delay respectively. With the

Tips

Continuous shooting speeds may be adversely affected by a very low battery, when shooting in low-light conditions, and when using AI Servo focusing mode.

The eyepiece cover can be used in conjunction with the self-timer and slow shutter speeds or Bulb mode to prevent light from entering the viewfinder and affecting the exposure.

aid of a tripod or other camera support, you can take advantage of the former to include yourself in the photograph, or to reduce camera shake when slow shutter speeds are being used and no remote release is available. When the shutter release has been fully depressed, the self-timer countdown lamp will flash and the beep will sound, both speeding up for the final two seconds. To cancel the self-timer after countdown has begun, press the **AF•DRIVE** button.

1) To change the Drive mode setting, press the **AF•DRIVE** button on the top of the camera. The viewfinder display will switch off.

2) Rotate the ◯ Quick Control dial to change the setting, which can be viewed on the top LCD panel or on the LCD monitor.

Maximum burst

This is the maximum number of images that can be processed in a single burst when using Continuous shooting, or consecutively when using Single-frame advance. The maximum burst size is affected by various factors, notably the image-quality setting. The number of frames available ranges from six when shooting RAW + JPEG simultaneously to 3297 when shooting Small/Normal JPEG only. However, the maximum burst figure shown in the bottom-right corner of the viewfinder is limited to a maximum of 99, indicating 99 or higher.

The maximum burst size should not be confused with the number of shots available on the memory card, which also depends heavily on the image-quality setting *(see page 86 for more on image quality)*.

› Mode dial

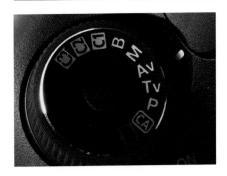

Mode dial	
Full Auto	⬭
Creative Auto	**CA**
Program	**P**
Shutter-priority	**Tv**
Aperture-priority	**Av**
Manual	**M**
Bulb (time exposure)	**B**
Camera User mode 1	**C1**
Camera User mode 2	**C2**
Camera User mode 3	**C3**

The Mode dial provides 10 different shooting modes, each of which will be explained in detail later in this chapter. These include two automated modes, three with user-defined settings (Camera User modes), and a Bulb setting for long exposures. To select a particular mode, turn the dial until the desired mode's icon is lined up with the mark on the camera body.

Custom exposure modes

One very useful function available on the EOS 7D is the ability to define a whole set of parameters and settings, and save it as a Camera User mode. You can do this three times over, as the 7D has three Camera User modes: **C1**, **C2**, and **C3**.

To make use of this facility, think about the situations in which you take photographs and identify the key factors that affect each one. Depending on what you shoot most often, you may find it useful to create a group of settings for studio or close-up work using Live View; a group for wedding photography that incorporates Highlight Tone Priority and noise reduction; a group for use with multiple wireless flash; and so on.

This function is particularly useful if you are using two or more bodies, as you can set up identical Camera User Settings on each one. You can always switch to one of the other modes if you need to break away from your favored settings.

› Operating the shutter-release button

The shutter-release button has two functions. Partially depressing it brings into play the autofocus and metering functions. Pressing it fully releases the shutter and takes the picture using the focus and exposure settings that were registered when you only partially depressed the shutter release. If the shutter-release button is fully depressed immediately, there will be a momentary delay before the picture is taken. If you have purchased an additional battery grip, exactly the same applies to the additional shutter-release button provided on the battery grip for vertical shooting.

Tips

*In **P**, **Tv**, **Av**, **M**, and **B** modes, metering and focusing can also be activated by pressing the **AF•ON** button. See pages 132–4 for further options.*

Even while menus are displayed, an image is being reviewed, or an image file is being recorded, the camera will immediately go to picture-taking readiness if you partially depress the shutter-release button—unless the buffer is full.

› Main dial

The Main dial, next to the shutter-release button, is used for adjustments to the settings required for shooting. It is used sometimes on its own, and on other occasions after depressing a button to select the function you wish to adjust.

In **P** mode, the Main dial, used on its own, will adjust both the aperture and the shutter speed while retaining the equivalent exposure. In **Tv** and **M** modes, it will adjust only the shutter speed. In **Av** mode, it will adjust only the aperture.

The Main dial is also used to adjust metering mode, autofocus mode, and ISO, in combination with the buttons located immediately above the LCD panel on top of the camera. (Each of these buttons governs two different functions; the other is adjusted using the Quick Control dial.) After pressing a button, the ability to adjust that function will remain active for six seconds. Having adjusted a setting, it is not necessary to wait for the six seconds to elapse: partially depressing the shutter-release button will immediately return the camera to shooting readiness.

In all of the above instances, any adjustments made will be visible in the LCD panel on top of the camera, but only the ISO setting will be visible in the viewfinder. (When adjusting metering mode or autofocus mode, the viewfinder display is temporarily turned off.)

› Quick Control dial

On the EOS 7D, the Quick Control dial has its own isolation switch, marked (on) or **LOCK** (off). For those familiar with the Quick Control dial on earlier Canon DSLRs, this is simply a variation of the Quick Control dial on/off setting that is incorporated into the main power switch.

With the Quick Control dial switch set to , the dial can be rotated to adjust the aperture in **M** mode, and to set exposure compensation in **Tv**, **Av**, and **P** modes.

With the Quick Control dial switch set to either or **LOCK**, the dial functions in the same way as the Main dial when used in conjunction with the buttons next to the LCD top panel. White balance, Drive mode, and Flash exposure compensation can be adjusted in this way.

› Multi-controller ☼

The Multi-controller is located on the back of the camera, just above the Quick Control dial, and acts like a small joystick. It is programmed to accept eight directional commands, and has a button incorporated into its center. This control can be used for adjusting white-balance settings; during Live View, to move the magnifying frame or AF point; to select an AF point during normal shooting, depending on the AF-point selection method; to choose settings on the Quick Control screen; and during some menu operations.

› Button layout

With each new camera model, Canon tends to make minor changes to button layout and/or the functions assigned to those buttons. There are three new buttons on the EOS 7D, but many users may also be disappointed that Canon steadfastly refuses to allocate a button specifically to Mirror lockup, continuing to rely on the menu system to activate this function.

Two of the three additions can be found on the top-left side of the camera back. The first is the **Q** Quick Control button. Press this button to display the Quick Control screen for 10 seconds to amend shooting settings. During Live View operation, it can be used to access settings for Auto Lighting Optimizer and image quality. In Movie mode, it fulfils the same functions and offers access to the movie recording size options. In AF Quick mode, it can also be pressed to select the AF point and AF area selection mode. *(See Chapter 3 for more on the use of the* **Q**

button in Live View and Movie modes.)

The second change on this part of the camera is the appearance of the RAW/JPEG One-touch RAW+JPEG button, which also activates the Direct print function. When the currently selected file-quality setting is JPEG-only, this button can be pressed to record a RAW image too. Conversely, if the current setting is one of the RAW options, pressing RAW/JPEG will also record a

> **Note:**
> If the camera is already set to record both RAW and JPEG images, pressing the RAW/JPEG button will have no effect.

JPEG image, by default at the ◢L Large/ Fine setting. *(See pages 87–8 for more information on using the ᴿᴬᵂ/ᴶᴾᴱᴳ button.)*

The third notable change in button layout is the addition of the **M-Fn** Multi-function button, which is located near the Main dial and the shutter-release button. This can be used in conjunction with the 🔲/🔍 button to change the AF-area selection mode *(see page 63)* and to set Flash exposure lock *(see page 179)*. Using C.Fn IV-1 Custom Controls,

the **M-Fn** button can be programmed to perform a wide range of functions *(see pages 132–4).*

› Electronic level

Another innovation from Canon is the built-in level, which can be displayed on the LCD monitor by pressing the **INFO** button (depending on the **INFO** button display setting in 📷 Set-up menu 3).

The level of tilt, both horizontal and vertical, is indicated in 1° increments. When the outer parts of the full-width line are red, it indicates that the camera is not laterally level. When corrected, these sections of the line turn green, as shown in the example opposite.

Within the central portion of the Electronic level display there is a longer white line that indicates the degree of

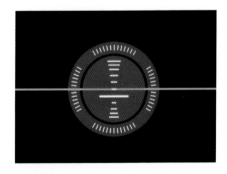

forward or backward tilt. In the example shown here, this white line is just below the center line, indicating that the camera is tilted very slightly upward.

Viewfinder electronic level

After using the Electronic level on the LCD monitor, the viewfinder version comes as something of a surprise. To use it, you must first assign the **M-Fn** button to **VF electronic level** using C.Fn IV-1 Custom Controls *(see pages 132–4)*.

When you have done this, press the **M-Fn** button when you are ready to shoot. The viewfinder will display what looks like an AF-point array in the form of seven horizontal sensors running across the center of the display and five running vertically, to form a cross. At this point you need to think in terms of a spirit level. What you are looking for is the equivalent of that centered bubble: a single sensor in the middle of the viewfinder. If the display is loaded on one side, the camera is tilted to the side. If it is loaded in the top (or bottom) half of the display, the camera

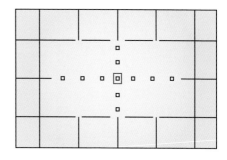

is tilted upward (or downward). Level the camera so that the display gradually becomes centered. If the display switches off, press **M-Fn** again.

When the 7D is tilted left/right ("roll") or up/down ("pitch"), the display indicates the extent of the roll or pitch—either side of the central sensor for roll, and/or above or below it for pitch. Each shift in the display represents 1° of roll or pitch, to a maximum of 6° roll and/or 4° pitch.

□	□	□	▣	□	□	□	Level
□	□	□	▣	▣	□	□	1° roll
□	□	□	□	▣	□	□	2° roll
□	□	□	□	▣	▣	□	3° roll
□	□	□	□	□	▣	□	4° roll
□	□	□	□	□	▣	▣	5° roll
□	□	□	□	□	□	▣	6° roll
□	□	□	□	□	□	▣	6°+ roll

SENSOR DISPLAY «

These examples show how the lateral sensors in the Viewfinder electronic level are displayed when the camera is tilted to the left. If the roll or pitch is greater than 6°, the red sensor at the end of the scale will flash.

» ⬜FULL AUTO MODE

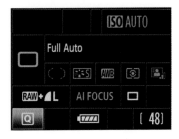

Full Auto mode is a blessing for the less experienced photographer in situations where there is insufficient time to think carefully about camera settings and where lighting (and therefore exposure) is changeable. Basically, the camera does the thinking for you. This is often thought of as a basic mode, but there is nothing basic about it at all, as it takes into account most of the settings over which you could have some control if you chose. The panel opposite indicates the various settings that the camera will select automatically, and which you cannot override.

Warning!

In both Full Auto and Creative Auto modes, some of the camera's menu options are "grayed out" and cannot be accessed. Other menus will not be visible at all *(see Notes)*.

Tip

To open the Shooting Settings screen before shooting—thus displaying the maximum information, including battery level—press **INFO***. Then press* **Q** *to open the Quick Control screen to change your settings. To go directly to the Quick Control screen, just press* **Q***. This applies to all shooting modes.*

› Using Full Auto mode

1) Turn the Mode dial to ⬜. If you do not wish to change any of the settings, go straight to step 5.

2) To change the file-quality setting or set the self-timer, press **INFO** until the Shooting Settings screen is displayed.

3) Press the **Q** button and use the ✳ Multi-controller to highlight the function you want to change. Rotate either the ⌒ Main dial or ⭕ Quick Control dial to change the setting.

4) Press **INFO** or partially depress the shutter release to exit the screen.

5) Aim the camera at the scene, keeping your main subject(s) within the clear central portion of the viewfinder.

6) Lightly press the shutter-release button to achieve focus. The ● in-focus indicator and automatically selected AF points will be displayed in the viewfinder. If the ● in-focus indicator light in the viewfinder blinks, focus has not been possible. The camera will also beep twice to confirm focus, unless the beep has been disabled in Shooting menu 1. Exposure settings (aperture and speed) will appear at the bottom of the viewfinder.

7) Retain light pressure on the shutter-release button to keep the focus and exposure settings locked. Recompose the picture if necessary and fully depress the shutter-release button to take the photograph.

Notes:
Shooting menu 1 is selectable, but **Flash control** is unavailable.

Shooting menu 2 and Shooting menu 3 are not displayed.

Shooting menu 4 📷 adopts the symbol for Shooting menu 2 📷, with the loss of three functions.

Set-up menu 3 is reduced to two selectable functions.

My Menu and the Custom Functions menu are not displayed.

8) The captured image will be displayed on the LCD monitor for two seconds, unless the review function has been adjusted or switched off.

FULL AUTO MODE SETTINGS

Quality settings
All settings are selectable using any one of RAW, MRAW, SRAW, or six levels of JPEG on their own, or in any combination of JPEG plus RAW, MRAW, or SRAW. Note: shooting RAW provides additional post-processing control compared with JPEG (e.g., Auto Lighting Optimizer settings can be adjusted).

Exposure control
Evaluative metering using 63 different zones; shutter speed and aperture are chosen to suit the light levels and subject; Auto ISO; Standard Picture

Style; Auto White Balance; Auto Lighting Optimizer; Peripheral illumination correction; Highlight alert.

Focus settings
Automatic AF-point selection in AI Focus mode. This will track a moving subject as long as you keep the illuminated AF point on it and continue to partially depress the shutter-release button to lock focus.

Frame advance
Single-frame advance; 10-sec. self-timer.

2 » (CA) CREATIVE AUTO MODE

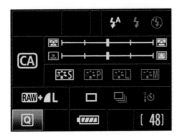

Creative Auto mode was first introduced on the Canon EOS 50D. In essence, Creative Auto adopts the default settings used by Full Auto mode, but introduces the possibility of overriding certain settings.

Full control over file-quality settings is provided, giving a total of 27 different combinations of RAW and JPEG from which to choose. Four Picture Styles are incorporated—Standard, Portrait, Landscape, and Monochrome—each using only the default parameter settings (although RAW images can be adjusted on the computer using Digital Photo Professional).

Two adjustable linear settings provide options to alter the degree of background blur and the overall brightness of the image. Each of these adjustments is achieved using a +/-2 sliding scale on the Quick Control screen. The background-blur scale adjusts the selected aperture to change the depth of field, with the corresponding shutter

speed changing accordingly—in effect, providing the same function as Program Shift in Program mode *(see pages 46-7)*. However, the function is presented simply, with a desired result in mind (i.e., a more- or less-blurred background) without touching on the technical aspects of aperture and depth of field.

The brightness scale is essentially a means of providing exposure compensation, again concentrating on the desired result while avoiding the need to explain the business of exposure and the relative properties of aperture and shutter speed.

In terms of developing one's skills as a photographer, Creative Auto mode is positioned somewhere between Full Auto and Program modes.

› Using Creative Auto mode

1) Turn the Mode dial to **CA**. If you do not wish to change any of the settings, go straight to step 5.

2) To change the settings, press **INFO** until the Shooting Settings screen is displayed.

3) Press the **Q** button and use the ✳ Multi-controller to highlight the function you want to change. Rotate either the ⌔ Main dial or ◌ Quick Control dial to adjust the setting.

4) Repeat step 3 for any other functions you wish to adjust. Press **INFO** or partially depress the shutter-release button to exit the Shooting Settings screen.

5) Aim the camera at the scene, keeping your main subject(s) within the clear central portion of the viewfinder.

6) Follow steps 6–7 on page 43 to achieve focus and take the photograph.

7) The captured image will be displayed on the LCD monitor for two seconds, unless the review function has been adjusted or switched off.

Notes:
Shooting menu 1 is selectable but **Flash control** is unavailable.

Shooting menu 2 and Shooting menu 3 are not displayed.

Shooting menu 4 📷 adopts the symbol for Shooting menu 2 📷, with the loss of three functions.

Set-up menu 3 is reduced to two selectable functions.

My Menu and the Custom Functions menu are not displayed.

CREATIVE AUTO MODE SETTINGS

Quality settings
All settings are selectable using any one of RAW, M RAW, S RAW, or six levels of JPEG on their own, or in any combination of JPEG plus RAW, M RAW, or S RAW. Note: shooting RAW provides additional post-processing control compared with JPEG (e.g., Auto Lighting Optimizer settings can be adjusted).

Exposure control
Evaluative metering using 63 different zones; shutter speed and aperture are chosen to suit the light levels and subject, but can be adjusted to increase/decrease background blur or to increase/decrease overall brightness; Auto ISO; four Picture Styles are selectable:

Standard, Portrait, Landscape, or Monochrome; Auto White Balance; Auto Lighting Optimizer; Peripheral illumination correction; Highlight alert.

Focus settings
Automatic AF point selection in AI Focus mode. This will automatically switch to AI Servo mode if linear movement of the subject is detected, tracking the subject as long as you keep it covered by the AF points and continue to partially depress the shutter-release button.

Frame advance
Single-frame advance; 10-sec. self-timer.

2 » (P) PROGRAM MODE

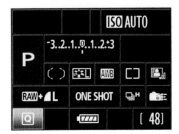

Program AE mode automatically sets the shutter speed and aperture. The specific combination can be adjusted, but only as a combination. For example, you can change 1/250 at f/8 to 1/1000 at f/4, or to any other combination that gives the same effective exposure—this is referred to as Program Shift. Full control is available over AF mode, Drive mode, and other functions, so Program AE retains a great deal of flexibility and is perhaps the next step up the learning curve from Full Auto and Creative Auto.

› Using Program mode

1) Turn the Mode dial to **P**. If you do not wish to change any of the settings, go straight to step 5. To change the settings, press **INFO** until the Shooting Settings screen is displayed.

2) Press the **Q** button and use the ✳ Multi-controller to highlight the function you want to change. Rotate the 🗘 Main dial or ⬭ Quick Control dial to change the setting.

3) Repeat for any other functions you wish to adjust. Press **INFO** or partially depress the shutter-release button to exit the Shooting Settings screen.

4) Aim the camera at the scene, keeping your main subject(s) covered by the currently selected AF points.

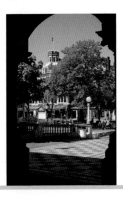

PROGRAM SHIFT «

Program mode is an ideal setting for capturing shots quickly, especially in conjunction with a wide-ranging zoom lens. You can easily select a combination of fairly narrow aperture and slower shutter speed for maximum depth of field (far left). But by rotating the 🗘 Main dial, it takes only a fraction of a second to select a faster shutter speed when you want to freeze movement (left). Program Shift automatically selects the wider aperture to match.

5) Lightly press the shutter-release button to achieve focus. The selected AF points will be displayed in the viewfinder. Unless you are using AI Servo, the ● in-focus indicator will be displayed. The camera will beep twice to confirm focus, unless the beep has been disabled in Shooting menu 1. If the ● in-focus indicator light blinks, focus has not been possible. Exposure settings (aperture and shutter speed) will appear at the bottom of the viewfinder. To change the exposure settings using Program Shift, rotate the ⚙ Main dial until the desired combination is shown. Rotate the ◐ Quick Control dial to set exposure compensation, if required.

6) Retain light pressure on the shutter release to keep the focus and exposure settings locked. Recompose the picture if necessary, and fully depress the shutter release to take the photograph. Continue to fully depress the shutter-release if you are using continuous shooting.

7) See step 8 on page 43.

7) See step 8 on page 43.

PROGRAM MODE SETTINGS

Quality settings
All settings are selectable using any one of **RAW**, M**RAW**, S**RAW**, or six levels of JPEG on their own, or in any combination of JPEG plus **RAW**, M**RAW**, or S**RAW**.

Exposure control
Evaluative metering using 63 different zones; Partial metering; Center-weighted average metering; Spot metering; Exposure compensation; Auto exposure bracketing; Auto Lighting Optimizer (four settings); Picture Styles; Custom Controls; Peripheral illumination correction; Highlight Tone Priority; Long exposure noise reduction; Manual or Auto ISO; High ISO noise reduction; ISO expansion; White balance: Auto plus six presets and Custom; Color temperature 2500–10,000°K; White balance shift and bracketing; ½- or ⅓-stop exposure increments; ⅓- or 1-stop ISO increments; Exposure Safety Shift in Tv/Av; Flash sync: Auto, 1/60–1/250 Auto, 1/250 fixed; flash exposure compensation.

Focus settings
One Shot; AI Servo; AI Focus; automatic AF-point selection; manual Single AF-point selection; manual Spot AF-point selection; manual AF-point expansion; manual Zone AF selection; AI Servo tracking sensitivity; AI Servo 1st/2nd image priority; AI Servo AF tracking method; AF Microadjustment.

Frame advance
Single-frame; High-speed continuous; Low-speed continuous; self-timer (10 sec. or 2 sec.).

2 » (Tv) SHUTTER-PRIORITY MODE

In Shutter-priority mode, the user sets the shutter speed, and the camera automatically selects a suitable aperture. This gives the photographer the opportunity to decide on shutter speed as the single most important function—perhaps to capture a fast-moving subject or to deliberately blur movement for pictorial effect. For the record, Tv stands for Time value.

The key factor in determining a suitable shutter speed is not the absolute speed at which the subject is traveling. What is important is the speed at which the subject is moving across the frame, and its size in relation to the area of the frame. For example, a 1:1 magnification of a flower moving gently in the breeze is more likely to blur than an express train some distance away taken with a wide-angle lens.

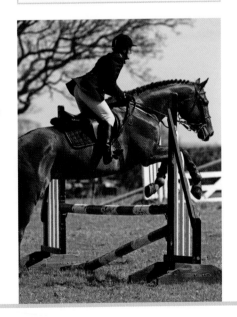

GYMKHANA »
Whether it's clearing fences or fencing, Shutter-priority mode is most photographers' first choice for capturing sporting events.

› Using Shutter-priority mode

1) Turn the Mode dial to **Tv** and set the desired shutter speed using the 🖐 Main dial. If you do not wish to change any other settings, go straight to step 2. To adjust other settings, follow steps 2-4 on pages 44-5.

2) Aim the camera at the scene, keeping your main subject(s) covered by the AF points currently selected.

3) For notes on achieving focus, see step 6 on page 43. To adjust the shutter speed, rotate the 🖐 Main dial. Rotate the ◯ Quick Control dial to set exposure compensation, if required.

4) Retain light pressure on the shutter-release to keep the focus and exposure settings locked. Recompose the picture if necessary, and fully depress the shutter-release to take the photograph. Continue to fully depress the shutter-release if you are using continuous shooting.

5) See step 8 on page 43.

SHUTTER-PRIORITY MODE SETTINGS

Quality settings
All settings are selectable using any one of **RAW**, M**RAW**, S**RAW**, or six levels of JPEG on their own, or in any combination of JPEG plus **RAW**, M**RAW**, or S**RAW**.

Exposure control
Evaluative metering using 63 different zones; Partial metering; Center-weighted average metering; Spot metering; Exposure compensation; Auto exposure bracketing; Auto Lighting Optimizer (four settings); Picture Styles; Custom Controls; Peripheral illumination correction; Highlight Tone Priority; Long exposure noise reduction; Manual or Auto ISO; High ISO noise reduction; ISO expansion; White balance: Auto plus six presets and Custom; Color temperature 2500-10,000°K; White balance shift and bracketing; ½- or ⅓-stop exposure increments; ⅓- or 1-stop ISO increments; Exposure Safety Shift in Tv/Av; Flash sync: Auto, 1/60-1/250 Auto, 1/250 fixed; flash exposure compensation.

Focus settings
One Shot; AI Servo; AI Focus; automatic AF-point selection; manual Single AF-point selection; manual Spot AF-point selection; manual AF-point expansion; manual Zone AF selection; AI Servo tracking sensitivity; AI Servo 1st/2nd image priority; AI Servo AF tracking method; AF Microadjustment.

Frame advance
Single-frame; High-speed continuous; Low-speed continuous; self-timer (10 sec. or 2 sec.).

2 » (Av) APERTURE-PRIORITY MODE

In Aperture-priority mode, the user sets the aperture, and the camera automatically selects a suitable shutter speed. This mode is normally selected when depth of focus is the key issue; that is, when you want to ensure that everything from the foreground to the background is in focus. Conversely, you can use differential focus to make your subject stand out against an out-of-focus background. A wide aperture ensures narrower depth of focus; a narrow aperture (higher f-number) will provide greater depth of field.

Many landscape photographers switch off autofocus on their lens when using Aperture-priority mode with a very narrow aperture. Instead, they manually focus on a point around one-third of the way into the zone they want in focus. Alternatively, they may use the depth-of-field scale on the lens, if it has one.

Common errors

If the shutter speed is flashing, it indicates that the selected aperture is too low or too high for the current ISO rating and a correct exposure cannot be achieved without adjusting the aperture or ISO. Enable Safety Shift in Custom Function I-6 and/or set Auto ISO to avoid this problem.

ARCHWAY ⌄
In this image, a narrow aperture made sure that everything, from the stonework of the arch in the foreground to the beautiful house in the background, was in focus.

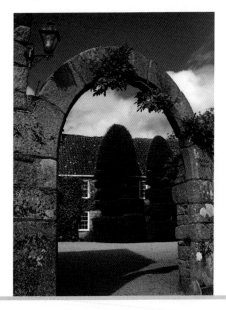

› Using Aperture-priority mode

1) Turn the Mode dial to **Av** and set the aperture using the ⚙ Main dial. If you do not wish to change any other settings, go straight to step 2. To adjust other settings, follow steps 2–4 on pages 44–5.

2) Aim the camera at the scene, keeping your main subject(s) covered by the AF points currently selected.

3) For notes on achieving focus, see step 6 on page 43. To adjust the aperture, rotate the ⚙ Main dial. Rotate the ⊙ Quick Control dial to set exposure compensation, if required.

4) See steps 7–8 on page 43.

APERTURE-PRIORITY MODE SETTINGS

Quality settings
All settings are selectable using any one of RAW, MRAW, SRAW, or six levels of JPEG on their own, or in any combination of JPEG plus RAW, MRAW, or SRAW.

Exposure control
Evaluative metering using 63 different zones; Partial metering; Center-weighted average metering; Spot metering; Exposure compensation; Auto exposure bracketing; Auto Lighting Optimizer (four settings); Picture Styles; Custom Controls; Peripheral illumination correction; Highlight Tone Priority; Long exposure noise reduction; Manual or Auto ISO; High ISO noise reduction; ISO expansion; White balance: Auto plus six presets and Custom; Color temperature 2500–10,000°K; White balance shift and bracketing; ½- or ⅓-stop exposure increments; ⅓- or 1-stop ISO increments; Exposure Safety Shift in Tv/Av; Flash sync: Auto, 1/60–1/250 Auto, 1/250 fixed; flash exposure compensation.

Focus settings
One Shot; AI Servo; AI Focus; automatic AF-point selection; manual Single AF-point selection; manual Spot AF-point selection; manual AF-point expansion; manual Zone AF selection; AI Servo tracking sensitivity; AI Servo 1st/2nd image priority; AI Servo AF tracking method; AF Microadjustment.

Frame advance
Single-frame; High-speed continuous; Low-speed continuous; self-timer (10 sec. or 2 sec.).

2 » (M) MANUAL MODE

Manual exposure mode provides ultimate control over exposure, as the shutter speed and aperture are set independently—the camera does not choose one to fit the other. This is particularly useful in awkward lighting conditions, at times when the camera's meter may be fooled by the luminosity or reflectivity of the subject matter, and when the desired effect is other than an averagely toned scene.

There are occasions when a particularly bright high-key image is required—a soft-focus portrait of a bride in her wedding dress is one common example. And sometimes, what might normally be deemed an underexposed result is needed, particularly in reportage images.

Another factor to bear in mind is that the camera offers a monochrome option, including the simulated use of black-and-white filters. Traditionally, metering for slide film has always been based on the highlights, while metering for black-and-white photography has been based on the

shadows. With the 7D in Manual mode, however, you can adopt different midtones to suit different styles of photography. You also have the benefits of Picture Styles and Highlight Tone Priority to fine-tune your way of working, though the latter restricts your minimum ISO to 200.

CITY SKYLINE ❯❯
This study of city-center architecture posed a number of potential metering problems, so Spot metering and Manual mode were used to ensure a perfect exposure.

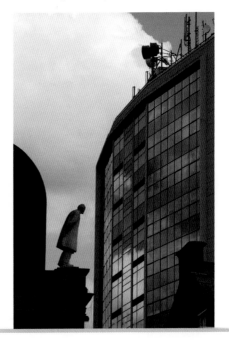

› Using Manual mode

1) Turn the Mode dial to **M**. Rotate the ⚙ Main dial to adjust the shutter speed and the ◯ Quick Control dial to adjust the aperture until the exposure-level indicator is centered. (If you are metering from a selected area, take the reading and make the necessary adjustment to center the exposure level indicator before recomposing the scene. Ignore the exposure-level indicator when the scene has been recomposed.)

2) To change other settings, press **INFO** until the Shooting Settings screen is displayed.

3) Press the **Q** button and use the �֍ Multi-controller to highlight the function you want to change. Rotate either the ⚙ Main dial or ◯ Quick Control dial to change the setting.

4) Follow steps 4–8 on pages 42–3.

MANUAL MODE SETTINGS

Quality settings
All settings are selectable using any one of **RAW**, M**RAW**, S**RAW**, or six levels of JPEG on their own, or in any combination of JPEG plus **RAW**, M**RAW**, or S**RAW**.

Exposure control
Evaluative metering using 63 different zones; Partial metering; Center-weighted average metering; Spot metering; Exposure compensation; Auto exposure bracketing; Auto Lighting Optimizer (four settings); Picture Styles; Custom Controls; Peripheral illumination correction; Highlight Tone Priority; Long exposure noise reduction; Manual or Auto ISO; High ISO noise reduction; ISO expansion; White balance: Auto plus six presets and Custom; Color temperature 2500–10,000°K; White balance shift and bracketing; ½- or ⅓-stop exposure increments; ⅓- or 1-stop ISO increments; Exposure Safety Shift in Tv/Av; Flash sync: Auto, 1/60–1/250 Auto, 1/250 fixed; flash exposure compensation.

Focus settings
One Shot; AI Servo; AI Focus; automatic AF-point selection; manual Single AF-point selection; manual Spot AF-point selection; manual AF-point expansion; manual Zone AF selection; AI Servo tracking sensitivity; AI Servo 1st/2nd image priority; AI Servo AF tracking method; AF Microadjustment.

Frame advance
Single-frame; High-speed continuous; Low-speed continuous; self-timer (10 sec. or 2 sec.).

2 » (B) BULB MODE

Bulb mode is used for exposures longer than the camera's maximum of 30 sec. The user sets the aperture by rotating the ⚙ Main dial or ⚙ Quick Control dial, and retains manual control of the shutter speed by depressing the shutter and releasing it only when the exposure is completed. The RS-80N3 remote release or the TC-80N3 timer/remote control should be used to avoid camera shake.

BULB MODE SETTINGS

Quality settings
All settings are selectable using any one of RAW, M RAW, S RAW, or six levels of JPEG on their own, or in any combination of JPEG plus RAW, M RAW, or S RAW.

Exposure control
Evaluative metering using 63 different zones; Partial metering; Center-weighted average metering; Spot metering; Exposure compensation; Auto exposure bracketing; Auto Lighting Optimizer (four settings); Picture Styles; Custom Controls; Peripheral illumination correction; Highlight Tone Priority; Long exposure noise reduction; Manual or Auto ISO (Auto ISO is fixed at ISO 400); High ISO noise reduction; ISO expansion; White balance: Auto plus six presets and Custom; Color temperature 2500–10,000°K; White balance shift and bracketing; ½- or ⅓-stop exposure increments; ⅓- or 1-stop ISO increments; Exposure Safety Shift in Tv/Av; Flash sync: Auto, 1/60–1/250 Auto, 1/250 fixed; flash exposure compensation.

Focus settings
One Shot; AI Servo; AI Focus; automatic AF-point selection; manual Single AF-point selection; manual Spot AF-point selection; manual AF-point expansion; manual Zone AF selection; AI Servo tracking sensitivity; AI Servo 1st/2nd image priority; AI Servo AF tracking method; AF Microadjustment.

Frame advance
Single-frame; High-speed continuous; Low-speed continuous; self-timer (10 sec. or 2 sec.).

» (C1, C2, C3) CAMERA USER MODES

The **C1**, **C2**, and **C3** settings on the Mode dial allow the user to define three complex combinations of settings to suit individual preferences or shooting situations. You can set these combinations using Set-up menu 3 *(see pages 124–5)*.

» FOCUS

Canon's autofocus lenses are all equipped with an AF/MF switch. It may be necessary to change to manual focus in very low light or when focusing on an object that has insufficient contrast for an AF point to latch onto. It can help you to obtain maximum depth of field when shooting landscapes, or when taking extreme close-ups—especially if you are using the x5 or x10 magnification facility in Live View.

The EOS 7D has a new AF system with 19 AF points, some or all of which may function as a group, or which can be selected singly (depending on shooting mode). Zone AF mode offers new ways to select AF points, all of which are "+" type, increasing sensitivity to both the horizontal and vertical characteristics of the subject.

Three different autofocus modes, including predictive autofocus, can be selected to suit static or moving subjects: One Shot, AI Focus, or AI Servo. Single AF points, Spot AF, AF-point expansion, and Zone AF are all selectable manually. The AF system's working range is from EV -0.5 to EV 18 at 68°F (20°C) at ISO 100. Autofocus lock is possible in One Shot mode and, when using flash, an AF-assist beam is triggered if enabled within the Custom Functions. AF Microadjustment enables minute focus corrections for up to 20 lenses. Autofocus is not possible on lenses slower than f/5.6, or effectively slower than f/5.6 when using

an extender. With lenses faster than f/2.8, the "+"-type center AF point will remain sensitive to both vertical and horizontal lines, as it is twice as sensitive as the remaining AF points (with the exceptions of the EF 28–80mm f/2.8–4 L USM and EF 50mm f/2.8 Macro). The other 18 AF points will remain sensitive to both characteristics on lenses with a maximum aperture of between f/5.6 and f/2.8.

LONESOME PINE ❯❯
The out-of-focus areas in an image can be just as important as the pin-sharp details.

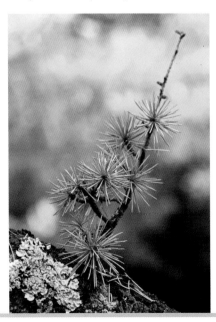

2 » AF MODES

› One Shot mode

In One Shot mode, the camera will focus just once on the subject when you partially depress the shutter-release button. It will not refocus until you withdraw pressure and partially depress the shutter-release button again. When focus is achieved, both the green ● focus confirmation light and the AF point(s) that achieved focus will be visible in the viewfinder. There will also be a double **beep** unless this has been switched off in Shooting menu 1. If you continue to hold down the shutter-release button, focus will be locked and you can recompose your picture.

› AI Focus mode

AI Focus is suited to a variety of still and moving subjects. In this mode, the camera will switch between One Shot and AI Servo modes according to the movement of the subject. If focus is achieved using One Shot mode, but the subject starts to move, the camera will automatically shift to AI Servo mode and track the subject, provided you keep the shutter-release button partially depressed. (See also C.Fn IV-1 on pages 132–4.)

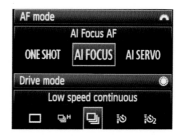

› AI Servo mode

AI Servo mode is suited to subjects that show sustained movement, and is particularly useful when the camera-to-subject distance keeps changing. The camera will continue to readjust focus automatically for as long as you partially depress the shutter-release button. The exposure settings, normally selected when you partially depress the shutter-release button, will only be fixed at the moment the picture is taken.

There are several Custom Function options relating to AI Servo mode. These are explained on pages 61–2.

› Selecting the focus mode

There are three ways of changing the focus mode. Which one you use depends on the display mode that is in operation on the LCD monitor. Only Method 2 uses the Quick Control screen.

Method 1: Using the LCD top panel

This will apply when neither the Shooting Settings screen nor the Quick Control screen is displayed on the LCD monitor.

1) Press the **AF•DRIVE** button, plus the top LCD illumination button ☼ if necessary. The display will stay on for six seconds ☉⁶ and the viewfinder display will be temporarily turned off.

2) Rotate the ⚙ Main dial to set the desired focus mode.

3) The chosen setting is shown on the LCD top panel.

Method 2: Using the Q button

This method will apply when the LCD display is active—regardless of whether it is displaying the Shooting Settings screen, Camera Settings display, or Electronic Level—or when the LCD display is blank.

1) Press **Q** to display the Quick Control screen on the LCD monitor. The most recently used function will be highlighted in green.

2) Use the ✲ Multi-controller to select the focus mode icon (One Shot, AI Focus, or AI Servo). Do not confuse this with the AF point icon. (To view the complete range of options for this function, press **SET**.)

3) Rotate the ⚙ Main dial or ◯ Quick Control dial in either direction to change the focus mode.

4) Press the **Q** button or partially depress the shutter-release button to exit.

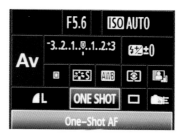

2

Method 3: Using the Shooting Settings screen

This method will apply when the Shooting Settings screen is displayed and the **Q** button has not been used to change the Shooting Settings screen to the Quick Control screen.

1) With the Shooting Settings screen displayed, press the **AF•DRIVE** button. A Focus mode/Drive mode settings screen will be displayed on the monitor, with the currently selected settings highlighted in green.

2) Rotate the 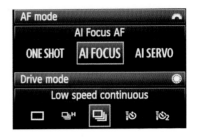 Main dial to change the focus mode.

3) Press the **INFO** button to exit.

Tip

When the servo is active in AI Focus mode, the focus confirmation beep is much quieter than in One Shot AF and the ● focus confirmation light does not illuminate. Neither will operate when AI Servo is selected.

Notes:

When the focus mode is changed in **Av**, **Tv**, **P**, **M**, or **B** shooting modes, it will be applied to the other shooting modes in this group too. (Camera User modes **C1**, **C2**, and **C3** will retain their registered settings and are not affected; Creative Auto and Full Auto are restricted to AI Focus anyway.) The currently selected focus mode in **Av**, **Tv**, **P**, **M**, or **B** shooting modes will also be retained after switching the camera off and back on again.

In any of the Camera User modes **C1**, **C2**, and **C3**, changes in focus mode will be retained by that Camera User mode as long as you stay within that shooting mode. However, to retain the change long-term, or if switching shooting mode, you must re-register the complete range of settings for that Camera User mode *(see pages 124–5).*

» AF POINT/ZONE SELECTION

The AF-point and AF-zone functions are explained in full on pages 63–5. Here, we will just outline the selection procedure. Note that in Full Auto and Creative Auto modes, 19-point AF is set automatically and cannot be overridden.

› Automatic selection

1) To select one of three automatic options available by default, press the ⊡/⊕ AF-point selection button when the camera is ready to shoot.

2) Press the **M-Fn** button repeatedly to toggle through the three options: single-point AF, Zone AF, and 19-point AF.

3) Partially depress the shutter-release button to return to shooting readiness.

› Manual selection

Manual selection of AF point in Single-point array
1) Press the ⊡/⊕ AF-point selection button.

2) Rotate the ⌒ Main dial to move the selected AF point laterally and/or rotate the ◯ Quick Control dial to move the

AF point vertically. (Note: use C.Fn III-7 to stop scrolling at the edge of the array, or to continue at the opposite side in "wraparound" fashion.) Alternatively, use the ☼ Multi-controller to move the AF point; this also permits diagonal movement of the AF point. Press the ☼ Multi-controller in to center the AF point.

3) Partially depress the shutter-release button to return to shooting readiness.

Manual selection of AF points in Zone array
1) Press the ⊡/⊕ AF-point selection button.

2) Rotate either the ⌒ Main dial or the ◯ Quick Control dial to move the selected AF points. (Note: "wraparound" scrolling of AF zones will not function with this method, even when enabled in C.Fn III-7.) Alternatively, use the ☼ Multi-controller to move the AF point; this also permits diagonal movement of the AF point. Press the ☼ Multi-controller in to center the AF point.

3) Partially depress the shutter-release button to return to shooting readiness.

› Setting a Custom Function

The names of the Custom Function group (e.g., C.Fn-II: Image) and the specific function (e.g., High ISO speed noise reduction) are displayed at the top of the screen, with the function number shown top right.

At bottom left is a row of all the function numbers for the currently selected Custom Function group, with an orange bar above the currently selected Custom Function menu.

Beneath that is a row of numbers indicating the setting for each separate function—**0** is the default setting. When a default setting has been changed, **0** will be replaced by the appropriate number in blue.

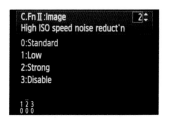

1) To change a Custom Function setting, press **MENU** and rotate the 🎛 Main dial to select 📷 Custom Functions.

2) Rotate the ◯ Quick Control dial to select the desired Custom Function group. Press **SET**.

3) Rotate the ◯ Quick Control dial to scroll through the individual functions in that group, which are named and numbered at the top of the screen.

4) To change a function setting, press **SET** to highlight (in orange) the currently enabled setting, shown in blue text.

5) Rotate the ◯ Quick Control dial to move the highlighting to another setting.

6) Press **SET**. The new setting will now be shown in blue and the highlighting will disappear.

7) Press **MENU** to exit.

Notes:
There are occasional exceptions to the setting procedure outlined in steps 4-5. These are explained in the text that accompanies the functions concerned.

Some Custom Functions are not available, or have limited availability, in Live View and Movie modes. See the table on page 137 for details.

› Custom Functions affecting AI Servo mode

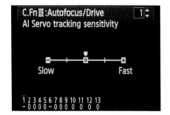

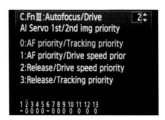

C.Fn III-1: AI Servo tracking sensitivity

The sensitivity of the AF system can be adjusted for AI Servo mode so that a slower setting will maintain focus tracking even when interruptions occur, or a faster setting will track subjects with greater ease. The latter is recommended by Canon for shooting situations in which you will repeatedly track a series of subjects entering the frame from the side.

This is one of the exceptions referred to opposite with regard to the setting procedure. When this screen is displayed, use the following procedure in place of steps 4–5: First, press **SET**. The function number in the top-right corner loses its ▲ and ▼ symbols. You can now adjust the setting using the ◯ Quick Control dial. The default setting is maintained as a blue marker at the center point of the scale. The adjusted setting is indicated by a white marker.

C.Fn III-2: AI Servo 1st/2nd image priority

This function affects the combined operation of AI Servo and Continuous shooting.

The default setting of **0** gives priority to focus acquisition for the first image recorded, after which focus tracking will take priority.

Setting **1** also gives priority to focus acquisition for the first image. After that, continuous shooting speed will be given priority instead of focus tracking.

Setting **2** gives priority to the shutter release, rather than focus acquisition, and subsequent frames will give priority to continuous shooting—as with Setting 1, but with a stronger bias.

Setting **3** gives priority to the shutter release, as with Setting 2, but subsequent frames will give priority to focus tracking.

2

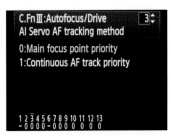

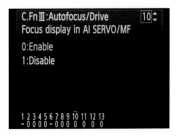

C.Fn III-3: AI Servo tracking method

Sometimes, when you are tracking a moving subject, someone or something will come between you and the subject you are tracking. This function determines how the AF system will react when this situation occurs.

The default setting of **0** provides **Main focus point priority**, so when another object is identified as being closer than the subject being tracked, the active AF point(s) will switch to the closer object.

Setting **1** provides **Continuous AF track priority**. This ensures that the subject being tracked will take priority, regardless of anything else that may enter the frame at a closer distance.

C.Fn III-10: Focus display in AI Servo/MF

Setting **0**: with Zone AF and Auto AF-point selection enabled in AI Servo mode, the AF point(s) acquiring focus will track the subject. With Manual focus selected, the AF point is the same as when AF is selected.

Setting **1**: the ● focus-confirmation indicator will not function. The AF point(s) being used to follow the subject will not be displayed.

> ### *Tip*
>
> *With Auto AF-point selection and AF-point expansion enabled, the camera will deem the main subject to be that upon which the first AF point acquired focus. With Zone AF enabled, the main focus point will be the active AF point.*

› Other Custom Functions affecting focus

C.Fn III-6: Select AF-area selection mode

Automatic 19-point AF will be used in Full Auto and Creative Auto modes and cannot be overridden. In the remaining modes, it is possible to select the following: any single AF point; Zone AF, which divides the AF point array into five groups of AF points; Spot AF, which combines a single AF point with Spot metering; AF point expansion; and automatic AF point selection using all 19 AF points (these are described in more detail on pages 64-5). Spot AF and AF point expansion need to be enabled in C.Fn III-6, while the other three methods are already enabled by default. You can also disable the default methods if desired.

To change the AF selection method and point/zone while shooting, see page 59.

1) Press **MENU** and rotate the Main dial to select the Custom Functions menu tab.

2) Rotate the Quick Control dial to highlight **C.Fn III: Autofocus/Drive**. Press **SET**.

3) Rotate the Quick Control dial to display **6: Select AF area selec. mode**. Press **SET**.

4) Rotate the Quick Control dial to highlight **Register**. Press **SET**.

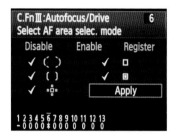

5) Rotate the Quick Control dial to scroll through the methods to be used. As each method is highlighted, its description appears on a blue background beneath the options.

6) Press **SET** to select or deselect the highlighted method. A tick will be added or removed accordingly.

7) Repeat step 6 for additional methods. You can add as many or as few as you like.

8) When you have completed your selection, rotate the Quick Control dial to highlight **Apply**. Press **SET**.

9) Highlight **Enable** to make selectable (using /and **M-Fn**) only those methods that have been ticked. Alternatively, highlight **Disable** to make functional only the three default methods (19-point, Zone, and Single-point). Note that you must set **Enable** to use AF-point expansion or Spot AF.

Auto AF-point selection: 19-point AF

In this mode, the whole array of 19 AF points is used automatically for focusing, so individual AF points are not displayed, as shown in the screengrabs. A varying number of these AF points, in any pattern, may achieve focus, and the camera will automatically interpret what it assumes to be the main subject covered by the AF-point array. Given a choice, the camera will favor a closer object as the main subject.

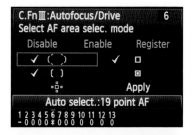

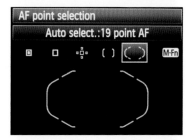

Manual AF-point selection: Zone AF

The AF-point array is used to create five zones. The center zone has nine AF points *(see top image, right)*; each of the others has four *(right, bottom)*.

The zone is selected manually, but when this is done, the selected AF point(s) within that zone are chosen automatically for focus acquisition. As with automatic 19-point selection, the camera will favor the closest subject(s) when assessing your intended main subject(s). There will be circumstances when AF-point expansion—which can look like a similar grouping of AF points—will be more effective in isolating your intended main subject.

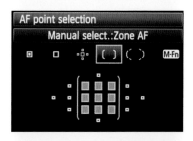

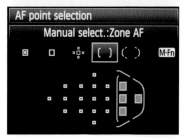

Manual AF-point selection: Single-point AF

This method demands that you isolate one small area of the scene upon which to focus, making it more suitable for static subjects. Any of the 19 AF points can be selected individually, as shown here.

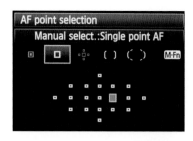

Manual AF-point selection: AF-point expansion

This adds the immediately adjacent AF points to the selected AF point *(right)* and is especially useful for tracking a moving subject. When focus is acquired with one of the adjacent AF points in One Shot AF mode, both the adjacent and the selected AF points will be displayed. Note: when AI Servo focus mode is in operation, the selected AF point must acquire focus first.

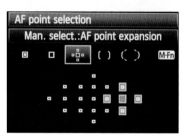

Manual AF-point selection: Spot AF

This function not only combines the AF point with the Spot-metering point for pinpoint exposure setting, it actually uses a smaller AF point than usual for even greater focusing accuracy. This method is better suited to static subjects. Spot AF is indicated by a square within a square, as shown here.

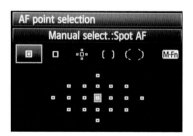

2

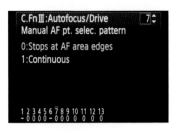

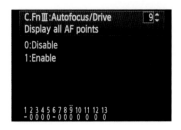

C.Fn III-7: Manual AF-point selection pattern

Setting **0** keeps the selected AF point within the confines of the AF-point array, as normal, stopping at its edges when you change to a peripheral AF point.

Setting **1: Continuous** is a very useful addition to the camera's functions. It offers a "wraparound" facility, so that with one click of rotation on the ⛭ Main dial or ◯ Quick Control dial, the selected AF point moves from far right to far left (or vice versa) or from top to bottom (or vice versa) respectively. In both cases, you must press the ⊞/⊕ button first.

This setting cannot be used in conjunction with 19-point AF auto selection or Zone AF modes.

C.Fn III-9: Display all AF points

This screen can be used to change the AF-point display during AF-point selection. Setting **0** will display all AF points during AF-point selection, but will only show the active AF point(s) while shooting.

Setting **1** displays all AF points during both AF-point selection and shooting.

> ### *Tips*
>
> *When using the Custom Functions menu, you can also employ the ❄ Multi-controller to change menus or menu items, pushing it left/ right or up/down depending on which menu screen you are using.*
>
> *At all times, be aware that other items may be displayed, including visual reminders to use ⛭ or ◯, or to press* **INFO** *or* **SET***. The* ▲ *and* ▼ *symbols are sometimes shown to indicate the need to scroll with the* ◯ *Quick Control dial to change a numerical setting.*

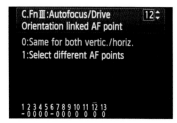

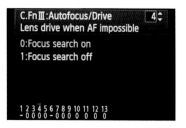

C.Fn III-12: Orientation-linked AF point

C.Fn III-12 allows you to set the camera up separately for landscape (horizontal) and portrait (vertical) use, with different settings for each of the following: AF-area selection mode, manually selected AF point, and Zone AF. Portrait orientation is subdivided again, so that you can choose between having the camera grip at the top or at the bottom—the camera will sense the difference. Adjust the settings as desired and register them as described on page 70.

C.Fn III-4: Lens drive when AF impossible

Despite the "+"-type AF points, which improve focus acquisition, there will still be times when AF will struggle to achieve focus, particularly in low-light conditions. In these cases it can be quicker to focus manually. (Many EF lenses offer full-time manual focus, which can be used even when the lens is switched to **AF**.) C.Fn III-4 allows the camera to disengage AF when the lens is unable to achieve focus using AF, so that it will not continue to "hunt." Selectable in **AF Quick** only in Live View mode and not at all in Movie mode.

C.Fn III-11: AF-assist beam firing

This determines when the built-in flash and/or an attached Speedlite will fire a brief burst of flash to illuminate the subject to aid focusing, prior to taking the picture. Option **3** restricts the use of the AF-assist beam to those EX Speedlites that have an infrared (IR) AF-assist beam. Note: these settings will be overridden if the EX Speedlite in use has the AF-assist beam disabled in its own Custom Functions.

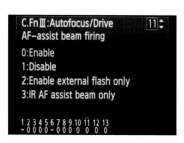

2

C.Fn III-8: Viewfinder display illumination

With C.Fn III-8, the AF point(s) and grid in the viewfinder can be illuminated in red. With setting **0**, viewfinder illumination will be triggered automatically in low light.

C.Fn III-5: AF Microadjustment

All lenses contain many components that are engineered to microscopic tolerances, but minute differences may still occur. This is an issue that is unlikely to trouble the majority of photographers, except for those involved with extreme close-ups, studio work, or fine art photography that demands the utmost precision.

It has always been possible to take a lens to a Canon Service Center to have it calibrated, but the EOS 7D has this facility built in. These adjustments effectively move the focal plane forward or backward to ensure absolute precision when focusing. Any adjustments made are applied only within the camera. The lens is not affected in any way, other than by responding to the AF commands issued by the camera.

Recognition of the need for this adjustment will arise from a repeated tendency for the sharpest plane of focus in your images to be beyond, or in front of, the subject plane that you believe should be sharpest. This tendency may be exhibited regardless of the lens in use

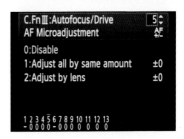

Warning!

AF Microadjustment is not normally required. Carry out this adjustment only if it is absolutely necessary. Note that, if carried out improperly, AF Microadjustment may prevent correct focusing from being achieved. If camera settings are cleared, the microadjustment setting will be retained, although the menu will be reset to the default **0: Disable** setting.

at the time, or it may suggest that one particular lens requires compensation. Settings can be applied individually to a maximum of 20 lenses. If a lens is combined with either the EF 1.4x or 2x extender, this will be treated as a separate camera/lens combination.

Adjustment is made in small increments: up to 20 in either direction, forward or backward. You can choose to adjust all the lenses you use by the same amount, or you can adjust one lens at a time—in which case the camera will store all the relevant information and recognize each lens when it is fitted.

Any adjustments made can later be reset to zero, or adjusted further by repeating the AF Microadjustment operation. If adjustments have been made for a particular lens, that lens must be fitted to the camera for later adjustments to be implemented.

1) To perform AF Microadjustment, carefully review your suspect images at 100% (actual pixel level), looking for a consistent tendency for the sharpest plane of focus to be either in front of or behind where it should be.

2) Set the camera on a tripod, aimed at a target subject at a distance typical of the way you normally use that lens. Camera-to-subject distance should be at least 50x focal length. Subject lighting should be even and bright enough for the AF system to acquire focus easily using the center AF point. Make sure the subject has some depth (i.e., discernible detail) both in front of and behind the point you focus on.

3) If you are using a zoom lens, start your tests with the lens set at its longest focal length. Evaluate the results before testing it at wider settings.

4) Test shots (Canon suggests Large/Fine JPEG) should be taken with the lens set at maximum aperture in Manual or Aperture-priority mode, with One Shot AF and a low ISO selected. Any Image Stabilizer on the lens should be switched off. It is also recommended that you enable Mirror lockup and use either the self-timer or a remote release.

5) Select C.Fn III-5. Highlight either **Adjust all by same amount** or **Adjust by lens** and press **SET**. Press **INFO** to display the adjustment screen.

6) Adjust as desired and press **SET**. You may need to take a series of test shots at different AF Microadjustment settings. For each shot, move the pointer forward on the AF Microadjustment scale if you perceive back-focusing, or backward if your sharpest plane of focus is closer to the camera than it should be. Canon suggests starting with +/-20 and progressively reducing the amount until you feel the setting can be finalized.

7) Don't use the camera's LCD monitor to judge AF Microadjustment test results: observe your test images at 100% on your computer monitor. When you arrive at an image that comes closest to placing the plane of focus where you feel it should be, try shooting a variety of subjects at that setting and assess the results. Make further adjustments if necessary.

› Other camera functions affecting focus

Registering and using an AF point

1) Set the AF-area selection mode to Single-point AF, Spot AF, or AF-point expansion. (The AF point cannot be registered in Zone AF and 19-point AF auto selection modes.)

2) Select an AF point manually *(see pages 64–5).*

3) Hold down the ⊞/⊕ button and press the ☼ button. A single beep will sound and the AF point will be registered. The registered AF point will be displayed as a tiny rectangle . Use C.Fn III-12 to choose whether to employ the same registered AF point in both landscape and portrait camera orientation, or to opt for different registered AF points

for horizontal and vertical use. When registering an AF point in vertical mode, you can set one for times when the camera grip is at the top and another for occasions when the camera grip is at the bottom. The camera will sense the orientation that is required.

4) When an AF point has been registered, it is possible to switch to this point with a single button-push using **AF•ON** or ✳/⊞•⊖ , depending on which functions have been assigned to these buttons in C.Fn IV-1: Custom Controls. The registered AF point will only be selected while pressure is maintained on the **AF•ON** or ✳/⊞•⊖ button. (Partially depressing the shutter-release button while holding down the **AF•ON** or ✳/⊞•⊖ button does not lock focus on the registered AF point that has been temporarily chosen in this way.) The camera can be in any AF mode except automatic 19-point AF, but when Zone AF is the current mode, focusing will switch to the zone containing the registered AF point rather than a single AF point. To cancel the registered AF point, press the ⊞/⊕ and **ISO•**⚡ buttons at the same time.

AF lock

Maintaining light pressure on the shutter-release button will lock focus (and exposure) so that you can recompose the image safe in the knowledge that your main subject will be in sharp focus. *(For moving subjects, see also AI Focus and AI Servo modes on page 56.)* However, this is not the only mechanism for locking focus. In shooting modes other than Creative Auto or Full Auto, pressing the **AF•ON** button has the same effect as partially depressing the shutter-release button *(see also C.Fn IV-1 on pages 132–4).*

Depth-of-field preview

The depth-of-field preview button is located on the front of the camera, just below the lens-release button. Pressing it will stop the lens down to the currently selected aperture, giving a more accurate impression of the range of acceptable focus. A smaller aperture (higher f-number) will provide greater depth of field, but the viewfinder will appear darker as you stop down. The exposure is locked while the depth-of-field preview button is depressed.

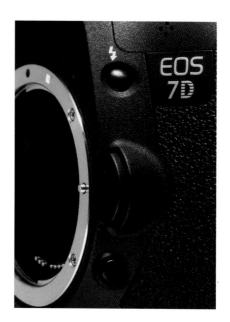

Exposure is a product of two factors: time and aperture. The aperture is the size of the opening through which light falls onto the digital camera's sensor. The time is the shutter speed, which is measured in fractions of a second: 1/60, 1/125, 1/250, 1/500, 1/1000, and so on. This is why Canon's shorthand for Shutter-priority mode is Tv (Time value).

The aperture (opening) itself is measured in f-stops. The larger the number, the smaller the opening. Each stop represents a halving or doubling of the adjacent stop. Thus f/11 allows half as much light in as f/8, but twice as much as f/16. The abbreviated sequence runs: f/2.8, f/4, f/5.6, f/8, f/11, f/16, f/22.

To obtain a more precise exposure, the EOS 7D can employ intermediate settings, of either shutter speed or aperture, using ½- or ⅓-stop increments.

The photograph on the opposite page was taken with a shutter speed of 1/500 sec. and an aperture of f/8. From the table below you can see that any of the corresponding combinations of shutter speed and aperture would have resulted in the same exposure.

› ISO settings

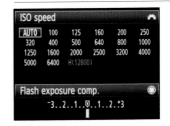

The ISO speed is a measure of the sensor's sensitivity to light, and effectively governs the combined exposure values of aperture and shutter speed. A higher ISO speed requires less exposure and is therefore more useful in low-light conditions. Doubling the ISO figure is equivalent to a 1-stop reduction in exposure, and vice versa. However, higher ISO speeds produce more "noise," creating a more grainy-looking image, often with flecks of color in

Shutter speed/Aperture							
Shutter speed (sec.)	1/60	1/125	1/250	1/500	1/1000	1/2000	1/4000
Aperture (f-stop)	22	16	11	8	5.6	4	2.8

the shadows. As a general rule, the slower the ISO speed, the crisper the final image.

The 7D's Auto ISO setting will select an ISO between 100 and 3200—except in Bulb mode, when the setting will be fixed at ISO 400. This figure will also apply when using flash and Auto ISO, but if overexposure is detected, the ISO may be reduced to as low as ISO 100. (When using bounce flash with an EX Speedlite in Program, Creative Auto, or Full Auto modes, the Auto ISO range is ISO 400–1600.)

Manual ISO settings can be used between ISO 100 and ISO 6400 in ⅓- or 1-stop increments, expandable to 12,800 (H). To set ISO 12,800 (H), it is necessary to enable ISO expansion in C. Fn I-3 *(see page 128).*

To set the ISO speed, use one of the following three methods:

Method 1: Using the LCD top panel

This method will apply when neither the Shooting Settings screen nor the Quick Control screen is displayed on the LCD monitor.

1) Press the **ISO•** 🔲 button, and the top LCD panel illumination button ☼ if necessary. The display will stay on for six seconds ⏱⁶ and the setting is shown in both the viewfinder and the LCD panel on the top of the camera.

2) Rotate the 🎛 Main dial to set the desired ISO speed.

BLOIS, FRANCE　　　　　**«**
The term ISO has been retained on digital cameras, but originates from the different sensitivities of film. For instance, a 200 ISO film is only half as sensitive as a 400 ISO film and therefore needs twice the exposure. This photograph was taken at 1/500 at f/8, with a setting of 100 ISO. Had that setting been 200 ISO, the necessary exposure would have been 1/1000 at f/8 or 1/500 at f/11 (i.e., twice the shutter speed, or an aperture one stop smaller).

2

Method 2: Using the Q button

This method will apply when the LCD monitor is active (regardless of whether it is displaying the Shooting Settings screen, Camera Settings display, or the Electronic Level) or when the LCD display is blank.

1) Press **Q** to display the Quick Control screen on the LCD monitor. When it is displayed, the most recently highlighted function will be shown in green.

2) Use the �֎ Multi-controller to highlight the ISO speed icon.

3) Rotate either the ⚙ Main dial or the ◯ Quick Control dial in either direction to change the ISO speed. (To view the complete range of options for this function on screen, press **SET**.)

4) Press the **Q** button or partially depress the shutter-release button to exit.

Method 3: Using the Shooting Settings screen

This method will apply when the Shooting Settings screen is displayed and the **Q** button has not been used to change the Shooting Settings screen into the Quick Control screen.

1) With the Shooting Settings screen displayed, press the **ISO•⚡** button.

2) An ISO/Flash exposure compensation settings screen is displayed, with the current settings highlighted in green.

3) Rotate the ⚙ Main dial to change the ISO setting.

4) Press the **INFO** button to exit.

Tips

Increasing the ISO speed will also increase the effective range of flash.

If Highlight Tone Priority is enabled in C.Fn II-3, the ISO range will be ISO 200–6400 (regardless of the ISO expansion setting in C.Fn I-3).
D+ *will be shown next to the ISO setting as a reminder.*

In C.Fn II-2, it is possible to adjust the ***High ISO speed noise reduction*** *setting. There are four settings: Standard, Low, Strong, and Disabled. The default setting, surprisingly, is not* ***Disabled****, but* ***Standard****. I say surprisingly because noise reduction, when not disabled completely, is applied at all ISO speeds and slows the camera down marginally. If* ***Strong*** *is selected, the maximum available burst will also be reduced noticeably.*

› Exposure and metering

A light meter is simply a gadget that measures the quantity of light falling on it (known as an incident reading) or how much light is reflected by the subject (a reflected reading). Through-the-lens (TTL) metering makes use of reflected light readings, which means that they are more likely to be fooled by highly reflective surfaces in your shot.

How helpful a meter reading is depends on how you, or your camera, interpret the result. Any light meter—from Canon's multi-zone evaluative system to that of a simple 1° spot meter—averages its readings, and provides a recommended shutter speed and aperture (for a given ISO) that would give the correct exposure for an 18% gray card. Traditionally, the process works as follows (though the 7D's new iFCL metering also reads color data):

1) The extent of the area to be metered is determined by the metering mode you have selected.

2) The camera's light meter "sees" this scene in black and white, and takes the meter reading.

3) The meter suggests an exposure that would give an overall tone of 18% gray.

4) The camera or the photographer adjusts the suggested reading to account for highlight and shadow preferences.

NORTH AMERICAN WOOD DUCK ⌄
The camera's light meter should give you perfect whites and accurate colors across the spectrum.

The Canon EOS 7D provides four different metering modes to cover any eventuality:

Evaluative metering

This function benefits most from the 7D's completely new 63-zone system, which incorporates focus, distance, and luminance information in its scene analysis. It is capable of coping with a wide range of lighting situations, including backlighting.

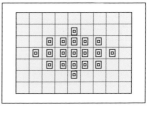

Center-weighted average metering

This metering system gives added bias to readings taken from the center of the frame, then averages readings from the whole area.

Partial metering

This mode takes readings from just 9.4% of the frame at the center, and is especially useful when the background is significantly brighter than the subject. It can also be used, in effect, as a spot meter with a larger than normal "spot."

Spot metering

This meters from a small area at the center of the frame, which equals just 2.3% of the viewfinder area. It can be used to take readings from small, but important areas of the subject to determine the average tone.

› Changing the metering mode

There are three methods of changing the currently selected metering mode, depending on which display mode is currently operating on the LCD monitor. Only one of these methods uses the Quick Control screen.

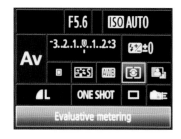

Method 1: Using the LCD top panel

This method will apply when neither the Shooting Settings screen nor the Quick Control screen is displayed on the LCD monitor.

1) Press the ⊡•WB button, plus the top LCD panel illumination button ☼ if necessary. The setting display will only stay on for six seconds ⟲⁶. The viewfinder display will be turned off temporarily.

2) Rotate the ⌇ Main dial to set the desired metering mode.

3) The setting is shown on the LCD top panel using the symbols ⊡, ⊙, ⟦·⟧, or ⟦ ⟧.

Method 2: Using the Q button

This method will apply when the LCD monitor is active (regardless of whether it is displaying the Shooting Settings screen, Camera Settings display, or the Electronic Level) or when the LCD display is blank.

1) Press **Q** to display the Quick Control screen on the LCD monitor. When it is displayed, the most recently used function will be highlighted in green.

2) Use the ✣ Multi-controller to move the highlighting to the metering icon.

3) Rotate either the ⌇ Main dial or ◯ Quick Control dial in either direction to change the metering mode. (To view the complete range of options for this function on screen, press **SET**.)

4) Press the **Q** button or partially depress the shutter-release button to exit.

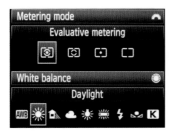

Method 3: Using the Shooting Settings screen

This method will apply when the Shooting Settings screen is displayed and the **Q** button has not been used to change the Shooting Settings screen into the Quick Control screen.

1) With the Shooting Settings screen displayed, press the ⬛•**WB** button.

2) A Metering mode/White balance settings screen will be displayed, with the current settings highlighted.

3) Rotate the Main dial to change the metering mode.

4) Press the **INFO** button to exit.

Notes:
In any one of the Camera User modes **C1**, **C2**, and **C3**, a change in metering mode will be retained by that Camera User mode as long as you stay within that shooting mode. However, to retain the change long-term, or if switching shooting mode, you must reregister the complete range of settings for that Camera User mode *(see pages 124–5).*

When the metering mode is changed while in **Av**, **Tv**, **P**, **M**, or **B** shooting modes, it will be applied to the other shooting modes in this group too. (Camera User modes **C1**, **C2**, and **C3** will retain their registered settings and will not be affected; Creative Auto and Full Auto are restricted to Evaluative metering anyway.) The current metering mode in **Av**, **Tv**, **P**, **M**, or **B** shooting modes will also be retained after switching the camera off and back on again.

› AE lock

The AE lock (Auto Exposure lock) function is used when there is a difference between the area of the image to be metered and the area used to achieve focus (as is often the case with Spot metering), or when multiple frames will be taken using the same exposure.

Tips

The AE lock function can also be assigned to other camera/lens controls (see C.Fn IV-1 Custom Controls on pages 132–4).

Notes:
In Partial metering, Spot metering, and Center-weighted average metering modes, AE lock is applied at the center AF point. This is also the case when the lens itself is switched to MF.

When the AF-point selection method is automatic, AE lock uses the AF point that acquires focus. However, when AF-point selection is made manually, AE lock will use the manually selected AF point.

1) Focus on the subject by partially depressing the shutter-release button.

2) Press the ✳/⊞• ⊖ button (☇⁴). The ✳ icon is displayed in the viewfinder, indicating exposure lock. The setting will be overridden by pressing the ✳/⊞• ⊖ button again.

3) Recompose the picture and fully depress the shutter-release button.

4) To take multiple shots at the locked exposure, continue to depress the ✳/⊞• ⊖ button while repeating step 3 as many times as required.

Common errors

One of the most frequent causes of badly exposed images is the tendency to shoot first and ask questions later. Often, you have a lot more time to get the shot than you think—certainly enough to consider which of the camera's metering modes is most likely to give the best result.

› Exposure compensation/bracketing

In most instances, the exposure suggested by the camera will be quite adequate provided there are no bright highlights and deep shadows that contain detail that you want to retain. In these cases, you can use exposure compensation to shift the overall exposure and pull in additional detail. In-camera this will have the effect of making all the tones darker or lighter, depending on the option you choose. In post-processing, however, it is possible to adjust highlights or shadows in isolation using the Digital Photo Professional software packaged with the camera.

Auto exposure bracketing (AEB) allows a sequence of three shots to be taken, with up to three stops difference in exposure between each pair. This function can be combined with exposure compensation.

Regardless of which metering mode has been selected, exposure compensation of up to +/-5 stops in ½- or ⅓-stop increments can be set in **Av** Aperture-priority, **Tv** Shutter-priority, and **P** Program modes. **CA** Creative Auto also offers the ability to adjust exposure compensation, but in a completely different way and to a lesser extent *(see page 44)*.

STREET LIGHTS ⌃
Evaluative metering is normally very effective in a wide range of situations, but in this case it was fooled by the large expanse of sky dominating the frame. An additional ⅔-stop exposure was required to retain detail in the subject.

> ### *Tip*
>
> *If you have essential detail in both the bright highlights and the deep shadows, it may be beyond the capacity of the sensor to capture the entire range of tones. In such cases, consider bracketing a series of exposures and combining them on the computer later using HDR (High Dynamic Range) software.*

› Setting exposure compensation/bracketing

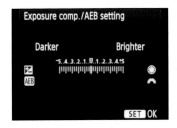

To set exposure compensation and Auto exposure bracketing, turn the Mode dial to any setting except **M** Manual, ⭕ Full Auto, or **CA** Creative Auto. (If you are only setting AEB, **M** Manual can also be used.) Turn the ⭕ Quick Control dial switch to ⌐. There are three ways to adjust these functions:

Method 1: Using the viewfinder/top panel

1) This method applies to exposure compensation only. Frame your shot and partially depress the shutter-release button to obtain an exposure reading. Consider the balance between highlight and shadow areas, and assess the level of compensation needed.

2) Check the ▮▮▮ exposure-level indicator at the bottom of the viewfinder or in the LCD top panel to make sure that the indicator is at the center of the exposure scale.

3) To set the level of compensation, turn the ⭕ Quick Control dial. Rotating it in one direction will increase the exposure and the opposite direction will decrease it, one increment at a time. The indicator on the exposure scale ▮▮▮ will show the extent of the compensation.

4) Take the photograph and review the result. You may wish to increase or decrease the level of compensation and take further exposures.

5) To cancel exposure compensation, repeat step 3 and return the indicator to the center point of the exposure scale ▮▮▮.

Warning!

Although exposure compensation can be set to +/-5 stops, neither the LCD top panel nor the viewfinder can display compensation beyond +/-3 stops, in which case the indicator at +3 changes to ▶, and the indicator at -3 changes to ◀. The LCD monitor, however, can display the full range of compensation and is therefore more useful for setting compensation beyond +/-3 stops *(see the next page)*.

Method 2: Using the Q button

1) Frame your shot and partially depress the shutter-release button to obtain an exposure reading. Consider the balance between highlight and shadow areas, and assess the level of compensation needed.

2) Press the **Q** button. The Quick Control screen will be displayed on the LCD monitor, with the most recently viewed function highlighted in green.

3) Use the ✳ Multi-controller to highlight the exposure scale 3..2..1..•..1..2..3.

4) Rotate the ⬡ Quick Control dial to adjust exposure compensation, or the ⚙ Main dial to adjust Auto exposure bracketing, or both.

5) Press the **Q** button or partially depress the shutter-release button to exit.

Method 3: Using the menu system

1) Press **MENU** and rotate the ⚙ Main dial to select 📷 Shooting menu 2.

2) Rotate the ⬡ Quick Control dial to highlight **Exp.Comp./AEB**. Press **SET**.

3) Rotate the ⬡ Quick Control dial to adjust exposure compensation or the ⚙ Main dial to change the Auto exposure bracketing, or both.

4) Press **SET**. Press **MENU** or partially depress the shutter-release button to exit.

Tips

The order in which the underexposed, normal, and overexposed pictures are taken when bracketing can be set to **0,-,+** *(default) or* **-,0,+**. *This choice is made using Custom Function I-5.*

When combining both exposure compensation and AEB, the central bracketed exposure can be set at up to +/-5 stops with a bracketing increment of up to 3 stops. The LCD monitor will display the full exposure scale up to the resulting +/-8 stops required (see display on opposite page).

In **Av**, **Tv**, *and* **P** *modes, exposure compensation settings will be retained even if you change the shooting mode. The same applies to AEB, but includes* **M** *shooting mode too.*

Exposure compensation settings will be retained when the camera is switched off and on again. The same applies to AEB settings unless C.Fn I-4 is enabled (the default setting). If both exposure compensation and AEB are set, and C.Fn I-4 is switched on, only the exposure compensation setting will be retained when the camera is switched off and back on again.

› Highlight Tone Priority

Exposure compensation adjusts all tones by the same amount, but Highlight Tone Priority expands the dynamic range of the highlights only. This ensures the retention of highlight detail without sacrificing all shadow detail. This can be very useful in high-contrast situations, such as a typical wedding shot with the bride in white and the groom in a dark suit. This mode is only available in the ISO 200–6400 range.

1) To select Highlight Tone Priority, press the **MENU** button and select the 📷 Custom Functions menu.

2) Highlight **C.Fn. II Image** and press **SET**.

3) Rotate the ◯ Quick Control dial to show **3: Highlight tone priority**.

4) Press **SET** to highlight the existing setting.

5) Rotate the ◯ Quick Control dial to change to the alternative setting.

6) Press **SET** again to save the setting, then press **MENU** to exit.

Half-stop settings

If the exposure-level increment is set to ½-stop in C.Fn I-1, the exposure compensation/bracketing scale in both the viewfinder and the LCD top panel will be displayed with ⅓-stop intervals along the scale itself, but with ½-stop settings shown by two indicators. Any scale displayed on the LCD monitor will be corrected to show either ½- or ⅓-stop increments.

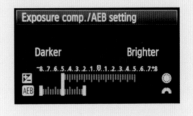

STEAM TRAIN »
Highlight Tone Priority is useful for extending the dynamic range of the highlight areas in high-contrast shots like this.

2 » MENUS

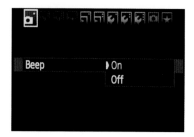

The EOS 7D's menu screens are displayed on the LCD monitor on the back of the camera. The 11 tabs consist of four Shooting menus, two Playback menus, three Set-up menus, a Custom Functions menu, and a customizable My Menu to give you quick access to the options you use most frequently. Each of the menus is represented by a symbol, and each menu category is color-coded to make identification easier.

The currently selected item on any menu is highlighted in the same color as the menu category. For example, the Shooting menu 1 symbol is red, so Shooting menu 1 items such as **Beep**, shown above, are also highlighted in red.

When an item is selected, a secondary menu is often displayed, sometimes followed by a third menu screen or a **Cancel/OK** dialog box.

› Selecting menu options

1) Press the **MENU** button and use the ⌒⌒⌒ Main dial to scroll through the color-coded menu tabs.

2) To change the highlighting to a different item on the selected menu, rotate the ○ Quick Control dial.

3) To select an item once it is highlighted, press the **SET** button.

4) If secondary menus or confirmation dialog boxes are displayed, use the ○ Quick Control dial and **SET** button as described in steps 2–3.

5) When a setting has been changed, press **SET** to save the new setting.

6) To exit at any stage, press the **MENU** button to go back one level and repeat if necessary.

You can also use the ✳ Multi-controller to change between menus or menu items, pushing it left/right or up/down depending on the menu screen you are using.

» MY MENU ★

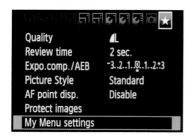

Quality 4L
Review time 2 sec.
Expo.comp./AEB ⁻3..2..1..0..1..2:3
Picture Style Standard
AF point disp. Disable
Protect images
My Menu settings

For faster access to the menu items you use on a frequent basis, you can register a combination of up to six menus and Custom Functions to My Menu, adjusting the order as required.

1) Press the **MENU** button and select ★ My Menu. Choose **My Menu settings** and press **SET**.

2) Rotate the ◌ Quick Control dial to select **Register** and press **SET**.

3) Rotate the ◌ Quick Control dial to select the item to include. Press **SET**, then **OK** when the dialog box is displayed.

4) Repeat the process for up to six items and press the **MENU** button to exit.

5) To sort the order in which items are displayed, select **My Menu settings**, then **Sort**. Highlight the item you wish to move. Press **SET**. Rotate the ◌ Quick Control dial to move the item up or down the list. Press **SET** to finalize the setting.

6) To delete an item from the display, select **My Menu settings**, then **Delete**. Select the item you wish to delete and press **SET**. Select **OK** and press **SET** again.

7) If you want My Menu to be displayed first every time the **MENU** button is pressed, enable the **Display from My Menu** option. If this option is disabled, the last menu viewed will be displayed first.

2 » SHOOTING MENU 1 📷

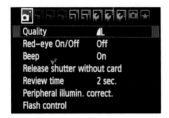

The EOS 7D has four Shooting menus, which use red highlighting to differentiate them from the other menus. Between them, the Shooting menus control all the basic shooting-related functions, some of which you may set only once, while others you may wish to change regularly. Consider adding the latter items to My Menu (see page 85).

› Quality

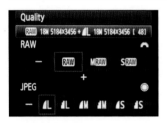

There are 27 different settings for image recording quality (not including the Movie options), using various combinations of JPEG and RAW files. The **M**RAW and **S**RAW settings offer all the advantages of RAW quality and workflow but with files that are much smaller than full RAW files.

Smaller files take up significantly less space on your memory card. They also write faster so you won't need to wait while the buffer empties. The burst size (the maximum number of shots you can take before the buffer is full) is also increased.

As the camera performs a number of processing tasks on JPEGs compared with RAW files, much less post-processing is required. The disadvantage of shooting JPEGs is that you have far less control over the recorded image than is the case with a RAW file. JPEG is also a "lossy" format, so there is some deterioration in quality. The smaller the file, the greater the compression and the greater the loss of picture quality.

Using RAW files suits those who require the highest-quality images and are prepared to use suitable computer software to bring those images to fruition. The main advantage of shooting RAW files is that the original image data is always retained, and any TIFF or JPEG conversions made from them are saved as separate files. Any changes made to the RAW files to achieve these conversions can be undone quickly and easily.

File-quality settings

Quality		Pixels	File size	Shots per 4GB card (approx.)	Max. burst (4GB CF)	Max. burst (4GB UDMA)
JPEG	▲L	17.9Mp	6.6MB	593	94	126
	▟L		3.3MB	1169	469	1169
	▲M	8.0Mp	3.5MB	1122	454	1122
	▟M		1.8MB	2178	2178	2178
	▲S	4.5Mp	2.3MB	1739	1739	1739
	▲S		1.1MB	3297	3297	3297
RAW	RAW	17.9Mp	25.1MB	155	15	15
	MRAW	10.1Mp	17.1MB	229	24	24
	SRAW	4.5Mp	11.4MB	345	38	38
RAW+ JPEG*	RAW +	17.9Mp	25.1MB	122	6	6
	▲L	17.9Mp	+6.6MB			
	MRAW +	10.1Mp	17.1MB	164	6	6
	▲L	17.9Mp	+6.6MB			
	SRAW +	4.5Mp	11.4MB	217	6	6
	▲L	17.9Mp	+6.6MB			

Figures will vary depending on camera settings and brand of memory card.
*Both file types will be saved in the same folder with the same file name, but with different extensions
(.JPG and .CR2 for the RAW file).

One-touch RAW+JPEG button ^RAW/JPEG

When RAW-only or JPEG-only is selected, pressing the ^RAW/JPEG button is a quick way of changing the settings so that both types of file are recorded.

When ^RAW/JPEG is pressed, if one of the JPEG options is already selected, a RAW file will also be recorded. This can be RAW, MRAW, or SRAW (selectable in 🞄⁑ Shooting menu 3). If one of the RAW options is currently selected, a JPEG file will also be recorded.

This can be any of the six JPEG options (selectable in 🞄⁑ Shooting menu 3).

This simultaneous recording setting is temporary and applies only to the next shot taken, or the next sequence if a continuous drive mode is set. After the shutter has fired, simultaneous recording activated by the ^RAW/JPEG button is canceled. (Neither partially depressing the shutter release, nor releasing that partial pressure, has any effect on this temporary setting.)

There is no indicator in the viewfinder that shows when the RAW/JPEG button has been pressed, but the RAW and JPEG symbols will blink in the LCD top panel. These symbols will also blink in the Shooting Settings screen, but the Quick Control screen will only display the file setting that was selected before RAW/JPEG was pressed.

The setting can be canceled by pressing any one of the **Q**, **MENU**, ✱✱, or ▶ buttons; by activating Live View/Movie mode; or by switching off the camera.

Notes:
If simultaneous recording is already selected, pressing the RAW/JPEG button has no effect.

Simultaneous recording that has been selected in the normal way via the menu system or Quick Control Screen is not canceled after the shutter has been fired.

› Beep

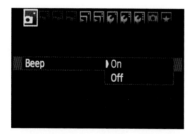

The beep is very useful to confirm focus, especially if you wear spectacles and have difficulty getting your eye right up to the viewfinder. However, the beep can also be an unwelcome distraction in situations such as a church or museum, so you can choose to turn it off.

› Release shutter without card

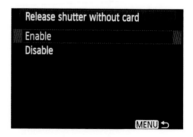

With this function, you can choose to allow the camera to function without a memory card installed. This facility might be used when capturing a large number of images direct to your computer, or disabled so that you will be prompted if you forget to insert a memory card.

› Review time

After shooting, the camera will display the image on the monitor for 2, 4, or 8 sec., or for as long as you like if you select **Hold**. Alternatively, if you want to conserve battery power and review images later, you can turn this function off.

› Peripheral illumination correction

In some circumstances, there may be a slight loss of brightness in the corners of the image. This function corrects this issue in-camera when shooting JPEG files, provided the function is selected prior to shooting. With RAW files, you need to make the correction within Digital Photo Professional (which Canon advises is capable of making a higher level of correction than is the case in-camera).

The EOS 7D comes programmed with correction data for over two dozen lenses (you can check the list in EOS Utility). This also includes certain combinations of lenses and extenders. The correction data for lenses not already registered in the camera can be added manually.

> *Note:*
> For details of the **Red-eye On/Off** and **Flash control** items in Shooting menu 1, see Chapter 5, Flash.

Shooting menu 2 includes settings that control exposure, color, contrast, and sharpness, among others. As with Shooting menu 1, selected menu items are highlighted in red.

› Exposure comp./ AEB setting

This is the time to dial in some exposure compensation *(see pages 80–2)*. The EOS 7D allows a maximum of +/-5 stops. Auto exposure bracketing (AEB) is useful when you're not sure how the balance between highlights and shadows will work out. Three exposures are recorded, with one either side of the nominal setting at up to three stops difference. Additional indicator marks on either side of the central indicator show the level of over- and underexposure. Auto exposure bracketing can also be combined with exposure compensation *(see pages 81–2)*.

The camera's metering modes *(see page 76)* should cover most situations, but occasions may arise when you wish to adjust exposure settings to compensate for unusual circumstances such as backlighting or a highly reflective subject.

› Auto Lighting Optimizer

This function will automatically correct the balance of contrast and brightness if the selected exposure would otherwise produce an unbalanced image. Three levels of correction are provided, or it can be disabled. The default setting is **Standard**.

In ⬭ Full Auto and **CA** Creative Auto modes, Auto Lighting Optimizer (ALO) will be applied automatically at the Standard setting, but shooting RAW gives you the option of changing this in post-processing. In **P**, **Tv**, and **Av** modes, the Standard setting is enabled by default, but can be adjusted in-camera, as well as in post-processing using Digital Photo Professional. During exposures made in **M** or **B** modes, this feature is disabled.

> ### Tips
>
> *ALO settings applied to JPEG images in-camera cannot be adjusted in post-processing. ALO cannot be applied retrospectively in Digital Photo Professional if ALO was disabled when the JPEG image was recorded. However, ALO can be adjusted, or applied retrospectively, to RAW images.*
>
> *Some change in image noise may be noticed when ALO is applied. ALO and Noise Reduction adjustments in DPP are both applied via the same Tool Palette tab to RAW images. Therefore it is possible to apply a level of Luminance or Chrominance Noise Reduction, or both, then switch ALO off/on or adjust it while viewing the effect using a magnified image.*

› White balance

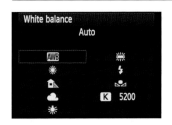

For other colors to be rendered accurately, white must be represented correctly. In most cases, this means obtaining a pure white, without the color cast that comes with artificial light sources and from natural lighting at different times of the day. These variations are measured by color temperature, expressed in degrees Kelvin. The user can specify an exact color temperature in the range 2500–10,000°K, if this is known, or use the white balance presets programmed into the camera.

White balance presets

AWB	Auto white balance	range 3000–7000°K
☀	Daylight	5200°K
⌂	Shade	7000°K
☁	Cloudy	6000°K
⚡	Tungsten lighting	3200°K
⚟	White fluorescent light	4000°K
⚡	Flash	6000° K

2

› Custom white balance

A Custom white balance setting 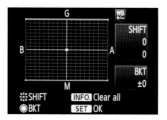 in the range 2000–10,000° K can be created to suit a particular shooting situation.

1) Photograph a plain white object, ensuring that it fills most of the frame, using manual focus and exposure settings as suggested by the camera. Any white balance setting can be used at this stage.

2) In 📷ⁱ Shooting menu 2, highlight **Custom WB** and press **SET**.

3) Select the image you recorded in step 1 and press **SET**.

4) You will be presented with a dialog box that reads **Use WB data from this image for Custom WB**. Select **OK** and the data will be imported.

5) You will be prompted to set the white balance function to . Press **SET** and you will return to Shooting menu 2.

6) Rotate the ⬤ Quick Control dial to highlight **White balance**. Press **SET**.

7) In the **White balance** submenu, rotate the ⬤ Quick Control dial to highlight . Press **SET**.

8) Press **MENU** to exit.

Notes:
If you have registered a Personal white balance setting using the software provided with the camera, it will be replaced by any new Custom white balance setting obtained using .

If the image captured in step 1 is taken with the Picture Style set to Monochrome, it cannot be selected in step 3.

› White balance shift/bracketing

These functions have been incorporated into the same menu screen, providing a simple graphic representation of a complex process. Adjusting the settings is not unlike using color-correction filters, except that nine levels of correction are possible. They can be applied to any white balance setting, including Custom, °K, and white balance presets. Each increment is equivalent to a 5-mired shift.

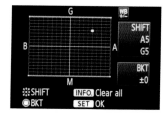

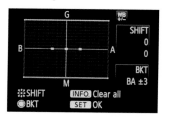

Setting White balance shift

1) Press **MENU**. In 🖿 Shooting menu 2, highlight **WB SHIFT/BKT** and press **SET**.

2) Use the ✳ Multi-controller to move the white cursor ■ from its central position to the new setting. The bias can be toward blue/amber and/or magenta/green (indicated by **B**, **A**, **M**, **G**), and the blue panel at the top right displays the new coordinates using the initial letter of the color plus a number from 0 to 9 (in this example **A5**, **G5**).

3) Press **INFO** at any time to reset the bias to **0,0**.

4) Press **SET** to finalize your setting. During White balance shift, ⁺⁄₋ᵂᴮ will be displayed in the viewfinder, the LCD top panel, Shooting menu 2, and the Shooting Settings screen (but not the Quick Control screen). The setting is shown as text in the Camera Settings screen.

Setting White balance bracketing

White balance bracketing can be used in conjunction with White balance shift to capture three versions of the same image, each with a different color tone. The primary image will use the cursor location as set for White balance shift. Either side of this, two further images will be captured with a difference of up to three levels in single-level increments, each increment being 5 mireds. You can bracket the exposures with either a blue/amber bias or a magenta/green bias.

The bracketing sequence when shooting will be as follows: standard white balance, blue bias, amber bias or standard white balance, magenta bias, green bias.

1) Press **MENU**. In 🖿 Shooting menu 2, highlight **WB SHIFT/BKT** and press **SET**.

2) Rotate the ◌ Quick Control dial clockwise to set blue/amber bracketing, or anticlockwise to set magenta/green bracketing (reverse the direction to return the setting to zero, or press **INFO** to clear all shift/bracketing settings). The blue panel bottom right displays the new

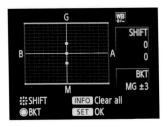

BKT settings using the initial letters of the color bias plus the degree of bracketing (**MG +/-3** in the example above).

3) If it is appropriate to the situation, use the ✷ Multi-controller to move the white cursor (■ if step 2 is not yet completed, or ■ ■ after step 2) from its central position to a new base setting, to be bracketed either side.

4) Press **SET** to finalize the setting. During White balance bracketing there is no viewfinder indication, but the icon for the currently selected white balance setting will blink on and off in both the LCD top panel and the Shooting Settings screen (but not the Quick Control screen). The setting is shown as text in the Camera Settings screen.

5) Press **INFO** at any time to cancel bracketing. This will also reset the cursor to **0,0**.

Notes:
It is only necessary to press the shutter release once to capture the three bracketed images. However, both the total number of shots available on the memory card and the number of burst images available will be reduced by three.

White balance bracketing can also be combined with Auto exposure bracketing, in which case pressing the shutter release three times will result in nine images being captured.

› Color space

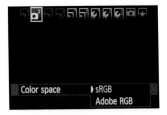

The term color space is used to describe the range of colors that can be reproduced within a given system. The EOS 7D provides two color spaces: sRGB and AdobeRGB. The latter offers a more extensive range and is likely to be used by those for whom the final image is to be converted to the CMYK color space for commercial printing in books and magazines. Canon recommends sRGB for what it classifies as "normal use."

› Picture Styles

Picture Style	◑.◐.♨.◐
⭐S Standard	3 , 0 , 0 , 0
⭐P Portrait	2 , 0 , 0 , 0
⭐L Landscape	4 , 0 , 0 , 0
⭐N Neutral	0 , 0 , 0 , 0
⭐F Faithful	0 , 0 , 0 , 0
⭐M Monochrome	3 , 0 , N , N
⭐1 User Def. 1	Standard
⭐2 User Def. 2	Standard
⭐3 User Def. 3	Standard
INFO. Detail set.	SET OK

In Full Auto mode, Standard Picture Style is selected automatically. In Creative Auto mode, the choice is limited to Standard, Portrait, Landscape, and Monochrome. In both modes, the Picture Style parameters are fixed and cannot be adjusted.

In all other shooting modes, any Picture Style can be selected and tailored to your own individual requirements. Any of the Picture Styles can be incorporated into the **C1**, **C2**, and **C3** Camera User modes. In addition, three User Defined Picture Style settings can be created.

The Picture Style menu can be accessed quickly and easily by registering it to ★ My Menu *(see page 85)*, or by pressing the ⁂ button.

All of the following options apply equally to JPEG and RAW files, but RAW file users also have the option of resetting the Picture Style or changing the parameters later on the computer.

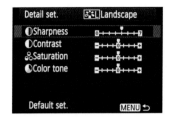

Detail set.	⭐L Landscape
◑ Sharpness	0┼┼┼┼▼┼┼7
◐ Contrast	⊟┼┼┼0̅┼┼┼⊞
♨ Saturation	⊟┼┼┼0̅┼┼┼⊞
◐ Color tone	⊟┼┼┼0̅┼┼┼⊞
Default set.	MENU ↩

Color parameters

For each of the 7D's Picture Styles there are four sets of parameters, as follows: ◑ Sharpness, ◐ Contrast, ♨ Saturation, and ◐ Color tone. With the exception of ◑ Sharpness, the settings for which range from 0 to +7, all the settings range from -4 to +4. Their effects are self-explanatory, with the exception of Color tone, in which a lower setting (-4, for example) gives a reddish skin tone, while a higher setting produces a yellower skin tone.

Picture Style default settings

	◐ Sharpness	◑ Contrast	⧓ Saturation	◐ Color tone
Standard	3	0	0	0
Portrait	2	0	0	0
Landscape	4	0	0	0
Neutral	0	0	0	0
Faithful	0	0	0	0

	◐ Sharpness	◑ Contrast	◉ Filter effect	⊘ Toning effect
Monochrome	3	0	None	None

Note: Default settings for the three User Defined styles are all set to Standard.

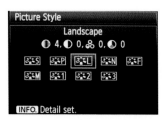

Setting a Picture Style using the ✚ button

1) Press the ✚ Picture Style selection button and rotate either the ✑ Main dial or ◯ Quick Control dial to highlight the desired Picture Style.

2) The name of the highlighted Picture Style will be displayed at the top of the screen, along with the current parameter settings using the following symbols: ◐ Sharpness, ◑ Contrast, ⧓ Saturation, and ◐ Color Tone (the exception is Monochrome—*see pages 98–9*).

3) To confirm the new Picture Style selected in step 1, and its existing parameter settings, press **SET**.

4) To change the parameters of the Picture Style, press the **INFO** button. The **Detail set.** screen appears, showing all four parameters with a sliding scale for each one.

5) Rotate the ◯ Quick Control dial to highlight the parameter you wish to change. Press **SET**.

6) The chosen parameter is now displayed on its own. Rotate the ⊙ Quick Control dial to change the setting—clockwise to increase the setting or anticlockwise to decrease it. The white indicator will move along the scale accordingly, leaving a gray indicator that shows the default setting.

7) Press **SET** to finalize the parameter setting. Repeat steps 5–7 as necessary.

8) Press **MENU** once to return to the Picture Style screen, then press **SET** to finalize your choice of Picture Style.

Setting a Picture Style using the menu system

1) Press **MENU**. In 🔳 Shooting menu 2, rotate the ⊙ Quick Control dial to highlight **Picture Style** and press **SET**.

2) Rotate the ⊙ Quick Control dial to highlight the desired Picture Style. (The three User Defined options can be found underneath the Monochrome item—use the ⊙ Quick Control dial to scroll down if necessary.)

3) To confirm the new Picture Style selected in step 2, and its existing parameter settings, press **SET**.

4) If you wish to change the parameters of the Picture Style, press the **INFO** button to change to the **Detail set.** screen showing all four parameters with a sliding scale for each. Rotate the ⊙ Quick Control dial to highlight the parameter you want to change. Press **SET**.

5) The chosen parameter is now displayed on its own. Rotate the ⊙ Quick Control dial to change the setting—clockwise to increase the setting or anticlockwise to decrease it. The white indicator will move along the scale accordingly, leaving a gray indicator that shows the default setting.

6) Press **SET** to finalize the parameter setting. Repeat steps 4–6 as necessary.

7) Press **MENU** once to return to the Picture Style screen, then press **SET** to finalize your choice of Picture Style.

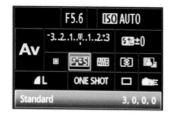

Setting a Picture Style using the Q button

This method will apply when the LCD monitor is active (regardless of whether it is displaying the Shooting Settings screen, Camera Settings display, or Electronic Level) or when the LCD display is blank.

1) Press the **Q** button to display the Quick Control screen on the LCD monitor. When it is displayed, the most recently used function will be highlighted in green.

2) Use the �֍ Multi-controller to highlight the Picture Style icon.

Tip

If you change a Picture Style setting, you will see that the new setting is indicated by a white marker, but the original setting remains in view as a gray marker. This makes it easy to return to the default settings, so don't be afraid to experiment.

3) Rotate either the ⟳ Main dial or ◯ Quick Control dial in either direction to change the Picture Style. (To change the parameter settings, press **SET** and follow steps 4–8 on pages 96–7.)

4) Press the **Q** button or partially depress the shutter-release button to exit.

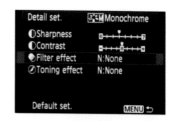

Monochrome parameters

The Monochrome Picture Style uses different parameters than the other Picture Styles. In addition to ● Sharpness and ◐ Contrast, there are two Monochrome-only settings, ◉ Filter effect and ⊘ Toning effect, the symbols for which replace those for Saturation and Color Tone as soon as Monochrome is selected.

The procedure for setting or adjusting the parameters for Sharpness and Contrast is exactly as outlined on the previous pages. The procedure for setting Filter effects or Toning effects is the same up to the point where a single parameter is shown on screen. Instead, you are presented with a menu *(see next page).*

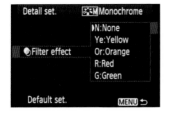

Monochrome filter effects

The ⊘ Filter effect menu offers a choice of yellow, orange, red, or green filter effects, or none. **Yellow** will make blue skies look less washed out and clouds appear crisper. **Orange** makes blue skies look darker and clouds more distinct. **Red** makes blue skies look extremely dark and clouds very white, with an overall high-contrast effect. **Green** is good for lips and skin tones, and makes foliage look crisper. Each filter makes its own color lighter and its opposite darker.

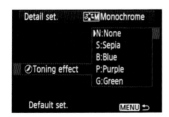

Monochrome toning effects

The ⊘ Toning effect menu offers a choice of Sepia, Blue, Purple, Green, or None.

1

2

3

4

FERRARI MECHANICS ⌃
1. Original image.
2. Monochrome Picture Style, no filter.
3. Monochrome Picture Style, Red filter.
4. Monochrome Picture Style, Green filter.

2

User Defined Picture Styles

You can adjust the parameters of a Picture Style and register it as one of three User Defined styles, while keeping the default settings for the base style.

1) Press the ✦ Picture Style selection button and rotate the ⊙ Quick Control dial to highlight **User Def. 1/2/3**, then press the **INFO** button to bring up the **Detail set.** screen.

2) Highlight the currently selected base Picture Style at the top. Press **SET**.

3) Rotate the ⊙ Quick Control dial to change the base Picture Style. Press **SET**.

4) The **Detail set.** screen will appear again, this time with your desired base

Picture Style indicated. Rotate the ⊙ Quick Control dial to highlight a parameter and press **SET**.

5) The chosen parameter will now appear on a screen on its own. Rotate the ⊙ Quick Control dial clockwise to increase the setting or anticlockwise to decrease it. The white indicator will move along the scale, leaving a gray indicator that shows the default setting. Press **SET**.

6) Repeat steps 4 and 5 as necessary to change other parameters.

7) Press **MENU** to finalize all parameters and return to the Picture Style screen, then press **SET** to finalize your choice of Picture Style.

CHANGING SEASONS «
The User Defined feature enables you to try out unusual combinations of settings, or extreme adjustments that you would never use in normal circumstances. In this image, spring has been changed to fall using extreme Color tone adjustment and a slight change to the Saturation. All other settings are identical.

» SHOOTING MENU 3 📷⋮

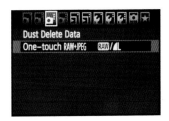

› Dust Delete Data

Under normal circumstances, the EOS 7D's Self-Cleaning Sensor Unit, which is triggered every time you switch the camera on or off, will keep dust specks from spoiling your images. When visible traces do remain, however, you can append Dust Delete Data to your images. This will ensure that the dust spots are erased automatically at a later stage in the Digital Photo Professional software provided. When the Dust Delete Data has been obtained, the information is appended to all images recorded after this point, but this has no significant impact on file size. The Dust Delete Data can, and should, be updated regularly and especially before an important shoot.

1) To obtain the Dust Delete Data, point the camera at a solid-white subject, set the lens focal length to 50mm or longer, and select **MF** manual focus, rotating the focusing ring to the infinity setting.

2) In 📷⋮ Shooting menu 3, select **Dust Delete Data** and press **SET**. Select **OK** then press **SET**.

3) When automatic sensor cleaning is completed, the following message will appear: "Press the shutter button completely when ready for shooting."

4) Photograph the solid-white subject at a distance of 8–12in (20–30cm), making sure that it completely fills the frame.

5) The image will be captured in **Av** Aperture Priority mode at an aperture of f/22. The image will not be saved, but the Dust Delete Data will be retained. A message screen appears reading: "Data obtained." Press **OK**.

6) If the Dust Delete Data was not obtained, a message will advise you of this. Follow the preparatory steps carefully and try again.

> ### Tip
>
> *Narrow apertures make dust spots more noticeable, usually in areas of plain color such as blue sky.*

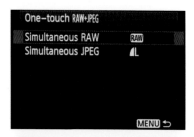

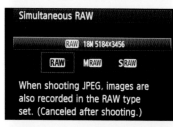

› One-touch RAW+JPEG

This menu item determines the exact file sizes recorded by the camera when the **RAW JPEG** One-touch RAW+JPEG button is used *(see pages 87–8)*. When either RAW or JPEG alone is selected, pressing the **RAW JPEG** button provides a quick way of changing the settings temporarily so that both types of file are recorded for the next shot (or the next sequence if a continuous drive mode is used).

If one of the JPEG options is already selected, a RAW file will also be recorded when **RAW JPEG** is pressed. This file can be in **RAW**, M**RAW**, or S**RAW** format.

If one of the RAW options is currently selected, a JPEG file will also be recorded when **RAW JPEG** is pressed. This file can be saved using any of the six JPEG options.

> **Note:**
> Shooting menu 4 📷 deals exclusively with Live View. Full details of this menu can be found in Chapter 3, Live View and Movie mode.

» PLAYBACK MENU 1 ▶

Playback menu 1 is identified by blue highlighting and covers the protection, deletion, and rotation of selected images. It also enables you to choose images for printing or transferring to the computer.

› Image display

Index display
By using the **✳/⊞•**�─ Reduce and **⊞/**☐ Enlarge buttons, you can display a single image, four images, or nine images at a time. These last two displays are referred to as index displays, which are also employed by the Protect and Rotate functions in ▶ Playback menu 1—but not by the Erase function, which displays a maximum of three images.

Single-image display

Index display: four images

Index display: nine images

Magnifying images

In single-image display, you can use the ⊞/⊕ Enlarge button to magnify the image to check its quality. The ✳ Multi-controller can be used to move the magnified portion around the image.

Full image

Magnified portion of the image

Tip

To return the magnified image to a full image with a single keystroke, press the ▶ Playback button.

Scrolling

The ⊙ Quick Control dial will always scroll through one image at a time.

In single-image display, whether magnified or unmagnified, the 🛞 Main dial will scroll through the images according to the setting of **Image jump w/**🛞 in Playback menu 2; the current setting for this is displayed as a reminder. If you switch to rotating with the ⊙ Quick Control dial, the reminder will disappear.

In index display, rotating the 🛞 Main dial will scroll through one screen at a time (i.e., four or nine images in the Protect or Rotate functions, or three images at a time in the Erase function).

› Protect images

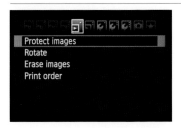

You can protect selected images to avoid accidental deletion. These will display the ⊙┐ key symbol.

Protected images (or the selected image, if you are using index display) will always show the ⊙┐ key symbol in the same position, just to the left of the folder number at the top of the screen.

1) To protect an image, press **MENU** and use the ⚙ Main dial to select ▶ Playback menu 1.

2) Rotate the ◌ Quick Control dial to select **Protect images** and press **SET**.

3) To change the display, press ✱/☷•◵ or ☷/◵ as required.

4) Rotate either the ◌ Quick Control dial or the ⚙ Main dial to select the image to be protected.

5) Press ☷/◵ repeatedly in single-image display to magnify the image as required, then use the ✳ Multi-controller to move the magnified portion of the image. Press ✱/☷•◵ to return to the unmagnified image.

6) Press **SET**. The 🔒 key icon will appear on the top line of the display, regardless of whether a single image or index display is shown. With index display, the key icon on the top line of the screen relates to the image highlighted in blue (i.e., the selected image).

7) To cancel protection for an image, select it and press **SET**. The 🔒 key icon will disappear. (To delete a protected image, you must first cancel the protection for that image.)

8) To protect another image, repeat steps 3-6. Press **MENU** to exit.

Tip

*Batch protection of images is not possible in-camera, but can be achieved in post-processing using ZoomBrowser EX: select the images to be protected, choose **File**, and click on **Protect**.*

Note:
A key symbol together with the word **SET** is displayed in the top-left corner of the LCD monitor, regardless of how many images are displayed. This represents an instruction, not an indication that an image is protected.

Warning!

Protected images will still be deleted when you format a memory card.

› Rotate images

This function can be used to rotate selected images by 90° or 270° at a time, regardless of their current orientation. (To automatically correct the orientation of portrait images, select **Auto rotate** in ŶŢ Set-up menu 1.)

1) Press **MENU** and then use the main dial to scroll through the menu tabs until you reach ▶ Playback menu 1.

2) Rotate the ⊙ Quick Control dial to highlight **Rotate** and press **SET**.

3) To change the display, press ✱/☒•⊖ or ▣/⊕ as required.

4) Rotate either the ⊙ Quick Control dial or main dial to select the image to be rotated.

5) Press ▣/⊕ repeatedly in single-image display to magnify the image as required, then use the ✿ Multi-controller to move the magnified portion of the image. Press ✱/☒•⊖ to return to the unmagnified image.

6) Press **SET** to rotate the image through 90°, or press it twice to rotate the image through 270°. (If this step is completed while an image is magnified, the image will be rotated, but the display will revert to the unmagnified image.)

7) To rotate additional images, repeat steps 3–6. To exit, press **MENU**.

> *Note:*
> Movie images cannot be rotated.

› Erase images

The Erase facility enables you to delete selected individual images, all images in a selected folder, or all images on the memory card—with the exception of any protected images in each case.

There is a distinct advantage to erasing individual images via the menu as opposed to simply using the 🗑 button during

review. This is that images are selected for deletion (marked with a check) but not actually erased until you press the 🗑 button to delete all the selected images at once. Consequently, you can scroll backward and forward through similar images to make comparisons, and can uncheck an image if necessary.

Image display in Erase images
The ✳/▦•🔍 and ▤/🔍 buttons can be used with the Erase function, but they behave in a different way than in the Protect or Rotate functions *(see pages 104–6)*. With an image displayed, press the ✳/▦•🔍 button to display three images, as shown in the image below. This is the maximum number possible.

When three images are displayed, press the ▤/🔍 button to revert to a single-image display.

You can magnify a single image to assess it for quality. With a single image displayed, press ▤/🔍 repeatedly to magnify the image *(see page 104)*. Use the ✳ Multi-controller to move the magnified portion around the image. To return the magnified image to an unmagnified image with one keystroke, press the ▶ Playback button.

In the three-image display, when selecting images for deletion, each individual image is allocated a check immediately above it. This is always displayed, even when the image is not currently highlighted.

Warning!

Once deleted from the camera, images cannot be recovered.

If RAW+JPEG files have been recorded simultaneously, deleting an image will delete both versions.

2

Deleting images

The fastest way to delete a small number of images is to press the ▶ Playback button, scroll through the recorded images, and to press 🗑 for each one you wish to delete when it is displayed. However, several more sophisticated methods are outlined here.

Selecting and deleting individual images

1) Press the **MENU** button and use the 🛞 Main dial to scroll through the menu tabs until you reach ▶ Playback menu 1.

2) Rotate the ⊙ Quick Control dial to select **Erase images**. Press **SET**.

3) Rotate the ⊙ Quick Control dial to highlight **Select and erase images**. Press **SET**.

4) To change the display, press ✱/◨⦁🔍 or ⊟/🔍 as required.

5) Rotate either the ⊙ Quick Control dial or the 🛞 Main dial to select the image to be deleted.

6) Press ⊟/🔍 repeatedly in single-image display to magnify the image as required, then use the ✳ Multi-controller to move the magnified portion of the image. To return the magnified image to an unmagnified image with one keystroke, press the ▶ Playback button.

7) Press **SET** to mark the image for deletion. A check will appear above the image. The total number of images currently selected for deletion is also shown (5 in the example below). You can change the display at any time by using the ✱/◨⦁🔍 or ⊟/🔍 buttons.

8) Repeat steps 5 and 7 to select more images for deletion. Press the 🗑 button when you are ready to delete all of the selected images. Select **OK** in the confirmation dialog box.

9) Press **SET** to delete the selected images.

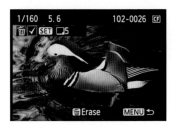

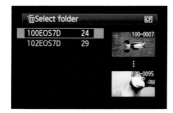

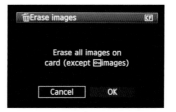

Deleting all images in a folder

1) Press the **MENU** button and use the ⚞ Main dial to scroll through the menu tabs until you reach ▶ Playback menu 1.

2) Rotate the ◯ Quick Control dial to select **Erase images** and press **SET**.

3) Rotate the ◯ Quick Control dial to highlight **All images in folder** and press **SET**.

4) If more than one folder exists on the memory card, all folders will be listed. Rotate the ◯ Quick Control dial to highlight the folder that contains the images you wish to delete. The first and last images in that folder will be displayed as thumbnails.

5) Press **SET**. A confirmation dialog box will be displayed.

6) Select **OK** and press **SET**. All unprotected images in the selected folder will be erased.

Deleting all images on a memory card

1) Press **MENU** and use the ⚞ Main dial to scroll through the menu tabs until you reach ▶ Playback menu 1.

2) Rotate the ◯ Quick Control dial to select **Erase images** and press **SET**.

3) Rotate the ◯ Quick Control dial to highlight **All images on card**.

4) Press **SET**. A confirmation dialog box will be displayed.

5) Select **OK** and press **SET**. All of the unprotected images on the memory card will be erased.

> **Note:**
> For setting **Print order** options in Playback menu 1, see page 246.

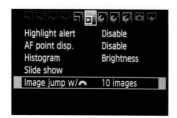

Playback menu 2 covers information relating to exposure and focus that can be included with the image being reviewed; the **Slide show** option, which initiates a continuous display of recorded images; and the **Image jump** settings for rapid image searching.

› Highlight alert

When this function is enabled, overexposed parts of the image will blink on and off during playback. If necessary, shoot the image again using exposure compensation to ensure a faster shutter speed or smaller aperture, or a combination of the two.

› AF point display

This function enables the superimposed display of the AF point(s) that acquired focus on the image being reviewed. If only one AF point was selected, only one point will be displayed. If automatic AF-point selection was in operation, all the focus points that engaged when the image was captured will be displayed.

› Histogram

When an image is being reviewed, pressing the **INFO** button brings up the Shooting Information Display, which shows the image at a smaller size, but with useful shooting

data, including a histogram. This menu allows you to choose between an overall Brightness histogram or an RGB histogram, which shows the relative brightness of the Red, Blue, and Green channels.

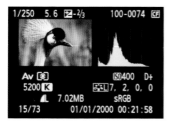

Brightness histogram

The Brightness histogram is a graph that shows the overall exposure level, the distribution of brightness, and the tonal gradation. It enables you to assess the exposure as a whole, to judge the richness of the overall tonal range, and ultimately to fine-tune the exposure that is required.

The histogram's horizontal axis shows the overall brightness level of the image. If the majority of the peaks appear on the left, it indicates that the image may be too dark. If the peaks are largely on the right, the image may be too bright. However, this depends on the result you are seeking. You might actually want a very "heavy" result, or perhaps a high-key, soft-focus image that is bright and ethereal in quality.

The histogram's vertical axis shows how many pixels there are for each level of brightness. Too many pixels on the far left

suggests that shadow detail will be lost. Too many pixels on the right indicates that highlight detail will be lost. The Highlight Alert function will cause these areas to blink on the image displayed.

In particularly contrasty situations, you may be in danger of losing both shadow and highlight detail in an image, in which case you may have to judge which you want to sacrifice in favor of the other.

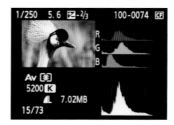

RGB histogram

The RGB histogram is a graph showing the distribution of brightness in terms of each of the primary colors—red, green, and blue. The horizontal axis shows each color's brightness level (darker on the left and lighter on the right). The vertical axis shows how many pixels exist for each level of brightness in that particular color.

The greater the number of pixels on the left, the darker and less emphatic that particular color will appear. Conversely, the greater the number of pixels shown on the right, the brighter that color will be, possibly to such an extent that the color is far too saturated and won't hold detail.

2 › Slide show

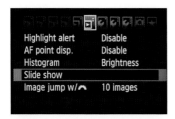

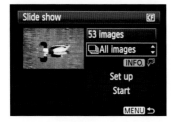

This function initiates a slide show of recorded images. The options include all images on the card; all images in a specific folder; all images shot on a specific date; and movies or still images recorded while in Movie mode. You can also select the duration of each slide, and opt to repeat the slide show. The display can include shooting information and histograms as described on pages 110–1; press **INFO** to change the display, and press **SET** to pause the slideshow.

1) To start a slide show, press the **MENU** button and use the ⚙ Main dial to scroll through the menu tabs until you reach ▶' Playback menu 2.

2) Rotate the ◌ Quick Control dial to select **Slide show** and press **SET**.

3) Rotate the ◌ Quick Control dial to highlight **All images** and press **SET**. Two arrows will be added to the highlighted **All images** box, indicating that you can scroll up or down for further options.

4) Rotate the ◌ Quick Control dial to display the other options: **Folder**, **Date**, **Movies**, and **Stills**. The total number of images available in each category is shown above. Note that the **INFO** icon below is grayed out if **All images**, **Movies**, or **Stills** is selected; for **Folder** and **Date**, it is "live" and the **INFO** button should be pressed to display a folder-selection screen or date-selection screen. (Thumbnails of the first and last images in a folder or taken on a specific date are displayed to aid your memory.) Highlight the desired folder or shooting date.

5) Press **SET** to finalize the selected source of images. The two arrows will no longer be displayed.

6) Rotate the ◌ Quick Control dial to highlight **Set up**. Press **SET**.

7) Rotate the ◌ Quick Control dial to highlight **Play time**. Press **SET**.

› Image jump with ⚙

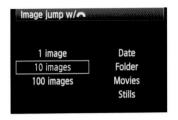

8) Rotate the ⊙ Quick Control dial to choose the desired playing time for each image: 1, 2, 3, or 5 seconds. Press **SET**.

9) Rotate the ⊙ Quick Control dial to highlight **Repeat**. Press **SET** and select **On** or **Off**.

10) Press **SET**, then **MENU**.

11) Rotate the ⊙ Quick Control dial to highlight **Start**. Press **SET**.

12) A loading screen will be displayed, and the slide show will start. Press **SET** to pause or resume the slide show. Press **INFO** at any time to change the display to include the shooting information and histogram. Press **MENU** at any time to exit the slide show.

This menu offers a variety of options for fast scrolling through the images on the memory card with the ⚙ Main dial. When this facility is activated, you can also rotate the ⊙ Quick Control dial to scroll through images one at a time. Using both dials in combination is a fast and efficient way to navigate through several hundred images to find the one(s) you want.

You can choose to scroll by a single image, 10 images, or 100 images at a time. You can also scroll by date, by folder, by the next movie, or by the next still image shot while in Movie mode.

This is the first of three menus covering settings that, in most cases, you will determine once and need not return to very often. Highlighting for all Set-up menus is in yellow.

› Auto power-off

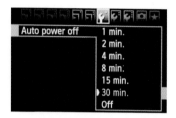

This setting enables you to save battery power while keeping the camera ready for action. You can instruct the camera to turn itself off after a set interval ranging from 1 to 30 minutes of inactivity, but power will be restored immediately as soon as you partially depress the shutter-release button (or, in fact, any other button). If you wish the camera to remain switched on at all times, you should select the **Off** option. The LCD monitor will always turn itself off after 30 minutes, regardless of the setting you choose in this menu.

› Auto rotate

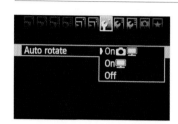

If Auto rotate is **On**, vertical images will be automatically displayed at the correct orientation. This can be applied to either the camera monitor and computer or just the computer.

› Format

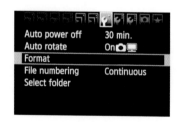

If the memory card is new or has been used in a different camera, this function will initialize the card. Formatting removes all images and is often used to clear a card when its images have been downloaded. Some personal data is retained, so be aware of this before discarding the card.

› File numbering

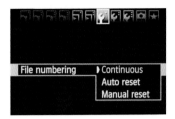

Each time you record an image, the camera allocates a file number to it and places it in a folder. Still images are assigned a sequential file number from 0001 to 9999 and will look like this: IMG_0001.JPG or IMG_0001.CR2. The prefix IMG_ is used regardless of file type, but the suffix will be .JPG for all sizes of JPEG file, or .CR2 for RAW files.

Movie files are stored in the same way, but with the prefix MVI_ and the suffix .MOV—for example, MVI_0001.MOV.

When a folder contains 9999 images, it is full, and the camera automatically creates a new folder. The first image

Warning!

Always use a freshly formatted memory card—file numbering continuity may be lost if you switch to a replacement card that already contains images. Reverting to a previously used folder may also result in loss of continuity.

in the new folder will revert to 0001, even if **Continuous** is selected in the File numbering menu. The camera can create up to 999 folders. In the event that you reach IMG_9999.xxx in folder 999, the camera will stop shooting until you replace the memory card, even if the card still has unused capacity.

If you select **Continuous**, when you change a memory card, the file number of the first image recorded on the new card will continue from the last image on the card you removed. So, if the last shot taken on a card was IMG_0673.JPG, the first shot on the new card will be IMG_0674.JPG. The same applies when you start a new folder.

If you select the **Auto reset** option, file numbering automatically starts again from 0001 each time you replace a memory card or create a new folder.

If you choose **Manual reset**, the camera creates a new folder immediately and starts the file numbering in that folder from 0001. This is convenient if you are shooting similar images in a variety of different locations or at different times and want to keep each set of images separate. This procedure can be extremely helpful when renaming files or adding captions at a later date. After a manual reset, the file numbering sequence will return to Continuous or Auto reset, as previously selected.

Tips

For continuous file numbering to be applied when you create a new folder, the last image recorded in the previous folder must have been taken with **Continuous** *selected, otherwise image numbering in the new folder will start from 0001.*

Date and time information is appended to every image so that images can be sorted on the computer in date/time order. This can be useful for sorting large numbers of images into categories—from a sports event, for example—provided you also keep a copy of the event program.

Continuous file numbering is sometimes assumed to be a mechanism for counting the number of shutter actuations. This is not the case. The term "continuous" in this context relates only to the continuation of the file-numbering sequence when you replace the memory card or create a new folder.

The **Format** *function can also be used to reset the file-numbering sequence (see page 114).*

› Select folder

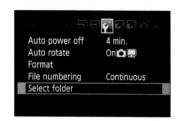

Folders are created sequentially using the format 100EOS7D, 101EOS7D, and so on. Each folder can hold up to 9999 images, and a new folder is created automatically when this figure is reached.

This menu allows you to select an existing folder or to manually create a new one. If you select **Create folder** in the secondary menu, the folder name will follow the standard sequence: if your highest numbered existing folder is 102, for example, the new one will be 103, as shown below.

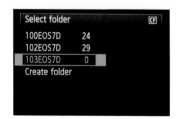

Selecting a folder

You may wish to select a specific folder to show images to friends or family, to assess images for quality, or to delete unwanted images. The number of images in each folder is also displayed in the folder list.

1) Press **MENU** and use the Main dial to scroll through the menu tabs until you reach Set-up menu 1.

2) Rotate the Quick Control dial to highlight **Select folder** and press **SET**. A new screen displays the existing folders on the memory card. The first and last images within the highlighted folder will be shown as thumbnails, as a visual reminder of the folder's content.

3) Rotate the Quick Control dial to select a folder. Press **SET**. The selected folder will now be the camera's current folder and the one into which any new images are saved. *(See the warning about file-numbering continuity on page 115.)*

Creating a folder

The EOS 7D automatically creates new folders when necessary, but you can create folders manually if you wish—in advance of an important shoot, for instance.

1) Press **MENU** and use the Main dial to scroll through the menu tabs until you reach Set-up menu 1.

2) Rotate the Quick Control dial to highlight **Select folder** and press **SET**. A new screen is displayed, listing the existing folders. At the bottom of the list is the **Create folder** option. Note: if there is a long list of existing folders, the **Create folder** option may not be visible, so use the Main dial to scroll down.

3) Highlight **Create folder** and press **SET**. A confirmation dialog will appear.

4) Select **OK** and press **SET**. The new folder number will appear at the bottom of the list, showing 0 images.

5) Press **MENU** to exit.

› LCD brightness

this sensor (most likely with your thumb). Auto screen brightness can still be adjusted to one of three levels.

1) To set LCD brightness, press the **MENU** button and use the ⚙ Main dial to scroll through the menu tabs until you reach ⚒ Set-up menu 2.

2) Rotate the ◯ Quick Control dial to highlight **LCD brightness** and press **SET**. If **Auto** is currently selected, the Auto display screen will be shown. If **Manual** is currently selected, the Manual display screen will be shown.

3) Rotate the ⚙ Main dial to select Auto or Manual.

Screen brightness often needs to be adjusted, either due to changing ambient light levels or so that you can assess the brightness and color of your images more accurately. The LCD brightness menu allows this to be done both automatically and manually, and the current setting is shown as either **Auto** or as a seven-point manual scale (see above).

The Auto setting will assess and adjust screen brightness automatically, based on ambient light levels measured by the small sensor above the ◯ Quick Control dial. If **Auto** is selected, take care not to obstruct

Tip

The grayscale on the LCD brightness screen is useful, but the image is even more so. The image shown is the last one viewed during playback. To display a different image on the LCD brightness screen, locate it using the ▶ button, then press ▶ again to exit before adjusting LCD brightness. The image you chose will be displayed on the LCD adjustment screen.

4) Rotate the ⟳ Quick Control dial to select the brightness level. Both the Auto and Manual screens are "live" and changes will be applied immediately.

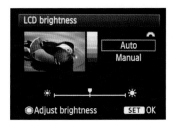

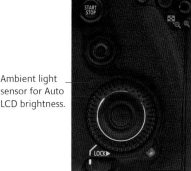

Ambient light sensor for Auto LCD brightness.

› Date/Time

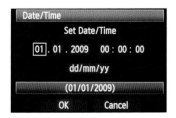

The Date/Time setting is important, since this data will be appended to each image as it is recorded and can be extremely useful for sorting images in post-processing. The date format can be dd/mm/yy, mm/dd/yy, or yy/mm/dd.

1) To set or amend the Date/Time, press the **MENU** button and use the ⚞ Main dial to scroll through the menu tabs until you reach ᶠᵀ˙ Set-up menu 2.

2) Rotate the ⟳ Quick Control dial to highlight **Date/Time** and press **SET**.

3) Rotate the ⟳ Quick Control dial to scroll through the different settings.

4) To change a setting, highlight it and press **SET**. Two arrows ▲ ▼ will be added to the highlighted item, indicating that you should scroll up or down to change the setting.

5) Rotate the ⟳ Quick Control dial in either direction to change the setting. Press **SET**. (Note: pressing **SET** at this point does not save any changes.) Repeat for each setting you wish to change.

6) To save all changes, highlight **OK** and press **SET**.

2

› Language

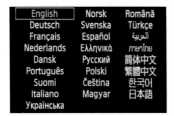

Twenty-five separate languages are programmed into the EOS 7D. If you are adventurous enough to set a different language, you may have trouble understanding the menu to restore your native tongue!

› VF grid display

The viewfinder (VF) grid is designed to help you keep horizons level in your pictures. The grid occupies the full image area except for the central portion where the AF points reside. It has no impact on AF-point selection or AF-area selection.

› Video system

You can connect the camera to a TV set using the cord provided, making it easy to share your images with family or friends. However, you must first use the Video

system menu to establish the correct video format. The choice of settings is between **NTSC** (more common in North America) and **PAL** (more common in Europe).

Note:
For full instructions on connecting your camera to both regular and high-definition TV sets, see page 236.

› Sensor cleaning

Dust specks on the camera sensor are one of digital photography's major irritations. Obviously, changing lenses in dusty or windy locations is best avoided, but it needs to be done quickly and carefully in any environment—and even if you leave a lens on the camera most of the time, if it is a push/pull-style zoom, the vacuum effect can pull in minute particles of dust, too. Dust spots show up particularly in areas of plain color, such as expanses of blue sky, and when using narrow apertures. To minimize the problem, don't use f/22 when f/8 will do.

While it may be necessary to have your camera's sensor professionally cleaned from time to time by an authorized Canon Service Center, the Integrated Cleaning System is designed to shake off particles of dust during routine use. If you enable **Auto cleaning** in this menu, the Self Cleaning Sensor Unit, which is attached to the sensor's front layer, will operate for approximately one second each time you switch the camera on or off, and the LCD monitor displays a message indicating that the operation is taking place. Auto cleaning can also be disabled.

You can activate the cleaning operation immediately by selecting **Clean now**. This will initiate a single cleaning cycle. The **Clean manually** setting should only be used by service technicians.

1) To select the Clean now function, rotate the ⊙ Quick Control dial to **Clean now** and press **SET**.

2) Select **OK** and press **SET** again. The LCD monitor will display the sensor-cleaning message. The sound of a single shutter operation will be heard, but no image will be recorded.

3) The manually selected sensor-cleaning operation takes slightly longer (approx. 2.5 sec.) than automatic cleaning.

Tips

For more effective cleaning, stand the camera on a flat surface.

Canon has pointed out that spots of lubricating fluid can very occasionally make their way onto the sensor surface. If you suspect this has happened, have the sensor professionally cleaned.

2 » SET-UP MENU 3 ⚙️

This menu is used for registering the settings for Camera User modes **C1**, **C2**, and **C3**, and to clear all camera settings back to their default values—take care not to use this function accidentally. Set-up menu 3 also identifies the current firmware installed in the camera; updates can be downloaded from Canon's web site, or installed for you at a Canon Service Center. You can also use this menu to add copyright information to your image data.

› Battery information

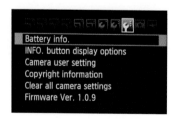

A simple graphic in the viewfinder, in the LCD top panel, and in the Shooting Settings screen shows the level of

battery charge. The **Battery info.** menu, however, provides access to more specific information. Because each LP-E6 battery has a serial number, individual batteries can be registered to the camera so they can be recognized when inserted. A maximum of six LP-E6 batteries can be registered.

Registering a battery

1) Press **MENU** and use the 🎛 Main dial to scroll through the menu tabs until you reach ⚙️ Set-up menu 3.

2) Rotate the ⭕ Quick Control dial to highlight **Battery info.** and press **SET**. The battery information screen will be displayed. Remaining capacity is indicated in 1% increments. The number of shots recorded with the selected battery since recharging is shown, and its recharging performance is displayed as a three-bar indicator in green. This changes to a single red bar when the battery should be discarded and a new one purchased.

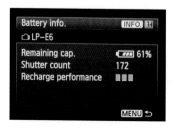

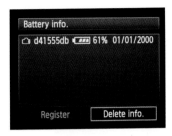

3) Press **INFO**. The battery history screen will be displayed, listing the batteries that have been registered. An unregistered battery will be grayed out. The date each battery was last used is also shown.

4) Rotate the ⊙ Quick Control dial to select **Register**. Press **SET**. A confirmation dialog will be shown.

5) Select **OK** and press **SET**. The battery history screen will be displayed, now including the newly registered battery in white text.

6) Press **MENU** to return to the battery information screen. Press **MENU** to exit.

Deleting battery information

1) Press **MENU** and then the 🔄 Main dial to scroll through the menu tabs until you reach ᵼᵼ Set-up menu 3.

2) Rotate the ⊙ Quick Control dial to highlight **Battery info.** and press **SET**. The battery information screen will be displayed.

3) Press **INFO**. The battery history screen will be displayed. Highlight the desired battery and select **Delete info.**.

4) Press **SET**. The Battery info. delete screen will be displayed.

5) Press **SET**. A check will appear next to the battery. Press the 🗑 button. A confirmation dialog box will appear.

6) Select **OK** and press **SET**. The battery history screen will be displayed, showing the deleted battery "grayed out."

7) Press **MENU** twice to exit.

Tip

Canon recommends that you write your battery's serial number on an adhesive label and fix it to the battery, at the end opposite to the electrical contacts. Switch the camera off before removing the battery.

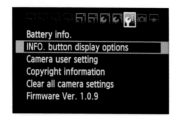

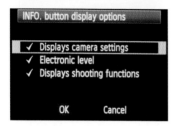

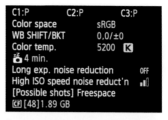

Camera settings screen

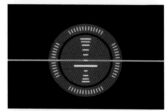

Electronic level

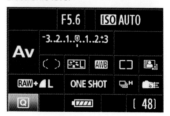

Shooting functions screen

This menu is used to determine which screen is displayed when the **INFO** button is pressed. Choose between a camera settings screen, the electronic level, and a shooting functions screen. More than one can be enabled, requiring the **INFO** button to be pressed repeatedly to scroll through the displays.

› Camera user setting

Three Camera User modes, **C1**, **C2**, and **C3**, can be found on the Mode dial. These can be set up to incorporate three groups of camera settings that you use in combination on a frequent basis.

1) To register Camera User mode settings, switch on the camera and select **C1**, **C2**, or **C3**. Activate the desired settings.

2) Press **MENU** and use the Main dial to highlight the Set-up menu 3 tab.

3) Rotate the ⊙ Quick Control dial to highlight **Camera user setting** and press **SET**.

4) On the next menu screen, highlight **Register**. Press **SET**.

5) On the following screen, rotate the ⊙ Quick Control dial to select **C1**, **C2**, or **C3**. Press **SET**.

6) In the confirmation dialog box that appears, select **OK**. Press **SET**. Your settings will now be registered and can be accessed by setting the Mode dial to that shooting mode.

Warning!

If you choose **Clear settings**, another screen asks you to select **C1**, **C2**, or **C3**. In the resulting dialog box, selecting **OK** and pressing **SET** will clear all settings for the selected Camera User mode.

› **Copyright information**

Use this menu to enter copyright information that will be added to the metadata for each image.

When this function is first used, both **Display copyright info.** and **Delete copyright information** will be "grayed out," since no information is stored.

Select **Enter author's name** or **Enter copyright details** and enter text as described below, to a maximum of 63 characters per entry. Press **MENU** to exit.

Entering text

1) Press **MENU** and use the ▨ Main dial to select the ⌂ Set-up menu 3 tab.

2) Rotate the ⊙ Quick Control dial to **Copyright information** and press **SET**.

3) Rotate the ⊙ Quick Control dial to highlight **Enter author's name** or **Enter copyright details**.

4) Press **SET**. The text entry screen will be displayed. The text entry area is at the top left, with the keypad below.

5) The text entry box is highlighted in blue. Press the ⚏ button. The highlighting will move to the keypad.

6) To enter text, rotate the ◯ Quick Control dial to scroll though the characters—or use the ❋ Multi-controller, which is especially useful for changing lines. You will find it easiest to make use of both controls. (Note: the space character is at the beginning of the top line.) When a character is chosen, either press **SET** or push the ❋ Multi-controller in. Repeat as necessary.

7) To delete the last character, press 🗑. To cancel a complete entry, press **INFO**. To save the entry and exit, press **MENU**.

Adding to saved text

1) Follow steps 1–4 for entering text. The text entry box will display any previously saved text.

2) Use the ⚏ button to move the highlighting to the keypad. Enter additional text as necessary.

3) To save the entry and exit, press **MENU**.

Editing saved text

1) Follow steps 1–4 for entering text. When displayed, the text entry box will display any previously saved text.

2) Use the ⚏ button to highlight the text entry box. Use the ◯ Quick Control dial and/or the ❋ Multi-controller to move the cursor around the existing text.

3) Use the 🗑 button to delete a preceding character. To input additional text, press ⚏ to highlight the keypad and enter text in the normal way. You can toggle between the keypad and the text entry box using the ⚏ button.

4) To save the entry and exit, press **MENU**.

› Clear all camera settings

This menu returns all camera functions to their default settings. When the Mode dial is set to **C1**, **C2**, or **C3**, the **Clear all camera settings** option in 📷 Set-up menu 3 and the **Clear all Custom Functions** option in the 📷 Custom Functions menu will not operate.

» CUSTOM FUNCTIONS MENU ◻️

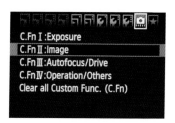

C.Fn I :Exposure
C.Fn II :Image
C.Fn III :Autofocus/Drive
C.Fn IV :Operation/Others
Clear all Custom Func. (C.Fn)

Custom Functions are divided into four groups primarily concerned with Exposure, Image, Autofocus, and Drive, with a final group called Operation/Others for additional options that don't fall into any of the previous categories. These groups are abbreviated to C.Fn I, C.Fn II, and so on, using Roman numerals. Choices within each group are referred to by their position in the respective menu, e.g., C.Fn II-3. There are many different menus, but the procedure for accessing each menu item is the same, and is described below.

1) To select a Custom Function, press **MENU** and rotate the ⚙️ Main dial to reach the ◻️ Custom Functions menu.

2) Rotate the ⚪ Quick Control dial to select C.Fn I, C.Fn II, C.Fn III, or C.Fn IV. Press **SET**.

3) When a Custom Functions category is opened, it does not display a secondary menu of its own. Instead, the last viewed submenu from within that category is

shown. Rotate the ⚪ Quick Control dial to scroll through the category's submenus. The number for each submenu is shown in the top-right corner.

4) Press **SET** to make the chosen submenu active. The selection will be highlighted.

5) Rotate the ⚪ Quick Control dial to highlight the desired setting within that submenu and press **SET**.

6) Press **MENU** to exit to the main Custom Functions menu.

> **Note:**
> Some Custom Functions are not available, or have limited availability, in Live View and Movie modes. See the table on page 137 for details.

> **Tip**
>
> *In each Custom Function category's submenu, the current settings for all the submenus in that Custom Function category are displayed numerically at the bottom of the display. The settings for each submenu are displayed on the corresponding line beneath, with a zero indicating the default setting.*

› C.Fn I: Exposure

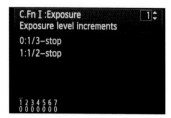

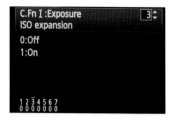

C.Fn I-1 Exposure level increments

This provides a choice between ½- and ⅓-stop increments for both normal and flash exposure settings.

C.Fn I-3 ISO expansion

Expands the normal maximum setting of ISO 6400 to ISO 12,800 (H). A high ISO will result in more noise in your images, but you can increase the level of noise reduction in C.Fn II-2.

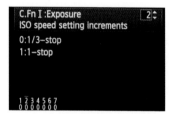

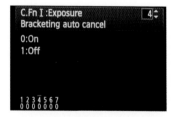

C.Fn I-2 ISO speed setting increments

This provides a choice between ½- and 1-stop increments for ISO speed settings. In Movie mode, it is selectable in **M** only.

C.Fn I-4 Bracketing auto cancel

With this feature set to **On**, Auto exposure bracketing (AEB) and White balance bracketing (WB-BKT) will be canceled if the camera's power switch is turned off. (This does not apply to Auto power-off, which can be interpreted as a standby setting.) Auto exposure bracketing will also be canceled before a flash is fired. If this function is **Off**, AEB and WB-BKT settings

are retained. AEB will still be canceled before a flash is fired, but the setting will be retained in the memory and reapplied when the flash has been turned off.

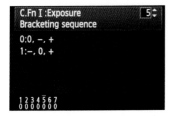

C.Fn I-5 Bracketing sequence

Choose between a bracketing sequence with the nominally correct exposure first, followed by the under- and overexposed images (**0, -, +**); or with the shots in order of exposure value (**-, 0, +**).

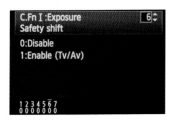

C.Fn I-6 Safety shift

This function applies solely to **Av** and **Tv** modes, and enables an automatic adjustment to the exposure if there is a last-moment shift in lighting conditions.

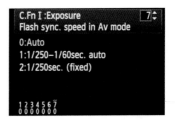

C.Fn I-7 Flash sync. Speed in Av mode

This function applies solely to Aperture-priority (Av) mode and the use of flash. The flash sync speed can be set to a fixed **1/250sec.**, or it can be left on **Auto**, when it will set a suitable speed to match the ambient light, up to a maximum of 1/250 sec. A third option enables you to select **1/250–1/60sec. auto**, which allows some flexibility without the risk of blur associated with a very slow shutter speed. You must also select the **Auto** option if you intend to use high-speed flash sync.

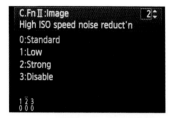

C.Fn II-1 Long exposure noise reduction

The default setting for this function is **Off**. If **Auto** is selected, the camera will automatically apply noise reduction to exposures of 1 sec. or longer provided it detects noise in the image just captured. When switched **On**, noise reduction will be applied to all exposures of 1 sec. or longer.

C.Fn II-2 High ISO speed noise reduction

This function will reduce noise at all ISO settings, not just high ISO speeds as it seems to suggest. When **Strong** is selected, the size of the maximum burst for continuous shooting will be drastically reduced when noise reduction is applied. The effects of noise reduction are best assessed in post-processing rather than on the camera's LCD monitor.

Notes:
Noise reduction is applied after the image is captured and will double the time taken to record the image.

If this function is set to *On* and you are shooting with Live View, the LCD monitor display will be disabled while noise reduction is applied.

The maximum burst for continuous shooting is drastically reduced when noise reduction is applied.

Tip

The tool palette in Digital Photo Professional includes a noise reduction function. It can be found in the NR/Lens/ALO tab.

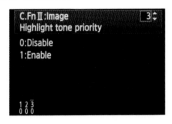

C.Fn II-3 Highlight tone priority

This function expands the dynamic range of the highlights to make sure that highlight detail is retained, without sacrificing existing shadow detail (though noise may increase in the shadows). It only operates in the ISO 200–6400 range. When Highlight Tone Priority is enabled, the additional symbol **D+** will be displayed alongside the ISO setting. Highlight Tone Priority can be combined with exposure compensation, but enabling Highlight Tone Priority automatically disables the Auto Lighting Optimizer function.

Note:
For C.Fn III 1-12, see pages 60–70.

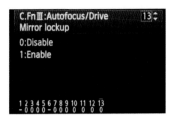

C.Fn III-13 Mirror lockup

To prevent the slight vibration that can be caused by the reflex mirror operation, the mirror can be locked up once focusing, framing, and exposure setting have been completed. When this function is enabled, fully depressing the shutter-release button once swings the mirror up and locks it in place. This operation sounds like shutter actuation, but is not. Press the shutter-release button a second time to take the exposure and release the mirror.

Note:
If the second shutter-release operation does not occur within 30 sec., the mirror will drop to its normal position and the exposure will be canceled.

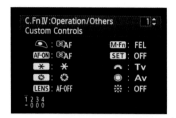

Function currently assigned to highlighted control

Control selected

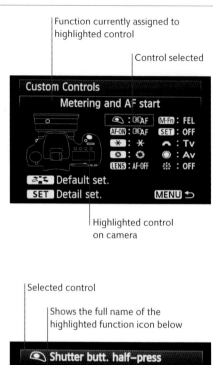

Highlighted control on camera

C.Fn IV-1 Custom Controls

This menu is perhaps the most powerful tool of all for customizing day-to-day use of the camera. It permits the allocation of different functions to each of 10 buttons or dials, one of which (the AF stop button) is only found on super-telephoto IS lenses.

1) Press the **MENU** button. Rotate the Main dial to scroll through the menu tabs until you reach the 🎥 Custom Functions menu.

2) Rotate the ⊙ Quick Control dial to select C.Fn IV. Press **SET**.

3) Use the ⊙ Quick Control dial to scroll to submenu 1, **Custom Controls**.

4) Press **SET** to make this menu active. The screen display changes to incorporate a camera diagram (showing either the top or the back of the camera) with the currently selected control highlighted in both the diagram and list of controls. The function assigned to the highlighted control is displayed above.

Selected control

Shows the full name of the highlighted function icon below

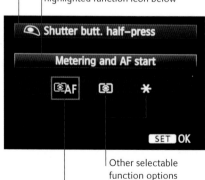

Other selectable function options

Function currently assigned highlighted in blue

5) Rotate the ⊙ Quick Control dial to highlight the control you wish to change. Press **SET**. The setting screen for that control will be displayed.

6) The name of the selected control is shown at the top of the screen on an orange background (**Shutter button half-press** in the example shown at the bottom of the opposite page). The text on a blue background is the name of the function icon that is highlighted in orange underneath the blue bar (**Metering and AF start** in this example). The highlighted function icon is the one that is currently assigned to the selected control; it is colored blue, while the remainder of the selectable function icons are white.

7) Rotate the ⊙ Quick Control dial to switch between the selectable functions. Press **SET**.

8) Press **MENU** to exit to the Custom Controls menu. Press **MENU** again to exit to the main Custom Functions menu.

> **Note:**
> The full range of functions assignable to the various buttons is shown in the table on page 134.

Metering and AF start

When an AF point is registered *(see page 70)*, you can switch to it with a single button-push using **AF•ON** or ✱/☐•⌕ , depending on how those two controls are assigned in C.Fn IV-1: Custom Controls *(see pages 132–4)*. The camera can be in any AF mode except automatic 19-point AF. The registered AF point will only be selected while pressure is maintained on the **AF•ON** (or ✱/☐•⌕) button. In Zone AF mode, focusing will switch to the zone containing the registered AF point. To cancel the registered AF point, press the ☐/⌕ button and **ISO•☒** button at the same time.

When **Metering and AF start** is assigned to the **AF•ON** (or ✱/☐ •⌕) button, and switching to the registered AF point is enabled*, you can instantly switch to the registered AF point by holding down that button. If **C.Fn III-12: Orientation linked AF point** is set to **Select different AF points**, you can register two different AF points: one for when the camera is held horizontally, and another for when it is held vertically.

*With **Metering and AF start** selected for the **AF•ON** (or ✱/☐•⌕) button, the setting screen will display **INFO. AF start point**. Press **INFO** and select **Registered AF point**.

› Functions assignable to camera controls

	Function	(shutter)	AF-ON	✱	⚙	LENS	M-Fn	SET	⌇	○	✳	Page
AF	⊙AF Metering and AF start	•	•*	•*	–	•	•	•	•	•	•	56
	AF-OFF AF stop	–	•	•	•	•	–	–	–	–	–	56
	AF↔ Switch to registered AF function	–	–	–	•*	•*	–	–	–	–	–	70
	ONE SHOT AI SERVO One Shot AI Servo	–	–	–	•	•	–	–	–	–	–	56
	⊡ AF point direct selection	–	–	–	–	–	–	–	–	•	•*	59
Exposure	⊙ Metering start	•	–	–	–	–	–	–	–	–	–	76
	✱ AE lock	•	•	•	•	•	•	–	–	–	–	79
	FEL FE lock	–	•	•	–	–	•	–	–	–	–	179
	Tv Shutter speed setting in M mode	–	–	–	–	–	–	–	•	•	–	52
	Av Aperture setting in M mode	–	–	–	–	–	–	–	•	•	–	52
Image	◖ Image quality	–	–	–	–	–	–	•	–	–	–	86
	RAW JPEG One-touch RAW+JPEG	–	–	–	–	–	–	•	–	–	–	87
	✿ Picture Style	–	–	–	–	–	–	•	–	–	–	95
	▶ Image replay	–	–	–	–	–	–	•	–	–	–	103
	⚙ Depth-of-field preview	–	–	–	•	–	–	–	–	–	–	71
Operation	((🖐)) IS start	–	–	–	•	•	–	–	–	–	–	219
	⌀ VF electronic level	–	–	–	–	–	•	–	–	–	–	41
	MENU Menu display	–	–	–	–	–	–	•	–	–	–	84
	Q Quick Control Screen	–	–	–	–	–	–	•	–	–	–	22
	OFF No function (disabled)	–	•	•	–	–	•	–	–	–	•	34

* The AF stop button is provided only on super telephoto IS lenses.

• Selectable

– Not selectable

C.Fn IV-2 Dial direction during Tv/Av

This menu appears to relate only to **Tv** Shutter-priority and **Av** Aperture-priority modes, but this is not the case—it also affects both **P** Program and **M** Manual modes. In addition, isn't clear from the menu screen whether either or both the Main dial and Quick Control dial are affected. To clarify matters, the effects of reversing the direction of the Main dial and Quick Control dial in all four modes are shown in the table below.

The menu title and wording in Canon's instruction manual haven't changed since this function was first introduced, and an update is long overdue.

Main dial

Normal

Tv	Selects a faster shutter speed (and corresponding aperture)
Av	Selects a narrower aperture (and corresponding shutter speed)
P	Selects a faster shutter speed and/or wider aperture
M	Selects a faster shutter speed (without changing the aperture)

Reverse direction

Tv	Selects a slower shutter speed (and corresponding aperture)
Av	Selects a wider aperture (and corresponding shutter speed)
P	Selects a slower shutter speed and/or narrower aperture
M	Selects a slower shutter speed (without changing the aperture)

Quick Control dial ◯

Normal

Tv	Sets positive exposure compensation
Av	Sets positive exposure compensation
P	Sets positive exposure compensation
M	Selects a narrower aperture (without changing the shutter speed)

Reverse direction

Tv	Sets positive exposure compensation
Av	Sets positive exposure compensation
P	Sets positive exposure compensation
M	Selects a wider aperture (without changing the shutter speed)

2

C.Fn IV-3 Add image verification data

This menu enables you to add data to your images that will verify their originality. The Original Data Security Kit OSK-E3 (available separately) is required to verify the data.

C.Fn IV-4 Add aspect ratio information

This function can be used to set one of six different aspect ratios to change the shape of the image. All are applied centrally and crop equally from the sides. Each aspect ratio uses the full image height in landscape orientation. In normal use (not Live View), the two vertical cropping lines

are not shown in the viewfinder, but they are superimposed on the full image area when the image is played back on the LCD monitor. (The vertical aspect ratio lines visible in playback will disappear when you press the 🗑 button to delete an image.)

In Live View operation, the vertical aspect ratio lines are added to the live LCD display and are also superimposed on the whole image area during playback.

The selected aspect ratio will be appended to the image data. The image will not be saved in a cropped format, but will display in Digital Photo Professional (DPP) according to the chosen aspect ratio. In DPP, these images behave in the same way as images that have been trimmed (cropped) within DPP itself. They appear in the Main Window with the full original image area, but with a white cropping frame. However, when opened in the Edit Image window, they display only the cropped area—unless the Trimming tool is used, in which case the full image area is shown with the cropped area visible, but shaded.

Clear all Custom Functions

This function differs from **Clear all camera settings** in Set-up menu 3 *(see page 126)* in that only Custom Function settings will be returned to their default settings when this option is selected.

› Custom Function availability

C.Fn I: Exposure	🗖 LV shooting	🎞 Movie shooting	Page
1 Exposure level increments	•	•	128
2 ISO speed setting increments	•	• (M)	128
3 ISO expansion	•	•	128
4 Bracketing auto cancel	•	–	128
5 Bracketing sequence	•	–	129
6 Safety shift	•	–	129
7 Flash sync. speed in Av mode	•	–	129
C.Fn II: Image			
1 Long exposure noise reduction	•	• (Stills)	130
2 High ISO speed noise reduction	•	• (Stills)	130
3 Highlight tone priority	•	•	131
C.Fn III: Autofocus/Drive			
1 AI Servo tracking sensitivity	–	–	61
2 AI Servo 1st/2nd image priority	–	–	61
3 AI Servo AF tracking method	–	–	62
4 Lens drive when AF impossible	•AF Quick	•AF Quick	67
5 AF Microadjustment	•AF Quick	•AF Quick	68
6 Select AF area selection mode	•AF Quick	•AF Quick	63
7 Manual AF point selection pattern	•AF Quick	•AF Quick	66
8 VF display illumination	–		68
9 Display all AF points	–	–	66
10 Focus display in AI SERVO/MF	–	–	62
11 AF-assist beam firing	•AF Quick	–	67
12 Orientation linked AF point	•AF Quick	•AF Quick	67
13 Mirror lockup	–	–	131
C.Fn IV: Operation/Others			
1 Custom Controls	As set	As set	132
2 Dial direction during Tv/Av	•	• (M)	135
3 Add image verification data	•	• (Stills)	136
4 Add aspect ratio information	•	• (Stills)	136

- • Settings available (in selected mode where indicated)
- - Custom Functions do not function during Live View shooting and/or movie shooting (settings are disabled).

Chapter 3
LIVE VIEW &
MOVIE MODE

3 LIVE VIEW & MOVIE MODE

The EOS 7D's Live View facility and its ability to shoot movies are treated here as two separate shooting modes, though they have a number of features in common. Shooting still images while in 🎥 Movie mode is dealt with in the Shooting movies section on pages 150–7.

Live View was originally devised so that the subject could be viewed on the camera's LCD monitor rather than through the viewfinder, but without the time-lag associated with compact cameras. However, DSLRs are not suitable for holding at arm's length like a compact, and Live View is easiest to use when the camera is mounted on a tripod, in situations where the subject stays still and the camera-to-subject distance remains constant.

On the 7D, Live View menu functions are grouped together in a single menu, 📷 Shooting menu 4. The **Q** Quick Control button, used in normal shooting to display the Quick Control screen, can be used in Live View to amend Auto Lighting Optimizer and image quality settings. Live View shooting 📷 can also take place with

the image displayed on a computer screen and the camera operated remotely using EOS Utility. Refer to the camera manual for full details.

In 🎥 Movie mode, the EOS 7D is capable of shooting full high-definition movies with 1080 vertical pixels. This requires a memory card with a read/write speed of at least 8MB per second.

Warning!

Prolonged use of Live View may lead to high internal camera temperature, which may ultimately cause damage to internal components. If the 🌡 high-temperature warning icon is displayed during shooting, cease using Live View immediately to allow the camera to cool down. If the internal temperature is sufficiently high, the EOS 7D will automatically disable Live View shooting, but only temporarily.

Do not point the camera directly into any light source, especially the sun, when in Live View mode.

» LIVE VIEW FUNCTIONS

› Preparation

1) Set up your subject, tripod, lighting, and camera using only the viewfinder at this stage. This will conserve battery power and prevent unnecessary heat buildup in the camera.

2) Select a shooting mode.

3) Press **MENU**. Rotate the 🎛 Main dial to select 📷 Shooting menu 4.

4) Rotate the ⬭ Quick Control dial to highlight **Live View shoot..** Press **SET**.

5) Rotate the ⬭ Quick Control dial to highlight **Enable**. Press **SET**. The display will revert to 📷 Shooting menu 4.

6) Follow the same procedure to adjust the other settings in 📷 Shooting menu 4 *(see pages 143–9).*

7) Press **MENU** to exit.

› Live View shooting

1) First, prepare for shooting as described above. Next, set the dedicated 📷/🎥 switch to 📷 and press the START STOP button. (The EOS 7D has no 🎥 Movie setting on the Mode dial.) The Live View image will be displayed on the LCD monitor with almost 100% scene coverage.

2) Partially depress the shutter-release button to focus on the key area of the subject. *(See pages 143-7 for more on Live View focus mode options.)*

3) Frame the scene using the image on the camera's LCD monitor. You can use Focus lock with the shutter-release button as normal.

4) Fully depress the shutter-release button. After the image has been reviewed, the LCD monitor returns immediately to Live View operation.

5) Press the START STOP button to cease Live View operation.

Battery capacity

Used as described without flash, the 7D should deliver approximately 230 recorded images at 73°F (23°C). At temperatures approaching freezing, this figure will be reduced to 210–220. A fully charged battery should provide 1½ hours of Live View shooting at 73°F (23°C)—but note the warning on the opposite page.

3

› Using the ISO•⚡️, AF•DRIVE, ⊡•WB, and ✳️ buttons

During Live View shooting, you can use the **ISO•⚡️**, **AF•DRIVE**, **⊡•WB**, and **✳️** buttons to quickly adjust their respective functions (though you cannot change the metering mode with the **⊡•WB** button). Simply press the button to bring up the corresponding setting screen, and rotate the ⚙️ Main dial or ◯ Quick Control dial to change the setting.

› Q Quick Control button

In Live View, the **Q** button gives you direct access to Auto Lighting Optimizer (ALO) and image-quality settings. When **AF Quick** focus mode is selected *(see page 146)*, you can also press **Q** to access AF-point selection and AF-area selection.

Setting ALO or file quality via Q

1) With Live View active, press **Q**. The icons for ALO and the currently selected file quality will be displayed. The last viewed icon will be highlighted in blue. Push the ✳️ Multi-controller in any direction to switch to the other icon.

2) Rotate the ⚙️ Main dial or ◯ Quick Control dial to change the setting of the highlighted icon.

3) Press **Q** to exit and return to Live View shooting.

Man. select.:AF point expansion

Setting AF point/AF area via Q

1) With Live View active and in **AF Quick** mode, press **Q**. All 19 AF points will be displayed on the screen.

2) Push the ✳️ Multi-controller in any direction until one of the AF points is shown in blue.

3) Press the **M-Fn** button repeatedly to scroll through the AF-area options: manual selection of a single AF point, manual selection of an AF zone, or auto selection using 19 AF points.

4) If single AF-point focus is selected, change the AF point by rotating the ⚙️ Main dial to move to a different AF point laterally and/or the ◯ Quick Control dial to move to a different AF point vertically. If Zone AF is selected, a group of adjacent AF points is shown in blue (nine in the center, or four in any other position). Rotate either the ⚙️ Main dial or the ◯ Quick Control dial to change the zone.

5) Press **Q** to exit and return to Live View shooting.

» SHOOTING MENU 4 📷

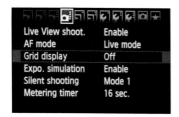

Shooting menu 4 is dedicated to Live View settings. It can be accessed at any time during Live View by pressing **MENU**. Press **MENU** again to exit Shooting menu 4 and return immediately to Live View.

› Live View shooting

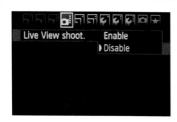

This menu provides a simple choice: to turn Live View on or off. If **Disable** is selected, pressing the 🔲 button will have no effect when its switch is set to 📷 Live View. However, the 🔲 button will still function when the switch is set to 🎥 Movie mode, even if **Disable** has been selected, so movies can still be shot.

› AF mode

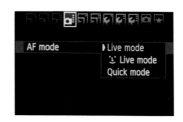

Three AF modes are provided for use with Live View: **AF Quick**, **AF Live**, and 😊 Live Face Detection mode. Although AF is fully functional, Canon still advises manual focusing using a magnified image display for optimum accuracy in Live View.

Tip

*The following pages describe, in detail, the menu system for setting **AF mode** in Live View. However, there is a shortcut. With Live View active, press the **AF•DRIVE** button. An AF/Drive setting screen is displayed. Rotate the 🎛 Main dial to change the AF mode setting. Press **AF•DRIVE** or partially depress the shutter-release button to exit. This quick method of changing the AF mode applies in all Live View AF modes.*

Live mode AF **Live**

Live mode AF **Live** makes use of a movable focusing frame, rather than the AF point array, and has the distinct advantage of allowing the focusing frame to be moved anywhere in the image, except right to the edge of the frame. Operation is slower than with Quick mode, but more flexible in terms of composition.

1) To set Live mode AF **Live** via the menu system, press **MENU** and select ◉ Shooting menu 4.

2) Rotate the ◯ Quick Control dial to highlight **AF mode** and press **SET**.

3) Rotate the ◯ Quick Control dial to select **Live mode** and press **SET**.

4) Press **MENU** to exit and return to Live View. The Live View image will be displayed. A single white rectangle indicates the AF point/focusing frame. (This is vertically oriented to distinguish it from the horizontal magnifying frame in Quick mode.)

5) To move the focusing frame, use the ✲ Multi-controller. Pressing it in will return the focusing frame to the center.

6) Position the focusing frame over the key part of the subject. Partially depress the shutter-release button to focus. When focus is acquired, the white rectangle will turn green and the beep will be heard. If AF proves impossible, the rectangle will turn red.

7) Fully depress the shutter release to take the picture. Unless image review has been disabled in Shooting menu 1, the captured image will be played back with the active AF point displayed in red. After review, the LCD monitor will return to Live View operation.

> ### *Tip*
>
> *In step 6 above, you can press the ⊡/⊕ button to magnify the image x5. The focusing frame will change to a square. Press ⊡/⊕ again to achieve x10 magnification, and a third time to go back to x1. Return the display to normal magnification before shooting.*

Live Face Detection mode AF ☺

Essentially this is the same as Live AF mode, except that the camera is programmed to recognize a forward-looking human face and to focus on that instead of the nearest part of the subject. Successful operation of Live Face Detection mode clearly depends upon the extent to which the whole face is visible, and its relative prominence in the frame. Face detection may also be adversely affected by excessive or poor light levels, or by tilting the camera. The camera may interpret another subject as a face if certain characteristics are present.

1) To set Live Face Detection mode **AF** ☺ via the menu system, press **MENU** and select 🖰 Shooting menu 4.

2) Rotate the ◎ Quick Control dial to highlight **AF mode** and press **SET**.

3) Rotate the ◎ Quick Control dial to select **AF** ☺ Live mode and press **SET**.

4) Press **MENU** to exit and return to Live View. The Live View image will be displayed without any AF point or magnifying frame.

5) Point the camera at the subject. When a single face is detected, the ⌐⌐ focusing frame will appear, centered on the subject's face. The appearance of the ⌐⌐ focusing frame does not indicate that focus is achieved. The size of the ⌐⌐ focusing frame will vary according to the area occupied by the subject.

6) If more than one face is detected, the ⟨ ⟩ focusing frame will be displayed instead. Use the ✵ Multi-controller to move the ⟨ ⟩ focusing frame over the face of the main subject.

7) Partially depress the shutter-release button to focus on the main subject.

> **Note:**
> Image magnification using the ⊞/⊕ button is not available in Live Face Detection mode **AF** ☺.

FACE DETECTION ⌄
Face detection AF works in three stages: detection (white frame), focus confirmation (green frame), and image capture (red frame).

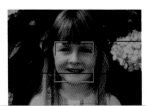

8) When focus is acquired, the AF frame will turn green and the beep will be heard. If focus proves impossible, the AF frame will turn red. If a face cannot be detected, a white rectangular frame will be displayed and the center AF point will be used for focusing instead.

9) Fully depress the shutter-release button to take the picture. Unless image review has been disabled in Shooting menu 1, the captured image will be played back with the AF point displayed in red. After review, the LCD monitor will return to Live View operation.

Quick mode AF**Quick**

In this mode, the AF system will focus in One Shot mode, just as if shooting using the viewfinder in the normal way, and makes use of the normal AF-point array. The Live View image display is briefly interrupted during the AF operation. Press the **Q** Quick Control button to display all 19 AF points—in conjunction with using the **M-Fn** button to toggle through all AF points, single AF point, and AF zone modes—it is possible to choose an AF-point selection method to suit almost any circumstance.

1) To set Quick mode AF**Quick** via the menu system, press **MENU** and select 📷: **Shooting menu 4**.

2) Rotate the ⚪ Quick Control dial to highlight **AF mode** and press **SET**.

3) Rotate the ⚪ Quick Control dial to select AF**Quick** mode and press **SET**.

4) Press **MENU** to exit and return to Live View.

5) To use the **Q** button to set AF-point selection, see **Setting AF point/AF area via Q** on page 142.

6) Aim the camera at the subject, placing the selected AF point(s) over the most important elements of the scene.

7) Partially depress the shutter-release button to focus. The Live View image will be turned off temporarily. You will hear the sound of the reflex mirror, but this is not the shutter being activated.

8) When focus is acquired, the AF point(s) that acquired focus will be displayed in red and the beep will be heard. The Live View image will be restored.

9) Fully depress the shutter release to take the picture. Unless image review has been disabled in Shooting menu 1, the captured image will be played back with the active AF point displayed in red. After review, the LCD monitor will return to Live View operation.

Manual focus

Live View was originally conceived for use with manual focus. For precision focusing, especially with the magnification function, it is still the best option.

1) To use manual focus, set the **AF/MF** switch on the lens to MF.

2) With Live View active and approximate focus already achieved, frame the subject and consider the point on which you want to focus more precisely.

3) Use the ❖ Multi-controller to move the white rectangular magnifying frame to this point. At any time, press the ❖ Multi-controller in to return the magnifying frame to a central position.

4) If necessary, press the ▣/🔍 button to magnify the image x5. The magnifying frame will no longer be shown. Press ▣/🔍 again for x10 magnification, and a third time to return to x1. While the image is magnified, adjust the focus manually to achieve absolute accuracy. Return the display to normal magnification before shooting.

5) Fully depress the shutter release to take the picture. Unless image review has been disabled in Shooting menu 1, the captured image will be played back for the time you have selected. After review, the LCD monitor will return to Live View operation.

› Grid display

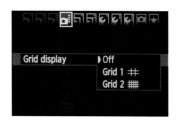

The grid display is off by default. **Grid 1** divides each side of the frame into thirds. **Grid 2** divides the longer side by six and the shorter side by four. Neither grid is displayed when the image is played back.

› Exposure simulation

This function displays an image on the LCD monitor that will simulate the brightness level of the image when it is recorded. If exposure compensation is applied, the image on the LCD monitor is "live" and its brightness level will change accordingly. Note that when **INFO** is pressed to show the Information Display, the histogram will only be shown if **Expo. simulation** is enabled.

3

› Silent shooting

There are two silent shooting modes, plus a **Disable** setting. The default setting is **Mode 1**, which is not silent, but is quieter than normal shooting and also permits continuous shooting at approximately 7 fps with High-speed continuous shooting. No image will be displayed on the monitor while the images are being recorded. If continuous shooting is selected, all images will be recorded using the same exposure as the first shot in the sequence.

In **Mode 2**, only one frame can be exposed at a time, regardless of whether continuous shooting is selected or not. After fully depressing the shutter release to take the photo, maintain full pressure on the shutter release to suspend all other camera activity. When you release pressure sufficiently for the release to return to its halfway position, camera activity will resume and the sound of the reflex mirror will be heard. This enables you to take a single picture with the minimum of

intrusion, before moving to a less intrusive position to allow the reflex mirror to return to its previous position.

When **Disable** is selected, Live View works in the normal way.

Tip

*When using a non-Canon flash unit, select **Disable**.*

Notes:
Silent shooting in Mode 1 or Mode 2 is not possible when using flash. If flash is used, the camera will default to the Disable setting.

If Mode 2 is selected and the remote controller RC-1 or RC-5 is used, the camera will default to Mode 1.

Warning!

If you use any extension tubes or vertical shift on a TS-E lens in Live View, you should disable Silent shooting, since exposure is likely to be inaccurate.

› Metering timer

This function determines how long the current AE lock setting will be retained in the camera's memory. The options range from 4 seconds to 30 minutes.

› Live View Information Display

Pressing **INFO** in Live View operation will toggle between four information displays. The choice between Brightness and RGB histogram depends on which has been set in Playback menu 2.

When **ExpSIM** is displayed, it indicates that the brightness of the Live View image closely resembles that of the image that will be captured. If **ExpSIM** blinks, the image on the screen is not representative of the image that will be captured, but the recorded image will still match the exposure settings you have selected. This discrepancy may be due to excessively dark or bright shooting conditions.

If AF mode is set to **AF** 🙂 or the camera is connected to a TV via an HDMI cable, the electronic level cannot be displayed.

Hints on using Live View

When flash is used, the shutter will sound as if it is firing twice, but only one image will be recorded.

Evaluative metering will always be applied, regardless of the current metering setting.

Auto Lighting Optimizer may make the image too bright. It can be disabled in Shooting menu 2.

Bright light sources may look black on the LCD monitor, but will appear correctly in the recorded image.

If subject lighting changes suddenly and significantly, the image on the monitor may be destabilized for a moment. Wait until the image is stable before shooting.

If the LCD monitor's brightness is set to a higher setting, some chrominance noise may be visible in the displayed image, but will not be apparent in the recorded image.

Battery life when using Live View will be reduced significantly, providing approximately one-third the number of exposures compared with regular camera use.

3 » SHOOTING MOVIES

To shoot movies, push the START/STOP switch to ▶🎥. You can use either auto or manual exposure modes. The ISO speed is set automatically within the range ISO 100–6400 (expandable to 12,800 H); aperture and shutter speed are also selected automatically unless you use **M** Manual shooting mode. Movies can be shot in full high-definition, with 1080 vertical pixels, requiring a memory card with a read/write speed of at least 8MB per second. Files are recorded with the .MOV file extension. In addition, it is possible to capture still images either while shooting movies or playing them back. Movies can also be played back on an HD TV.

Movie clips can be protected or deleted using exactly the same procedures as for still images *(see pages 104–9)*.

> **Note:**
> There are many hints and precautions related to making movies on page 157. Read these thoroughly before you start shooting.

› Shooting movies with auto exposure

Auto exposure can be used to shoot movies in any shooting mode except **M** Manual, and the camera will control the brightness levels to suit the scene being recorded. Unless you switch to **M** Manual mode, the same auto exposure method will always be applied to movie capture, regardless of the auto exposure mode selected on the Mode dial.

1) Use the START/STOP button to switch to ▶🎥. The reflex mirror will be heard flipping up and the live image will be displayed on the LCD monitor.

Warning!

Prolonged movie shooting may lead to high internal camera temperature, which ultimately may cause damage to internal components. If the 🔥 high temperature warning icon is displayed, you should cease shooting movies immediately to allow the camera to cool down. If the internal temperature is sufficiently high, the 7D will automatically stop shooting, but only temporarily.

2) Focus on the subject before you start recording. When you partially depress the shutter-release button, focusing will take place using the currently selected AF mode, unless the lens has been switched to MF. Either manual focusing or AF can be used; with the latter, choose between AF**Live**, AF **⚲**, and AF**Quick** focus modes *(see pages 145-7)*.

3) Press the **START STOP** button to begin recording. (It is not necessary to hold the button down.) During recording, the ● symbol will be displayed in the top right of the LCD screen.

4) To stop recording, press **START STOP** again. For playback, see page 156.

› Shooting movies with Manual exposure

With the Mode dial set to **M** Manual, you can select the shutter speed, aperture, and ISO manually.

1) Use the **START STOP** button to switch to ▷🎬. The reflex mirror will be heard flipping up and the live image will be displayed on the LCD monitor.

2) Set the Mode dial to **M**.

3) To set the shutter speed, rotate the 🎛 Main dial. The available shutter speeds will be determined by the frame rate 🎞**. At 🎞50/🎞60, shutter speeds of 1/60 –1/4000 sec. are possible. At 🎞24/🎞25/🎞30, the slowest shutter speed will be slightly lower, at 1/30 sec.

4) To set the aperture, rotate the ⭘ Quick Control dial. (The dial must be set to ⌐ first.)

5) To set the ISO speed, press the **ISO• 🔲** button and rotate the 🎛 Main dial. Both manual and auto ranges will cover ISO 100–6400 (unless Highlight Tone Priority is selected, when ISO 200 will be the minimum).

6) Focus on the subject before you start recording. When you partially depress the shutter-release button, focusing will take place using the currently selected AF mode, unless the lens has been switched to MF. Either manual focusing or AF can be used; with the latter, choose between AF**Live**, AF **⚲**, and AF**Quick** focus modes *(see pages 145-7)*.

7) Press the **START STOP** button to begin recording. (It is not necessary to hold the button down.) During recording, the ● symbol will be displayed in the top right of the LCD screen.

8) To stop recording, press **START STOP** again. For playback, see page 156.

Tips

If you shoot in Manual mode, the AE lock and exposure compensation functions cannot be used.

With **AWB** *selected, the white balance may change if either the ISO setting or aperture is adjusted during movie shooting.*

Shooting under fluorescent lighting may result in flickering images.

*With **Auto ISO** selected, movies can be recorded as if Aperture-priority shooting mode were in use, using a predetermined aperture and standard exposure.*

Highlight Tone Priority can be set in C.Fn II-3, but the ISO setting range will be limited to ISO 200–6400.

A shutter speed of 1/30–1/125 sec. is recommended for moving subjects. Subject movement will appear smoother at lower shutter speeds.

› Shooting still images in 🎥

While 🎥 Movie mode is selected on the **START STOP** switch, it is still possible to shoot a regular photograph (normally referred to as a "still" image in this context). Still images can be shot at any time, even while recording a movie—in which case the still image will be incorporated into the movie clip and will take up approximately 1 sec. of recording time. Movie recording will continue automatically after the still image has been recorded as a separate file; the image area of the still photograph will include the part of the frame that is normally shaded by a semitransparent mask when recording a movie.

When shooting still images in 🎥, most functions—including Picture Style, exposure compensation, and white balance—will be as set for shooting movies. The exceptions are as follows: image quality will be as currently selected in 📷 Shooting menu 1; shutter speed and aperture will be set automatically unless **M** Manual shooting mode is selected, and will be displayed when the shutter-release button is partially depressed; auto exposure bracketing will not be possible; all drive modes will be available except for self-timer settings; Flash will be disabled.

› Shooting functions ▶🎥

Using the ISO•🔆, AF•DRIVE, ☉•WB, and ⚡ buttons

When ▶🎥 Movie mode is selected, you can use the **ISO•🔆**, **AF•DRIVE**, ☉•WB, and ⚡ buttons to quickly adjust their respective functions (though you cannot change the metering mode with the ☉ •WB button). Simply press the button to bring up the corresponding setting screen, and rotate the 🎛 Main dial or ⊙ Quick Control dial to change the setting.

Quick Control button Q

In ▶🎥 Movie mode, the **Q** button gives you direct access to Auto Lighting Optimizer (ALO), image recording quality for still photos, and movie recording size. When AF Quick focus mode is selected *(see page 147)*, you can also press **Q** to access AF-point selection and AF-area selection.

Setting ALO or file quality via Q

1) With ▶🎥 active, press **Q**. The icons for ALO, still-image file quality and movie recording size will be displayed. The last viewed icon will be highlighted in blue. Push the ❀ Multi-controller in any direction to select a different icon.

2) Rotate the 🎛 Main dial or ⊙ Quick Control dial to change the setting.

3) Press **Q** to exit and return to movie shooting.

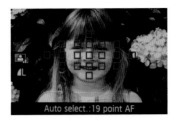

Auto select.:19 point AF

Setting AF point/AF area via Q

1) With ▶🎥 Movie mode active and in AF Quick mode, press **Q**. All 19 AF points will be displayed on the screen.

2) Push the ❀ Multi-controller in any direction until one of the AF points is shown in blue.

3) Press the **M-Fn** button repeatedly to scroll through the AF-area options: manual selection of a single AF point, manual selection of an AF zone, or auto selection using 19 AF points.

4) If Single-point AF is selected, rotate the 🎛 Main dial to move to a different AF point laterally, and/or the ⊙ Quick Control dial to move vertically. If Zone AF is selected, a group of adjacent AF points is shown in blue (nine in the center, or four in any other position). Rotate the 🎛 Main dial or the ⊙ Quick Control dial to change the zone.

5) Press **Q** to exit and return to movie shooting.

3

When is selected using the START STOP switch, the icon for Shooting menu 4 is replaced by when you press **MENU**.

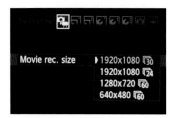

Movie rec. size

Selectable frame rates—in frames per second (fps)—will depend on whether the Video system function in Set-up menu 2 is set to **PAL** or **NTSC**. Movies can be recorded at the following sizes:

PAL

1920 x 1080 Full HD (25 fps or 24 fps)
1280 x 720 HD (50 fps)
640 x 480 (50 fps) Standard with a screen ratio of 4:3. (This option adds a shaded, semitransparent border to the image.)

NTSC

1920 x 1080 Full HD (30 fps or 24 fps)
1280 x 720 HD (60 fps)
640 x 480 (60 fps) Standard with a screen ratio of 4:3. (This option adds a shaded, semitransparent border to the image.)

Note:
The **AF mode, Grid display, Silent shooting**, and **Metering timer** options work in the same way for movie shooting as they do in regular Live View mode (see pages 143–9).

Recording quality

When shooting movies at full HD quality, you are advised to use a large-capacity memory card with a write speed of at least 8MB/sec. A 4GB card will provide approximately 12 minutes of recording time at 1920 x 1280; the same at 1280 x 720; and 24 minutes at 640 x 480. Movie recording stops automatically if a file reaches 4GB in size or exceeds 29 min. 59 sec. in length. A fully charged LP-E6 battery will provide approximately 80 minutes of recording time, but note the warning on page 150.

Tip

The dimensions of movie images when played back will correspond to the proportions of the quality setting selected. The semitransparent mask surrounding the images is a function of playback and will not be included in the recorded movie.

Sound recording

The 7D records in mono, but stereo sound is possible by connecting an external microphone fitted with a 3.5mm stereo jack to the 7D's microphone-in terminal. Recording level is set automatically. The built-in microphone will tend to pick up camera and lens sounds, such as the AF motor. Using an external microphone can reduce or even eliminate such noises.

If the Live View image is displayed on TV while movie recording is taking place, the TV will not play the soundtrack. This does not mean that no sound is being recorded.

› Editing movies in-camera

You can edit a movie clip in-camera by cutting the beginning and the end in one-second increments. This is done via the toolbar at the bottom of the screen.

1) Press the ▶ button and rotate the ⬚ Main dial or ⬚ Quick Control dial to select the movie clip to be edited. The length of the clip will be displayed in the top-left corner of the screen.

2) Press **SET**. A toolbar appears at the bottom of the playback screen.

3) Rotate the ⬚ Quick Control dial to select ✂. Press **SET**. The playback toolbar at the bottom of the screen will change to the editing toolbar.

4) Choose whether to cut the beginning ▨ or the end ▨. Press **SET**.

5) Select the section to be cut by either rotating the ⬚ Quick Control dial to move to the next frame, or by holding down ✳ Multi-controller left/right to fast-forward. The blue bar at the top of the screen shows the time remaining. Before you start to cut, white indicators are visible at both ends of the blue bar. As you set the section to be cut, one of these (depending on whether you are cutting the beginning or the end) will move toward the center of the blue bar. The cut section is shown in gray.

6) Select ▶, then press **SET** to play back the edited section. To edit again, repeat steps 4–5. To cancel the edit, select � and press **SET**.

7) To save the edited movie, select ↱ and press **SET**. You can save it separately as a **New file**, or select **Overwrite** to replace the original file. (If memory card space is too low to accommodate another movie file, only **Overwrite** can be used.) Press **SET**.

Movie playback shares most of the features of normal image playback *(see Chapter 2)*.

However, there are a few differences. At the foot of the playback screen is a toolbar that contains all the functions you need to navigate your movies *(see table below)*. All these functions can be selected using the ◌ Quick Control dial. The ⚙ Main dial adjusts the volume setting (shown in green). Movies cannot be played back in index display mode. The camera can be connected to a TV while recording, though no sound will be emitted during shooting *(see Sound recording, page 155)*. Use of the **INFO** display is not possible while recording connected to a TV. Movies can be played back on HD TVs using an HDMI cable for maximum quality.

The Slide show function can also be used to play back movie clips. Follow the same procedure as outlined on pages 112–3, except that the **Play time** and **Repeat** options do not apply to movies. The Slide show controls are very limited in comparison with using the movie playback toolbar.

Function		Description
↰	Exit	Returns to single-image display.
▶	Play	Pressing **SET** toggles between play and pause.
▮▶	Slow motion	Adjust the slow-motion speed by turning the ◌ Quick Control dial. The slow-motion speed is indicated on the upper right.
◀◀	First frame	Displays the movie's first frame.
◀▮▮	Previous frame	Each time you press **SET**, a single previous frame is displayed. If you hold down **SET**, it will rewind the movie.
▮▮▶	Next frame	Each time you press **SET**, the movie will play frame by frame. If you hold down **SET**, it will fast-forward the movie.
▶▶▮	Last frame	Displays the movie's final frame.
✂	Edit	Displays the editing screen.
▬▬▬▬		Playback position.
	mm' ss"	Playback time.
ıllı	Volume	Adjust the built-in speaker's volume by turning the ⚙ dial.

Hints on shooting movies

Avoid including bright light sources within the frame.

If a memory card with a slow writing speed is used, the monitor may display a five-bar graphic indicating how much data is yet to be recorded to the internal buffer. If this reaches the maximum five bars, movie shooting will be terminated automatically because the buffer cannot cope. You are advised to purchase a faster memory card.

If the remaining capacity of your memory card is insufficient, the movie recording size and time remaining will be displayed in red.

When no memory card is inserted, remaining time will be shown in red.

If the lens attached to the camera has image stabilization switched on (see pages 219–20), it will remain active at all times and affect battery usage adversely. This feature can be switched off if you are using a tripod.

The RC-1 Remote Control or RC-5 Remote Control can be used for movie shooting (depending on the drive mode selected), but the RC-1 should be set to 2-sec. delay. If immediate shooting is selected, a still image will be recorded. The RC-5 only offers a 2-sec. delay.

You can use Canon's ZoomBrowser EX/ImageBrowser software to extract a still image from a movie. This will provide a 2Mp image from the 1920 x 1080 movie setting, 1Mp from 1280 x 720, or 0.3Mp from 640 x 480.

The Silent shooting function (see page 148) will apply when shooting still photographs in Movie mode.

The **AF•ON** button can also be used to focus.

A single continuous movie clip will always be recorded as a single file.

The Electronic Level (see page 40) can be displayed prior to recording by pressing the **INFO** button, but display will cease when recording starts. (The Electronic Level cannot be displayed when the camera is connected via an HDMI cable to a TV, or if **AF ⌣** is selected.)

When recording starts, the time-remaining display will be replaced by the time elapsed.

When ⊞DISP. is shown in white, the image brightness level on the screen will approximate that of the movie that is about to be recorded.

Chapter 4
IN THE FIELD

4 IN THE FIELD

Every photograph is a snapshot in so far as it records a moment in time, usually measured in hundredths, if not thousandths, of a second. But not every photograph is worth a thousand words, as the old adage goes. So what is it that makes the difference?

Leaving technical competence aside for a moment, the most important factors are the intentions of the photographer, and the impact the image has on the viewer. In between those two factors lie the content of the image and its treatment, both of which have to be considered in the light of what *doesn't* take place within the frame as much as what does.

The simplest approach for the more experienced photographer is to visualize what you want to achieve before you even pick up the camera. When the end result is envisaged, the other considerations can fall into place quite quickly. But this is an equally valid approach for the novice: how can you judge your degree of success if you don't know what you were setting out to achieve?

The reference to what doesn't take place within the frame brings us to an aspect of photography that professionals deal with instinctively, but beginners rarely consider. It's important to step back from the scene in front of you and look for distracting elements, whether it's litter in the foreground or someone wearing a bright red coat in the background.

WILHELMINA «
A Ferruginous eagle, native to the USA but bred in captivity in the UK, ready to take flight within the grounds of Mont Orgueil Castle on the British island of Jersey. Falconry events provide a challenging, but rewarding opportunity to get out there and shoot some pictures.

» RECORDING MOTION

Few techniques will test your reflexes, and your understanding of basic photographic principles, more than shooting moving subjects—especially when high speeds are involved. You will also need to develop the ability to predict the best vantage point to capture the action.

Freezing the action

To capture a pin-sharp image of a fast-moving subject, three factors must be considered: a fast shutter speed, a firmly held or supported camera position, and an understanding of what I call "apparent speed." Also, remember that completely freezing the subject isn't always the best approach; a degree of blur often helps to increase the impression of speed.

With the 7D's top speed of 1/8000 sec., it is easy to freeze the action, but you may need to adopt a higher ISO setting in low light. Camera support is a matter of choice, but the single most useful tool for action shots is the monopod, which provides support while allowing mobility.

Now to "apparent speed." Ignore the actual speed of travel at this point: what matters is the speed of movement across the frame. A moving subject that passes at right angles to the camera has the highest apparent speed. A subject approaching head-on seems to move much more slowly. Often, the best compromise is a vantage point that has the subject moving toward you at an angle of around 45°. Compared with a subject crossing at right

PEDAL POWER »
A shutter speed of 1/500 sec. was used to capture this cyclist—fast enough to freeze her movement. But the wheels spin at a faster rate than the cyclist's overall forward speed, so they retain just enough motion blur to add to the impression of movement (inset).

4

angles, you will probably need less than half the shutter speed and can more easily control just the right amount of blur.

Panning

If you stand perfectly still and photograph a fast-moving subject, the likely result is that the subject will be blurred and all the stationary elements of the image will be sharp. Panning the camera to follow the subject can produce the opposite result: the moving object is sharp and the stationary elements are blurred.

The result depends largely on the shutter speed. An extremely fast shutter speed may even freeze the background if you pan slowly. Conversely, a slow shutter speed may create a blurred background and a blurred subject—this can be quite effective if the degree of blur differs

FREEDOM ⌄

When panning the camera, a high enough shutter speed will render both subject and background sharp, especially if there is a good distance between the two.

Tip

Filling the frame with a well-exposed moving subject is one of the hardest aspects of recording motion. Try using a focal length and camera-to-subject distance that will leave the subject a little smaller in the frame, then crop the result later on the computer.

between the subject and the background. The use of flash, especially second-curtain flash, in conjunction with the latter technique can produce very good results.

Blurring for effect

The most popular subject for this technique is undoubtedly water. As with fast-moving subjects, the scale and speed of travel across the frame are the key issues. It is helpful if the water's direction of travel is *across* the frame—the opposite of what we said about fast-moving subjects, because the aim is blur rather than sharpness. To obtain a slow shutter speed in bright conditions, a slow ISO setting and small aperture will be required. In very bright conditions, a neutral-density filter or polarizing filter can also be useful in reducing shutter speed by two stops or more. The precise shutter speeds needed to blur water vary with the situation, but at least half a second is a good rule of thumb.

» COMPOSITION

The term "composition" refers to the relative placement of objects within the frame. Personal preferences and intuition are all-important, but it is always worth learning from other photographers. It is also worthwhile learning from your own mistakes rather than trying to follow a set of rules without knowing why or how those so-called rules work.

Balance

Every photograph includes a number of elements and they all contribute to its overall impact. Balance must be considered in terms of not just shape, but color, density, activity, mood, light, and perspective. Once again, this is a matter of personal preference, but it also has a great deal to do with the dimensions

BOLTON PEEL «⌃
CROSS, UK
These images show two very different treatments of this ancient stone cross, illustrating how easy it is to shoot both restful and dynamic versions of the same subject.

of the final photograph as well as the subject matter and its treatment.

To achieve balance, you must think in terms of the essence of the image. If the picture is highly dynamic, you may want it to have a "busy" feel, which can be achieved with striking angles, vivid color, blurred motion, and lots of detail.

Conversely, if you want a restful image, try to keep it as simple as possible and avoid "hard" shapes, straight lines, and bold colors. A landscape-format image is usually selected for tranquil scenes.

Finally, remember to make use of the entire frame, including the edges and corners. Silhouetted foliage can make an attractive frame when it runs along the top and side edges, and diagonal lines can be made even more dynamic by running them into the frame from the corners.

When it comes down to simple composition, you might think that a completely symmetrical photo has

absolute balance, but symmetry can make a composition seem far too anchored, so use it sparingly. Trust your instincts, don't try to follow set rules, and shoot from a variety of viewpoints. One of the great things about digital photography is that it will cost you nothing to experiment.

Directing the eye

It is generally accepted that the image seen as a whole will dictate the viewer's initial response. After that, there are a number of processes that can be harnessed to direct the viewer's eye to specific points in the image, and to lead the viewer through the image in the way you would like. For instance, the eye will naturally be drawn toward colors that stand out, especially reds and yellows, and along strong lines.

Converging lines are of particular importance. These tend to create triangles, which act as arrows—and, as we have

VALLEY GARDENS, HARROGATE, UK «

The eye is immediately drawn to the red flowers in the foreground, but, for once, I chose to draw the viewer into the scene from the bottom-right corner rather than the left. The eye follows the sweep of the flower bed around a curve and into the center of the picture. The tree running down the left of the frame acts as a "stopper" to prevent attention from wandering out of the image.

noted, a great deal of dynamism is derived from diagonal lines in a composition. These points of convergence also act as "stoppers" that temporarily arrest the viewer's eye movement and cause it to linger on a specific area of the image.

Photographers can also learn from painters in this regard. Western artists tend to paint with light flowing from the upper left, creating an image that is "read" from left to right. There is a school of thought that a person's first written language dictates their reading direction and that this also determines how they read images. If this were true, photography for Chinese or Urdu-speaking audiences, for example, would have quite different requirements, as Chinese writing runs from top to bottom in columns and Urdu is read from right to left. Once again, experiment with different approaches and see what works for you.

Golden rules

The "rule of thirds" is often referred to as one of the essential guides to composition, and it can work very effectively with some, but not all, subject matter.

However, the rule of thirds is actually a very simplistic tool that doesn't begin to compete with the system I will outline here. This system employs a set of principles, many centuries old, that identify certain ratios as being aesthetically pleasing. Examples of these can be found in nature as well as in the works of some of history's greatest artists. These principles gave rise to a series of expressions, including the Golden Ratio, Golden Rectangle, and Golden Mean.

The Golden Ratio has been calculated to the order of 20 million decimal places, but, for the sake of sanity and simplicity, we will call it 1:1.618.

RULES ARE MADE TO BE BROKEN »
This image makes some use of the rule of thirds, particularly for the horizon and the ewes with their lambs in the foreground. But don't be afraid to experiment with composition—there are more than enough sheep around already!

GOLDEN RATIO »

(Top) The sides of a Golden Rectangle are measured in accordance with the Golden Ratio (1:1.618). (Below) These rectangles can be used within the frame to aid composition.

To use the Golden Ratio, we start by constructing a Golden Rectangle (1) with sides that demonstrate a ratio of 1:1.618. We then identify a square at one end of the rectangle (2) with dimensions the same as the height of the original rectangle. If the remainder (3) from that exercise is turned through 90°, it will be seen that its dimensions are exactly proportional to those of the original rectangle. This process can be continued (4) ad infinitum.

The result is a set of rectangles that can be used within the image frame as an aid to composition. The dotted lines in the diagram above represent the thirds, and the continuous lines represent just a few

of the rectangles that can be constructed using the Golden Ratio principles. You can see how many more possibilities this system offers in terms of composition.

As photographers, we generally work with an original rectangle that uses a ratio of 1:1.5, but there is nothing to stop you cropping your images to the proportions of a Golden Rectangle and composing your images with that in mind.

» CARING FOR YOUR CAMERA

Basic camera care

Your camera will perform reliably in a wide range of circumstances, but it is not indestructible and the manufacturer's cautions regarding use and operating conditions should always be adhered to (full details can be found in the camera's manual). While the EOS 7D does not offer the same level of protection as Canon's flagship EOS 1D/1Ds series, which is designed for use by press photographers in all weathers, there are some improvements over earlier models.

Out in the field, water (especially salt water and wind-driven spray; rain is not quite so bad, as it tends to stay in droplet form when landing on the camera), dust, and sand can pose real problems. Keeping any of these from entering the camera via the lens mount is the priority, but you also need to keep dust and sand off the lens elements. Sand will scour the glass if you try to wipe it off, so careful use of a blower or blower-brush is recommended.

A UV filter on the lens provides useful protection and can always be replaced quickly and relatively cheaply.

Avoid dropping the camera, or having it knocked out of your hand in a crowd, by ensuring that you use the camera strap or a wrist strap at all times.

WEATHERSEALING »
This diagram shows the extent of the EOS 7D's protection from the elements.

In cold temperatures

The Canon EOS 7D is designed to operate in temperatures ranging from 32 to 104°F (0 to 40°C) at a maximum of 85% humidity. However, you should pay attention to the effective temperature, allowing for wind chill, rather than the still air temperature. When temperatures drop below freezing and wind speed increases, the effective temperature drops alarmingly. At 32°F (0°C), a wind speed of just 25mph (40km/h) will make it feel like 18°F (-8°C).

Batteries are notorious for their fall-off in performance when the temperature approaches freezing, so keep these inside your clothing when they are not needed. The camera body, too, should be kept as warm as possible while not in use. If you keep it in a camera bag, you can also wrap it in something that will

act as an extra layer of insulation. Signs that the camera is becoming too cold, apart from reduced battery performance, are the darkening of the LCD monitor and sluggishness in moving parts, especially those that are lubricated.

In heat and humidity

Short of dropping your camera into the sea, the worst thing that can happen to it is excessive heat. The recommended maximum working temperature of 104°F (40°C) may seem to cover most situations, but, if you've ever had to climb into a vehicle that has been parked in the sun for a while on a hot day, you'll know that this temperature is easily surpassed. As a result, you should never leave an uninsulated camera in these conditions. You can put it in an insulated coolbox such as those used

SNOWFALL «
The EOS 7D is designed to cope with freezing conditions, but follow a few simple precautions to maintain optimum performance.

for picnics or camping, but don't use the freezer packs that would normally aid the cooling process.

Protecting against humidity requires wrapping the camera in an airtight bag or container, along with a small bag of silica gel. Silica gel absorbs moisture, and a small bag of it usually comes in the box when you buy a new camera or lens—store it somewhere dry until you need it. To reduce condensation, allow your equipment and the bag or container in which it is stored to reach the ambient temperature before removing the equipment.

Water protection

Prevention is better, and usually a whole lot cheaper, than cure. However, there are times when we get caught out by the unexpected, and especially by the weather. It is worth investing in a camera bag that will prove good protection against the elements—Lowepro's AW (All Weather) models have a rain cover that tucks away discreetly when not required. Be extra cautious when working in a marine environment, as spray can be carried huge distances on a windy day. Likewise, the air can be laden with salt for a considerable distance away from the shore.

LIGHTHOUSE ⌃
Salt water is particularly damaging to your camera, so beware of sea spray.

Warning!

Never leave the 7D close to anything that emits a magnetic field or strong radio waves that may affect the camera's electronics or damage data.

4 » A SENSE OF DEPTH

A popular technique in landscape photography is to use a physical feature such as a river, road, or other strong line, to lead the viewer's eye into the picture. This creates a feeling of depth. Another, more subtle, way to do this is to make use of foreground and middle-distance features that are on different planes. Even though planes running parallel across the image can act as "stoppers," in some circumstances they can also create this same sense of depth.

MALTESE HILLSIDE **«**
In this image, depth is created by the distinct foreground, with the tree running the full height of the frame on the right; the receding rough terraces of the middle distance; and the house in the background.

Settings
> Aperture-priority (Av)
> ISO 100
> 1/250 at f/8
> Evaluative metering
> White balance: 5200ºK
> Picture Style: Landscape
> One Shot AF

» ALL-ROUND AWARENESS

If you observe people carrying cameras and see what catches their attention, you will notice that the vast majority of it is at eye level. As a consequence, they may be missing out on a multitude of photographic opportunities. Sometimes, as in this example, there's a photograph waiting just beneath our feet.

COBBLES »
This section of attractive cobbled sidewalk, with tiny, delicate flowers peeking out from between the stones, dates back centuries and was found in a village deep in the English countryside.

Settings
> Aperture-priority (Av)
> ISO 100
> 1/40 at f/22
> Evaluative metering
> White balance: Auto
> One Shot AF

This château in the Loire valley beckons tourists to leap out at the roadside to grab a quick memento of their visit. The first image *(inset, left)* perhaps reflects a typical shot using a digital compact with a wide-angle lens. Moving in closer, the second image *(inset, right)* shows how much of the approach road can be obscured by using a slightly longer focal length and moving closer to the flowers in the foreground, adding a band of bold color to the bottom of the image. However, closer inspection reveals some unsightly scaffolding on the château roof.

With a slight shift of viewpoint, but retaining the same focal length, I obtained a much more pleasing shot *(main image)*. The scaffolding is no longer visible and an overhanging branch completes the framing.

Settings (main image)
> Aperture-priority (Av)
> ISO 100
> 1/1250 sec. at f/4
> Evaluative metering
> White balance: 5200°K
> One Shot AF

FRENCH CHÂTEAU »
After trying a variety of different approaches, I eventually found the image I wanted.

» ABSTRACT

This section of an insect tower—created as a nesting ground for bees, aphids, and the like—was found in a garden I was visiting.

It wasn't constructed on a slant, but I took both level and slanted shots, and this is the version I prefer.

Settings
> Aperture-priority (Av)
> ISO 200
> 1/3200 sec. at f/4
> Evaluative metering
> White balance: Auto
> One Shot AF

INSECT TOWER ≫
We are surrounded by combinations of shape, texture, and color that combine to form interesting abstracts.

Chapter 5
FLASH

5 FLASH

Flash photography has developed to such an extent that it is often imbued with almost magical properties. Magic, say some, is simply the science that other people know, but we don't: the following pages should help to dispel some of the mystery.

The Canon EOS 7D is equipped with a built-in flash that provides a wide enough beam to be used with a 17mm lens and sufficient power to adequately light a subject 10ft (3m) away, assuming ISO 100 at f/4. In other words, it is a very useful tool in compact situations. The coverage is very even, not as harsh as earlier models, and blends well with ambient light. It can be used as the main source of lighting or as fill-in to relieve some of the dark shadows on a sunny day.

The advantages of using the built-in flash compared with using an EX Speedlite come down to weight and convenience. None of the Speedlites is exceptionally heavy, but carrying one still means additional weight, plus an extra set of batteries or a power pack, and possibly more recharging at the end of the day. Both make use of E-TTL II metering, AF-assist beam, red-eye reduction, flash exposure bracketing, flash exposure lock, and first- or second-curtain synchronization. All this means that the main advantages of using a Speedlite are its added power, off-camera capability, and variable output. Knowing these pros and cons means you can decide whether carrying the extra weight of a Speedlite is worthwhile for your purposes.

Canon 430EX II Speedlite

» E-TTL II FLASH EXPOSURE SYSTEM

The third generation of Canon's auto flash exposure system provides almost seamless integration of flash and camera in most situations. The E-TTL designation stands for "evaluative through-the-lens" metering, as opposed to measuring the flash exposure from a sensor within the flashgun. The fact that the exposure is based on what is seen through the lens means that you can position the external flash off-camera, at a different angle to the subject than that of the camera, and still achieve accurate exposure with EX Speedlites.

When the shutter-release button is fully depressed, it signals the Speedlite, assuming it is a recent E-TTL II model, to fire a pre-exposure metering burst to ascertain the correct exposure. The data gathered on the brightness levels of the subject during this initial burst of flash is compared with the data for the same areas of the image under ambient light. The correct flash output and exposure are calculated from these two sets of data. With many EF lenses, this burst will also assess the distance to the subject. The shutter activation and the main flash burst (assuming first-curtain sync is set) follow so quickly on the back of the metering burst that the two are inseparable to the naked eye.

Note:
For E-TTL II-compatible lenses that deliver distance information to help calculate flash exposure more accurately, see individual lens specifications on Canon's web site.

TIFF NEEDELL ⌄
This shot of racing driver Tiff Needell, attentively following the action in the distance, shows how well a built-in flash copes with filling in shadows on a bright sunny day. Note the catchlights in the eyes—these make portraits come alive.

The 7D's built-in unit is a good place to start working with flash. In low-light situations it can provide sufficient output to retain reasonable image quality for subjects up to approximately 20–23ft (6–7m) away (theoretically as much as 128ft/39m at f/3.5 and ISO 12,800), and it is also useful for providing fill-in flash. In Full Auto mode, everything is done for you; in Creative Auto mode, the only options are Auto, Manual (with no control over output), and Off. However, there are numerous ways to fine-tune its performance.

The basic flash functions are outlined in the next few pages. Some of these are explained more fully in the section on Wireless flash *(see pages 193–203)*. You will also find specific information about using flash for close-up photography in Chapter 6, Close-up *(pages 207–8)*.

Built-in flash settings	Aperture	Shutter speed
Bulb (B)	Set manually	Set manually
Manual (M)	Set manually	Set manually in range 30 sec.–1/250 sec.
Program (P)	Set automatically	Set automatically in range 1/60 sec.–1/250 sec.
Shutter-priority (Tv)	Set automatically	Set manually in range 30 sec.–1/250 sec.
Aperture-priority (Av)	Set manually	Set automatically, but in C.Fn I-7 can be set to 0: Auto (30 sec.–1/250 sec.) 1: Auto (1/60 sec.–1/250 sec.) 2: 1/250 sec. (fixed)

› **Red-eye On/Off (📷 Shooting menu 1)**

The phenomenon known as red-eye is encountered when light from the flash is picked up by the blood vessels at the back of the eye. It occurs more frequently when the flash unit is mounted close to the lens axis (as with the built-in flash).

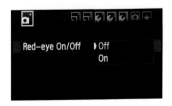

The 7D's red-eye reduction function uses the flash to direct a beam of light at the subject prior to the actual exposure and before the flash fires in the normal way. This beam causes the pupils to narrow so that red-eye is reduced.

When red-eye reduction is enabled and the flash is switched on, the exposure compensation scale 3..2..1..0..1..2..3 at the bottom of the camera viewfinder is temporarily replaced by IIIIII when focus is confirmed. For the most effective red-eye reduction, wait until the display returns to 3..2..1..0..1..2..3 before taking the photograph.

› Flash exposure lock

When part of the subject is critical in terms of exposure, you can take a flash exposure reading of that area of the image and lock it into the camera/flash combination. The following procedure assumes the **M-Fn** button is assigned to its default association of Flash exposure lock (see pages 132–4).

1) Adjust all the appropriate settings and switch on the external flash or raise the built-in flash. Aim the camera at the critical part of the subject. Check that the ⚡ symbol is displayed in the viewfinder.

2) Focus with the center of the viewfinder placed over the most important part of the subject.

3) Press the **M-Fn** button. The flash unit will emit a metering pre-flash and the camera will calculate the correct exposure, committing it to the memory. Each time **M-Fn** is pressed, this process will be repeated and the new reading will replace the existing one.

4) **FEL** is displayed briefly and the ⚡* Flash exposure lock symbol is displayed in the viewfinder.

5) Recompose the shot if necessary and press the shutter-release button.

6) The flash will fire, the picture will be taken, and the ⚡* symbol will be replaced by the ⚡ flash-ready symbol, indicating that no exposure settings are retained. If ⚡ blinks, the subject was beyond the range of the flash; move closer and repeat the procedure.

› Flash exposure bracketing/ compensation

Flash exposure bracketing is not built into the EOS 7D, but can be found on EX Speedlites from the 550EX upward. A less convenient, but equally effective alternative that can be used with the built-in flash is to adjust the flash exposure compensation settings for each of three shots, matching the bracketing process.

FLASH » FLASH FUNCTIONS

THE EXPANDED GUIDE **179**

5

Setting flash exposure compensation

You can use flash exposure compensation with the built-in flash or a compatible external flash, except in Full Auto or Creative Auto modes. It works in exactly the same way as normal exposure compensation, taking three different pictures at up to +/-3 stops, and enables you to control the end result so that the subject has a more natural appearance.

Flash exposure compensation can be set quickly and easily via the LCD top panel (Method 1), via the **Q** button (Method 2), via the Shooting Settings screen and the **ISO•🔆** button (Method 3), or via the menu system (Method 4).

Method 1: Using the LCD top panel

This method will apply when neither the Shooting Settings screen nor the Quick Control screen is displayed on the monitor.

1) Press the **ISO•🔆** button, plus the top LCD panel illumination button 🔅 if necessary. The setting display will only stay on for six seconds ⏱⁶. The setting is shown in both the viewfinder and the LCD top panel.

2) Rotate the ⬭ Quick Control dial to set the amount of flash compensation.

3) Take the picture and review the result, adjusting compensation and repeating the shot if necessary.

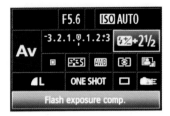

Method 2: Using the Q button

This method will apply when the LCD monitor is active (regardless of whether it is displaying the Shooting Settings screen, Camera Settings display, or Electronic Level), or when the LCD display is blank.

1) Press **Q** to display the Quick Control screen on the LCD monitor. When it is displayed, the most recently used function will be highlighted in green.

2) Use the ✥ Multi-controller to move the highlighting to the flash exposure compensation icon.

3) Rotate the 🗲 Main dial or the ⬭ Quick Control dial in either direction to change the amount of flash compensation. (To view the exposure compensation scale from -3 to +3, press **SET**.)

4) Press the **Q** button or partially depress the shutter-release button to exit.

5) Take the picture and review the result. Adjust the compensation and repeat the shot if necessary.

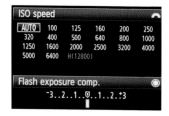

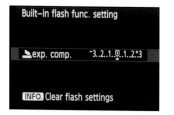

Method 3: Using the Shooting Settings screen

This method will apply when the Shooting Settings screen is displayed and the **Q** button has not been used to change the Shooting Settings screen into the Quick Control screen.

1) With the Shooting Settings screen displayed, press the **ISO•⚡** button.

2) An ISO/flash exposure compensation settings screen will be displayed, with the currently selected settings highlighted in green. Rotate the ⟳ Quick Control dial to change the amount of compensation.

3) Press the **INFO** button to exit.

4) Take the picture and review the result. Adjust the compensation and repeat the shot if necessary.

Method 4: Using the menu system
1) Press **MENU** and rotate the 🎛 Main dial to select 📷 Shooting menu 1.

2) Rotate the ⟳ Quick Control dial to highlight **Flash control**. Press **SET**.

3) For built-in flash: Rotate the ⟳ Quick Control dial to select **Built-in flash func. settings**. Press **SET**. Rotate the ⟳ Quick Control dial to select ⬆ **exp. comp.** and press **SET**. The flash exposure compensation scale will be displayed on its own.

For external flash: Rotate the ⟳ Quick Control dial to select **External flash func. setting**. Press **SET**. Rotate the ⟳ Quick Control dial to select 🔦 **exp. comp.** and press **SET**.

4) Rotate the ⟳ Quick Control dial to adjust the setting. The white indicator will move along the scale, leaving a blue indicator at the default setting of 0. Press **SET**.

5) Press **MENU** to exit to the main Flash control menu *(see page 182)*.

6) Take the picture and review the result. Adjust the compensation and repeat the shot if necessary.

› Flash control (🖻 Shooting menu 1)

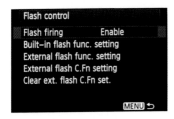

To open the Flash control menu, press **MENU** and rotate the 🗝 Main dial to 🖻 Shooting menu 1. Rotate the ⊙ Quick Control dial to highlight **Flash control** and press **SET**. All the menu options in the table on the opposite page now await you, and are all the more enticing because of the EOS 7D's new wireless flash transmitter. (Note: Do not confuse the wireless transmitter in this context with the wireless *file* transmitter, which is used to transfer recorded images to a computer.)

Not every menu option listed in the table will necessarily be available. The precise functions available for adjustment often depend on settings in other menus, and even on settings that share the same submenu. Other options will be expanded or reduced by your selection of EX Speedlite(s). The permutations that control wireless flash also depend to a large extent on the mix of different EX Speedlite models used—with or without the built-in

flash firing, and even if the built-in flash is always used as the "master"—and the way you organize "slave" units into firing groups *(see page 193)*.

› Flash firing

This simple Enable/Disable option controls both the built-in flash and any external Speedlite(s) you are using. If set to **Disable**, neither will fire, though the AF-assist beam will still function.

The Inverse Square Law

The Inverse Square Law states that as you double the flash-to-subject distance, four times the illumination is required. A one-stop increase in aperture doubles the exposure, so two stops will give four times the exposure. Flash coverage requires an increase of two stops when the camera-to-subject distance doubles.

Flash control menu summary

Flash control menu	Submenu	Option
Flash firing	Enable	
	Disable	
Built-in flash func. setting	Flash mode	E-TTL II
		Manual flash
		MULTI flash
	Shutter sync.	1st curtain
		2nd curtain
		Hi-speed
	E-TTL II	Evaluative
		Average
	Wireless func.	Disable
		⫶◨
		⫶◨(A,B,C)
		⫶◨+⫶◣
		⫶◨:⫶◣
		⫶◨(A,B,C)⫶◣
	Channel	1–4
	Firing group	◨(A+B+C)◣
		◨(A:B)◣
		◨(A:B C)◣
	◨:◣	8:1 to 1:8
	A:B fire ratio	8:1 to 1:8
	Flash exp. comp.	-3 to +3
	◣ exp. comp.	-3 to +3
	◨ exp. comp.	-3 to +3
	A,B exp. comp.	-3 to +3
	Grp. C exp. comp.	-3 to +3
External flash func. setting	Flash mode	E-TTL II
		Manual
	Shutter sync.	1st curtain
		2nd curtain
		Hi-speed
	Flash exp. bracketing	-3 to +3
	◨ exp.comp.	-3 to +3
	E-TTL II	Evaluative
		Average
External flash C.Fn setting	Depends on model of Speedlite	
Clear ext.flash C.Fn setting	Depends on model of Speedlite	

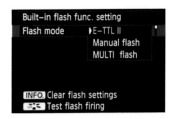

Three settings are available in the Flash mode menu: E-TTL II, Manual flash, and MULTI flash. Note that wireless flash is not possible in MULTI flash mode.

E-TTL II

E-TTL II is the most recent version of Canon's through-the-lens metering system for built-in flash units and EX Speedlites, making use of pre-exposure flash and distance information to determine the correct exposure. Two different settings can be selected: **Evaluative** or **Average**. The former makes full use of Canon's zone-based evaluative metering system and should be considered the norm unless you are very experienced with flash photography. The latter relies on an average reading for the whole scene.

With E-TTL II selected, several submenus are available. The exact combination of features available will depend on the options you have already selected *(see the table on page 183)*.

Manual flash

Manual flash is used to force a flash unit to emit its maximum output, or a selected fraction on a scale between 1/1 and 1/128. This can be useful to control fill lights and can be adjusted in accordance with changes in the distance between fill lights and the subject *(see The Inverse Square Law, page 182)*. However, you will lose all the benefits of Canon's metering system, so either experimentation or the use of a flash exposure meter will be required.

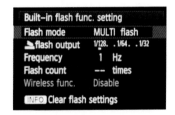

MULTI flash

This mode is for those photographers who want to set the flash output themselves, along with the radio frequency and the number of shots to be fired.

Menu options include **Flash output**, with options down to 1/128 power; **Frequency** from 1 to 199Hz, and **Flash count**, which sets the number of times the flash unit will fire. All three options are adjustable by pressing **SET** and rotating the ○ Quick Control dial.

› Built-in flash func. setting/Shutter sync.

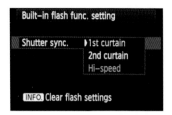

First- and second-curtain sync

A focal-plane shutter works by two shutter curtains moving across the frame. Both move across the focal plane at the same speed, but there is a small gap between them, which is how the sensor is exposed to the image projected by the lens. With a higher shutter speed, the curtains don't move any faster, but the gap between them gets narrower. With an extremely slow shutter speed, the entire frame may be exposed before the second curtain begins to follow the first. This makes it possible to control shutter speeds precisely and reach speeds of up to 1/8000 sec. With the E-TTL flash system, the flash actually fires twice. The first burst is a preflash in the sense that it fires just before the shutter opens, to determine exposure. The second burst is the one that illuminates the subject.

With **1st curtain** synchronization, the illuminating burst occurs as soon as the travel of the first curtain opens the gap between it and the second curtain. This second burst is normally so soon after the metering burst that, to the naked eye, the two are indistinguishable. With **2nd curtain** synchronization, the illuminating burst is fired at the end of the exposure, just before the second curtain catches up with the first. Because there is a longer time lag between metering and illumination, it may be more obvious that the flash has fired twice.

The duration of the flash is extremely short and, like using a fast shutter speed, it has the effect of freezing movement. However, the exposed image is subject to two light sources: flash and the ambient light. If the exposure is long enough for the ambient light levels to record subject detail, the final image will be illuminated by a mixture of flash and ambient light. The subject will be sharp, but there will also be a ghost image that is not, and there may be light trails from moving highlights.

Imagine a subject moving across the frame from left to right. With first-curtain sync, the flash will fire as soon as the shutter opens, freezing the image toward the left of the frame. Any ambient light will continue to expose the subject as it moves across the frame. The end result is a sharp subject with light trails extending into the area into which it is moving. With second-curtain sync, the subject is lit by the ambient light first and then frozen by the flash. This adds to the impression of forward movement and looks much more natural.

Hi-speed sync

Every camera has a maximum flash synchronization speed to ensure that the focal-plane shutter opens in conjunction with the flash exposure. Historically it was often 1/60 sec.; today, 1/200 or 1/250 sec. is the norm. The flash sync speed isn't a problem when taking photographs in the dark, but when using flash to fill in shadows on a bright day, a higher flash sync speed is crucial. One of the advantages of medium-format cameras has always been the predominance of leaf-shutter lenses, which allow higher flash sync speeds than could be achieved with 35mm cameras and their focal-plane shutters.

Current technology means that users of all contemporary EX Speedlites can dial in high-speed flash sync speeds right up to 1/8000 sec. This can be applied in Manual (M), Shutter-priority (Tv), and Aperture-priority (Av) modes. To use high-speed sync in Aperture-priority (Av) mode, you must first set Custom Function I-7 to **Auto**, or the maximum sync speed (in Av mode only) will be set to 1/250 sec. When high-speed sync is enabled, the ⚡H symbol will appear on the Speedlite's display. This symbol will also be displayed in the 7D's viewfinder (but not in the LCD top panel or the Quick Control screen) provided the shutter speed exceeds 1/250 sec.

Hi-speed sync is not possible with the built-in flash and will appear "grayed out" on the menu.

› External flash func. setting

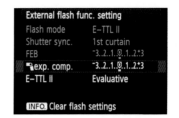

You can set a number of EX Speedlite functions on the camera, rather than on the Speedlite itself, by selecting **External flash func. setting** from the Flash control menu in 📷 Shooting menu 1. The options available will depend on the model of Speedlite you are using; unavailable options are "grayed out."

› External flash C.Fn setting

Depending on the model of EX Speedlite in question, it may be possible to set the Speedlite's Custom Functions on the camera, by selecting **External flash C.Fn setting** instead of **External flash func. setting**. The setting procedure is the same as that for setting the camera's own Custom Functions (see page 127).

› Clear ext. flash C.Fn set.

Use this option to clear the Speedlite's Custom Functions.

» EX SPEEDLITES

Canon's EX Speedlites are fully compatible with E-TTL II metering *(see page 184)*. The Speedlite range runs from the cheapest 220EX to the high-powered 580EX II. The model number is a quick and easy indication of the power of each unit—the 580EX has a Guide Number of 58 (meters at ISO 100), and the 430EX has a Guide Number of 43 (meters at ISO 100), for example. If you are interested in wireless flash photography, check whether the model is capable of acting as a master/slave unit or only as a slave unit.

Guide numbers

There is an easy way to compare the performance of different models of flashgun, and that is to look at their guide numbers (GN). This is a measurement of power that can be applied equally to any flash unit, and measures the maximum distance over which the flash will provide effective coverage. As this distance is dependent upon the sensitivity of the sensor, the measurement is qualified by the addition of an ISO setting. The guide number for Canon's 580EX II Speedlite is 190/58 (ft/m) at ISO 100.

Calculating flash exposure

Aperture also affects flash coverage, but the equations involved in calculating flash exposure are simple enough for us to calculate the third factor involved as long as we have the other two. (In the following examples, the term "flash-to-subject distance" is used because the flash could be used off-camera.)

The basic equation is as follows: *Guide Number / Flash-to-subject distance = Aperture*. This could also be written as *Guide Number / Aperture = Flash-to-subject distance*, or *Flash-to-subject distance x Aperture = Guide Number*. Take the 580EX II as an example, using the maximum flash-to-subject distance: *190 (GN) / 190 ft = Aperture*. We would therefore need an aperture of f/1 to achieve flash coverage. As this is unrealistic, let's take another example using a flash-to-subject distance of *50ft: 190 (GN) / 50ft = f/3.8* (f/4 for practical purposes).

If we know the Guide Number and the aperture we want to use—f/16, for example—but aren't sure of the flash-to-subject distance limitations, we can still calculate this easily: *190 (GN) / f/16 = Flash-to-subject distance*. This would give us an answer of 11.9ft (3.6m) as the maximum distance over which the flash would perform adequately with f/16 as our working aperture.

5

To make life easier, Canon provides zoom heads on some flashguns. These sense the focal length in use and harness the power of the flash more effectively by narrowing (or widening) the flash beam to suit the lens. For this reason, the full Guide Number also refers to the maximum focal length that the zoom head will accommodate automatically. Consequently, the full Guide Number for our example of the 580EX II Speedlite is 190/58 (ft/m) ISO 100 at 105mm. EX Speedlites also display a useful graphic indicating the distance over which flash can be used at current settings.

Attaching an EX Speedlite

With both camera and Speedlite switched off, mount the Speedlite on the camera's hotshoe and tighten the locking mechanism. Turn the camera's power switch to **ON** and switch on the Speedlite. On the camera, adjust the white balance setting to Flash, if this is available in the chosen shooting mode.

› 220EX Speedlite

The 220EX Speedlite is the smallest and least expensive Speedlite in Canon's range. It includes flash exposure lock compatibility and high-speed (FP) synchronization. However, this model cannot be used as a wireless slave unit, and it can't take Canon's external power pack.

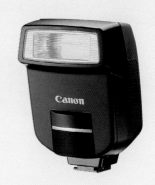

Max. Guide Number 72/22 (ISO 100 ft/m)
Zoom range 28mm fixed
Tilt/swivel No
Recycling time 0.1–4.5 sec.
AF-assist beam Yes
Weight (w/o batteries) 5.6oz (160g)
Master No
Slave No

› 270EX Speedlite

The 270EX Speedlite is the most recent introduction to Canon's range and is compatible with recent models starting with the EOS 50D. Firmware updates permit its use on a range of slightly older models. It has a handy Quick Flash function for use during continuous shooting, and communicates color-temperature information to the camera for optimal white balance correction.

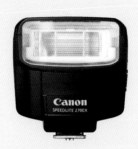

Max. Guide Number 89/27 (ISO 100 ft/m) at 50mm
Zoom range Two-step (fixed) 28mm and 50mm
Tilt/swivel Tilt only
Recycling time 0.1–3.9 sec.
AF-assist beam Yes
Custom Functions/settings 2
Weight (w/o batteries) 5.1 oz (145g)
Master No
Slave No

› 430EX II Speedlite

The 430EX II Speedlite includes flash exposure lock compatibility and high-speed (FP) synchronization. It can be used as a wireless slave unit with the 550EX, 580EX, 580EX II, Speedlite Transmitter ST-E2, Macro Twin Lite MT-24EX, and Macro Ring Lite MR-14EX.

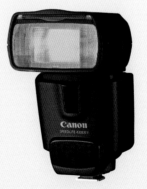

Max. Guide Number 141/43 (ISO 100 ft/m) at 105mm
Zoom range 24–105mm (14mm with wide panel)
Tilt/swivel Yes
Recycling time 0.1–3.7 sec.
AF-assist beam Yes
Custom Functions/settings 6
High-speed sync Yes
Wireless channels 4
Weight (w/o batteries) 11.2oz (320g)
Master No
Slave Yes

› 580EX II Speedlite

The 580EX II Speedlite offers flash exposure lock, high-speed (FP) synchronization, 14 Custom Functions, flash exposure bracketing, automatic or manual zoom head, and strobe facility. It can be used as either a master or slave unit for wireless flash photography. It even provides color-temperature control for optimal white balance and manual settings down to 1/128 power in ⅓-stop increments. To the already popular EX 580, the Mk II version has added weathersealing, 20% faster recycling, a PC socket, and an external metering sensor for non-TTL flash.

Max. Guide Number 190/58 (ISO 100 ft/m) at 105mm
Zoom range 24–105mm (14mm with wide panel)
Tilt/swivel Yes
Recycling time 0.1–6 sec.
AF-assist beam Yes
Custom Functions/settings 14
High-speed sync Yes
Wireless channels 4
Catchlight reflector panel Yes
Weathersealing Yes
Weight (w/o batteries) 13.2oz (375g)
Master Yes
Slave Yes

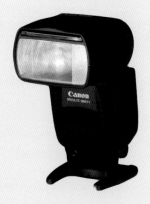

Tip

The Compact Battery Pack CD-E4 improves EX Speedlite recycling times and the number of flashes available. It also permits the fast changeover of CPM-E4 battery magazines.

› MR-14EX Macro Ring Lite

This consists of a control unit, which is mounted on the hotshoe, and a ring-flash unit, which is mounted on the lens. The ring-flash unit has two flash tubes on opposite sides of the lens, and the lighting ratio between them can be adjusted to provide better shadow control. It also has built-in focusing lamps and modeling flash, and is capable of acting as master unit for wireless flash photography. The Ring Lite is designed for close-up photography where a hotshoe-mounted flash would be ineffective due to the short camera-to-subject distance.

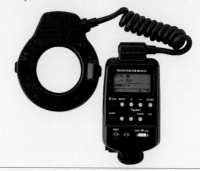

Max. Guide Number 46/14 (ISO 100 ft/m)
Designed for use with EF macro lenses
Tilt/swivel No
Modeling flash Yes
Recycling time 0.1–7 sec.
Weight (w/o batteries) 14.2oz (404g)

› MT-24EX Macro Twin Lite

The Twin Lite consists of a control unit, which is mounted on the camera's hotshoe, plus two small flash heads, which are mounted on either side of the lens and can be adjusted independently. This model offers far more flexibility than the Ring Flash. It has the same wireless capabilities as the Ring Flash and is designed for use with the same EF Macro lenses.

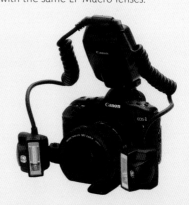

Max. Guide Number 79/24 (ISO 100 ft/m)
 (with both heads firing)
Zoom range N/A
Tilt/swivel Yes
Recycling time 4–7 sec.
Weight (w/o batteries) 35.2oz (998g)

Bounce flash

Direct flash often gives a light that is flat and harsh. To reduce its impact, you can use a diffuser, or bounce the flash off a suitable reflective surface. While there is a small diffuser on the market that will fit a built-in flash, bounce flash remains the preserve of those using EX Speedlites and other compatible flashguns mounted on the hotshoe or used off-camera with the Off-camera Shoe Cord OC-E3.

Depending on the model, if the flashgun is mounted on the camera's hotshoe, bounce flash can be achieved by rotating and tilting the flash head to point at the reflecting surface—which, ideally, should normally be a little above and to one side of the subject. Bounce flash, especially when used with the flashgun off-camera, is a good way of softening both light and shadows—and controlling where they fall.

The concept of bounce flash is that the surface being used to reflect the flash will provide, in effect, a larger and therefore more diffuse light source. This also assumes that it is light enough in tone to perform this purpose and that it won't imbue the subject with a color cast. If the reflecting surface has a matte finish or is darker in tone, it will be less effective because it will absorb some of the light and will require a much wider aperture or shorter flash-to-subject distance to work effectively.

With the bounce flash technique, the flash-to-subject distance includes the distance to the reflecting surface and from that surface to the subject. In addition, about two stops of light are likely to be lost when using this technique, so the flash-to-subject distance will be considerably shorter than would normally be the case for any given aperture.

HARVEST **《**

Direct flash would be too harsh at such a close distance, so the light from a camera-mounted 550EX Speedlite was bounced off the white ceiling.

» WIRELESS FLASH

Canon's wireless flash system retains full E-TTL II compatibility. It requires a master unit to act as the controller, which may or may not have a flash head incorporated into it, plus any number of secondary flash units as slaves. Most of the wireless settings can be controlled direct from the camera's own menu system.

The master unit communicates with its slave units by means of pre-exposure flashes. (In the case of the ST-E2 Speedlite transmitter, these are in the form of infrared flashes, as it does not incorporate a flash head.) These pre-exposure flashes will be evident even if the master unit is disabled (i.e., not used as an actual flashgun in the wireless setup).

It has always been an advantage to use an ST-E2 Speedlite transmitter when shooting handheld with multiple stand-mounted flash units, because the ST-E2 makes for a more lightweight combination than using a 550EX or 580EX Speedlite mounted on the camera as the master unit. Unfortunately, when using ratio control for the different firing groups,

the ST-E2 is restricted to just two firing groups. The EOS 7D's built-in wireless transmitter does not have that problem, and therefore provides an equally lightweight and maneuverable solution, with the added bonus of its ability to use three different firing groups.

Tips

Any number of flash units can be used as slave units, as long as they share the line of sight and transmission range of the master unit. Line of sight, strictly speaking, isn't absolutely necessary when shooting indoors, as reflective surfaces like walls pass on the signals transmitted. However, any diffusers or softboxes that obscure the sensor on the front of a flash unit will prevent vital information being transmitted.

Different models of EX Speedlite can be used simultaneously as slave units, either singly or jointly within the same firing group, provided their slave and channel settings are coordinated.

Only first-curtain flash synchronization is possible when using wireless flash.

Note:
For more specific instructions regarding different models of EX Speedlite, refer to the flash unit's instruction manual.

When using the 7D's wireless flash menus, the key to understanding the relationship between external and built-in flash, and between the different firing group permutations, is the use of symbols and punctuation, specifically the colon (:), the comma (,), brackets, and the plus sign (+). These are used in various combinations to identify the different wireless function arrangements available. Speedlites acting as "slave" units can be allocated to one of three firing groups: A, B, and C. More than one flash unit can be assigned to a firing group.

The ⯀🔦 and 🔦 symbols refer to external Speedlite(s).

The ⯀◣ and ◣ symbols refer to the built-in flash.

Therefore, ◣ **exp. comp.** refers to flash exposure compensation applied only to the built-in flash, and 🔦 **exp. comp.** refers to flash exposure compensation applied to all external Speedlites.

A and **B** and **C** indicate the slave ID allocated to separate flash firing groups. Therefore, **A, B exp. comp.** refers to flash exposure compensation for firing group A and firing group B, and **Grp. C exp. comp.** refers to flash exposure compensation solely for firing group C.

If you have experimented with wireless settings, but are still confused by the many options available, clear all flash settings as shown on page 197 and start again, carefully following the instructions given.

› Preparation and settings

1) Press **MENU** and select 📷 Shooting menu 1.

2) Highlight **Flash control** and press **SET**. The **Flash control** menu is displayed.

Flash control

Flash firing	Enable
Built–in flash func. setting	
External flash func. setting	
External flash C.Fn setting	
Clear ext. flash C.Fn set.	

MENU ↩

3) In the **Flash control** menu, select **Flash firing**. Press **SET** and change the setting to **Enable**. Press **SET**. The display will return to the Flash control menu. *(For details of the* **External flash func. setting**, **External flash C.Fn setting**, *and* **Clear ext. flash C.Fn set.** *options, see page 186.)*

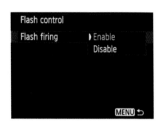

4) In the **Flash control menu**, select **Built-in flash func. setting** and press **SET**. With all flash settings at their default values, the Built-in flash func. setting menu will be as shown. Note that when the flash settings are changed, a complex series of submenus is set into operation.

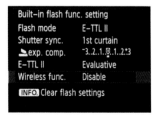

5) In the **Built-in flash func. setting** menu, select **Flash mode** and press **SET**. Select the desired flash mode from E-TTL II, Manual flash, or MULTI flash, and press **SET**. Note that each of the three options has its own submenu. *(For more on the Flash mode menu, see page 184.)*

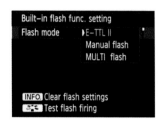

6) The next menu item is **Shutter sync.**. Only **1st curtain** is available when using wireless flash and the other options are "grayed out." (The following menu item, ⬛ **exp. comp.**—exposure compensation for the built-in flash—can be ignored at this stage; when wireless flash has been enabled, other exposure compensation options will present themselves.)

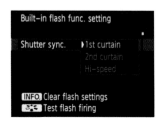

7) If E-TTL II was selected in step 5, select **E-TTL II** from the Built-in flash func. setting menu, and press **SET**. Select either **Evaluative** or **Average** and press **SET**. *(See page 184 for more on evaluative and average E-TTL II metering.)*

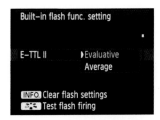

Wireless flash setup

To set up your wireless flash system successfully, you may also need to refer to your EX Speedlite's instruction manual. If you do not have one, they can usually be downloaded in .pdf format from Canon's web site.

1) Raise the built-in flash.

2) Set each Speedlite as a slave unit (this setting must be made on the Speedlite itself).

3) Set the built-in flash and each Speedlite to the same transmission channel (1–4).

4) Set the slave ID for each Speedlite (A, B, or C) if the ratio of one firing group to another will be set.

5) Position camera and subject no more than approximately 33ft (10m) apart.

6) Position all slave units within an 80° arc centered on the camera, within approx. 16ft (5m) of the camera if outdoors, or 23ft (7m) indoors, and so that each slave unit's wireless sensor has line of sight with the camera.

7) In the Built-in flash func. setting menu, select **Wireless func.** and press **SET**. Select one of the wireless function options displayed (other than **Disable**) and press **SET** *(see page 194 for an explanation of the symbols).*

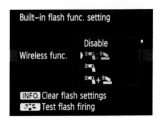

8) Set any necessary flash/firing group ratios, exposure compensation, or flash output adjustments.

9) Fire a test flash to check exposure and light-source balance.

10) Adjust positioning or settings as necessary before taking the picture. Always make a final assessment of your images on the computer rather than on the camera's LCD monitor.

› Clear flash settings

1) Press **MENU** and select ◻ Shooting menu 1.

2) Highlight **Flash control** and press **SET**.

3) Select **Built-in flash func. setting** and press **SET**.

4) Press **INFO** to clear all flash settings. In the resulting dialog box, select **OK** and press **SET**.

» WIRELESS FLASH: REFERENCE

Wireless function settings
≡📷 and ≡📸 **used to indicate wireless function settings only**
Wireless function

≡📷	External Speedlite used wirelessly as slave unit off-camera. Built-in flash acting as master, but not firing.
≡📷 : ≡📸	External Speedlite used wirelessly as slave unit off-camera. Built-in flash both acting as master and firing. The available flash ratio is from 8:1 to 1:1 (from 1:1 to 1:8 is not possible).
≡📷 + ≡📸.	Multiple external Speedlites in two or three groups plus built-in flash firing. Various firing group options, ratio options, flash exposure compensation options.
≡📷 (A,B,C)	Available only when Manual flash is selected.
≡📷 (A,B,C) ≡📸	Available only when Manual flash is selected.

Notes
The symbols ≡📷 and ≡📸 (shown "firing") are only displayed when setting the wireless function.
The symbols 📷 and 📸 are used when setting the firing group, flash ratio, exposure compensation, and flash output.

5

Firing ratios

Ratio A:B	Exposure difference for B
1:8	B emits 3 stops more light
1:4	B emits 2 stops more light
1:2	B emits 1 stop more light
1:1	Same output
2:1	B emits 1 stop less light
4:1	B emits 2 stops less light
8:1	B emits 3 stops less light

Firing group settings

⚑ and ◣ used for firing group, flash ratio, exposure compensation, and flash output

Firing group

⚑ (A:B)	Multiple slave Speedlites in two firing groups, with ratio range of 8:1 to 1:8 possible. Built-in flash acting as master, but not firing.
⚑ (A+B+C)	Multiple slave Speedlites will fire as one group, each with equal flash output. (Individual slave ID is ignored, so can be A or B or C or mixed.) Built-in flash acting as master, but not firing.
⚑ (A:B C)	Multiple external Speedlites in three firing groups, with built-in flash acting as master, but not firing. Flash ratio can be set between Group A and Group B as the combined primary and secondary light sources. Group C is used for lighting background or as backlight, so it is controlled independently by exposure compensation.
⚑ (A:B) ◣	Multiple slave Speedlites in two groups, one group being A shared with firing built-in flash. Ratio between A (including built-in flash) and B can be adjusted.
⚑ (A+B+C) ◣	Multiple slave Speedlites and built-in flash will fire as one group.
⚑ (A:B C) ◣	Multiple external Speedlites in three firing groups, with built-in flash being in Group A and firing. Flash ratio can be set between Group A and Group B as the combined primary and secondary light sources. Group C is used for lighting background or as backlight, so it is controlled independently by exposure compensation.

› Manual wireless function settings

When Manual flash mode is selected in step 5 on page 195, two additional wireless function choices are available: 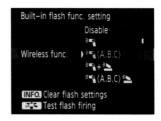 (A,B,C) and (A,B,C).

In Manual flash mode, the choice of setting for the wireless function determines the different permutations of flash output control that can be exercised, as shown in the table below.

Flash output	Manually set flash output can be set from 1/1 to 1/128 in ⅓-stop increments
▼	Flash output set manually is applied to all external Speedlites.
▼ (A,B,C)	Flash output set manually for each firing group.
▼ + ▲	Flash output set manually for each external Speedlite and built-in flash.
▼ (A,B,C) ▲	Flash output set manually for each separate firing group and also for built-in flash.

In the last example, four different flash output scales will be available in the menu, covering Groups A, B, and C, plus another scale for the built-in flash. Given that each scale extends by ⅓-stop increments from 1/1 down to 1/128, there is a total of 21 different settings for each of three firing groups (any one of which can contain multiple Speedlites), plus the built-in flash. This is why studio photographers favor Manual flash for absolute control.

Tip

When you are familiar with using multiple flash units, you may wish to experiment with attachments that can fine-tune the nature and direction of the light provided by individual flash units. For example, you can easily make a snoot from a piece of card—this will narrow the flash beam to create a spotlight effect.

5 » WIRELESS FLASH: FIRING GROUPS

› Wireless flash with two firing groups

Example 1

In the firing group shown in the diagram below, just one EX Speedlite is used off-camera, with a reflector to help fill in shadows on the opposite side of the subject. The maximum wireless range is around 23ft (7m) indoors or 16ft (5m) outdoors, from master to slave. Slave B should be positioned no more than 40° to the side of the camera. The built-in flash is used as a fill light to soften the shadows, and the EX Speedlite as the main light source. In this case, the ratio of A:B might be 1:4, with the built-in flash providing two stops less light—but, to achieve the desired results, experimentation may be necessary with the flash ratio, the distance between the reflector and the subject, and the reflector's angle relative to both the subject and the flash heads. More than one reflector could be used.

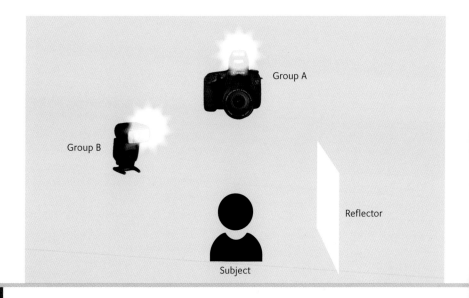

Group A

Group B

Reflector

Subject

Example 2

In this example, two EX Speedlites are used off-camera. Both are designated as being in firing group B, and each should be positioned no more than 40° to the side of the camera. The maximum wireless range is around 23ft (7m) indoors or 16ft (5m) outdoors, from master to slave.

As both EX Speedlites are in the same firing group, they will emit the same amount of light relative to one another—unless you have set each unit's output to Manual, in which case both will emit the maximum possible light or a selected fraction thereof (depending on the model). If this is the case, it may be

necessary to adjust the flash-to-subject distance with each EX Speedlite to obtain the correct balance.

Even though three flash heads will fire, the ratio will still be set to A:B, as both EX Speedlites are in group B. In this example, the main problem is likely to be shadows cast behind the subject, though these could be softened by positioning both EX Speedlites so that they illuminate both background and subject. Much depends on whether or not you decide to make the built-in flash the main light, as this will determine the output of the two EX Speedlites relative to it.

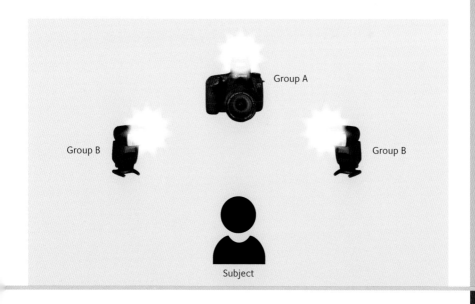

Group A

Group B

Group B

Subject

Example 3

Here, two EX Speedlites are used off-camera, as in Example 2. However, each Speedlite is designated as being in a different firing group, B and C. This increases the degree of flexibility.

Range limits and positioning in relation to the camera are the same as in Examples 1 and 2. The minimum A+B:C ratio possible is 3:1 (see Example 4), so, with this setup,

group C will always provide quite strong lighting. This makes it unsuitable for some situations; in particular, strong shadows will be thrown behind the subject, so the subject will need to be well away from any background. (Note: there is no menu selection for A+B:C. Instead, you select an A:B ratio and separately set C to +/-3 stops relative to the combined A+B output.)

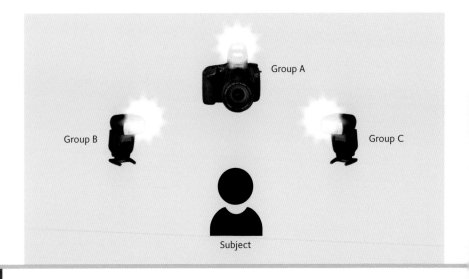

Example 4

An additional EX Speedlite has been added to light the background. Range limits and positioning in relation to the camera are the same as in Examples 1 and 2, though the additional EX Speedlite shown near the subject could be much farther away, while still remaining within the necessary 80° arc centered on the camera.

The EX Speedlite on the left has been deemed to be the main light source and has been assigned to group B. The camera's built-in flash is assigned by default to group A and will act as a fill light. However, the EX Speedlite on the right will also act as a fill light and has also been assigned to group A. An A:B ratio of 1:4, for

example, can now be set, with group B providing two stops more light than the combination of the built-in flash and the EX Speedlite on the right.

The final EX Speedlite is used to light the background and needs to be treated independently. This is done by assigning it to group C and changing the ratio setting to A:B C. Group C's flash output has a separate set of controls, including a +/-3-stop exposure compensation scale relative to the combined flash outputs of all group A and group B flash units. In this way, the background illumination can be adjusted without any impact on the main lighting situation at all.

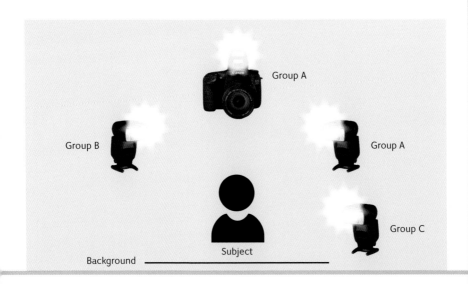

Group A

Group B

Group A

Group C

Background

Subject

Chapter 6
CLOSE-UP

6 CLOSE-UP

The revealing world of close-up photography is both fascinating and rewarding, and is available to all photographers with the minimum of additional equipment. What it does require, however, is great attention to technique and rock-solid camera support. The high magnifications involved mean that a slight error in focusing or the smallest camera movement will be immediately noticeable.

Lighting and depth of field are of the greatest importance in close-up photography. The latter is easily dealt with by choosing a very narrow aperture, and for this reason, purpose-built macro lenses often have a narrower aperture than usual, perhaps f/32 or f/45 rather than f/22. As well as making the use of depth-of-field preview more difficult, apertures like these require even slower shutter speeds, which means that lack of camera movement is even more crucial. This is one of the reasons why so much extreme close-up photography requires flash.

Another feature associated with very small apertures is the loss of resolution owing to diffraction.

CRYSTAL «
A simple close-up using off-camera flash in Live View mode.

» LIGHTING FOR CLOSE-UPS

Lighting is one of the most difficult aspects of extreme close-up work. The very narrow apertures and slow shutter speeds necessary cannot be overcome by using a high ISO speed without sacrificing quality, so diffuse ambient lighting is often not sufficient—unless you are working outdoors, when the additional problem of wind has to be considered.

Flash might seem the obvious solution, but it has its own problems. To start with, a flashgun mounted on the camera's hotshoe cannot be tilted down sufficiently to illuminate the subject at close proximity.

Off-camera flash
The starting point, then, for lighting close-ups is off-camera flash. With Canon cameras prior to the EOS 7D, this has required the 2ft (60cm) Off-camera Shoe Cord OC-E3, which retains all E-TTL II features. This is still necessary when using some flash units with the EOS 7D, but the camera's new built-in wireless transmitter renders the shoe cord redundant when using EX Speedlites that have a wireless slave feature. This gives you far greater flexibility in the positioning of flash units.

When using the Off-camera Shoe Cord OC-E3 with multiple EX Speedlites, the flash connected to the camera can act as the master unit (assuming the model in question has this facility), while additional

EX Speedlites that have a slave function can be triggered wirelessly at the same time. The difference when using the EOS 7D's built-in wireless transmitter is that the camera's built-in flash acts as the master unit, though it can also be prevented from firing while continuing to carry out that function. This also means that there is no need for a flash unit with the master function, provided the multiple EX Speedlites each have the slave feature.

Another benefit of the built-in wireless transmitter is that it is no longer necessary to have the master unit as close to the subject as with the Off-camera Shoe Cord, which usually requires diffusion of the rather harsh light at such short distances.

The two simplest ways to diffuse light from the flash are either to bounce the light off a white or near-white surface such as a sheet of white card or a Lastolite reflector, or to put translucent material between the flash and the subject. The oldest trick in the book is to drape a white handkerchief over the flash head.

This raises the issue of the size of the light source. One reason why bounce flash is so effective is that the effective size of the light source has been increased dramatically. If you bounce the light off a standard Lastolite reflector, you have a light source 38in (0.95m) in diameter, rather just than a couple of inches.

The best inexpensive solution for photographing small objects with just one off-camera flash is some form of light tent or light cube. Lastolite's ePhotomaker, originally designed to help people photograph items for sale on eBay, is a small light tent with one internal side consisting of reflective material and the rest being translucent white material, which acts as both diffuser and reflector.

By mounting the off-camera flash outside the ePhotomaker on the opposite side to the reflective material, a good balance of light and shadow can be achieved quickly and easily. All the product shots in this book were taken using this technique, with a 580EX Speedlite and a shoe cord, and sometimes with a 550EX as a wireless slave unit. A specially made Lastolite ePhotomaker with a black base and rear panel was used for some shots.

Ring flash

For maximum control of shadows, two or more flash heads are better than one. A possible solution in the field is to use a ring-flash unit, which has two small flash heads within a circular reflector that fits on the front of the lens with the flash heads on opposite sides of the lens.

However, this brings us back to the problem of the harsh effects of direct flash, and ring flash can also produce small doughnut-shaped reflections in shiny surfaces. Ring flash is best reserved for matte subjects, and for shooting flowers and similar subjects outdoors. As well as Canon's MR-14EX Macro Ring Lite (see page 191), a similar, but less expensive model is produced by Sigma. The ratio of one flash to the other can be adjusted for better three-dimensional modeling.

Canon also manufactures a very expensive lens-mounted two-head unit, the MT-24EX Macro Twin Lite. This consists of a control unit that mounts on the hotshoe and has two independently adjustable heads (see page 191). There are also many flash rigs that enable you to place two separate flash heads in a similar configuration using either wired or wireless flash. Remember that a wireless setup is necessary for full E-TTL II compatibility, and this is the most flexible choice when working in controlled conditions indoors.

Live View

Because depth of field is so limited in close-up photography, it is often impossible to get the whole of the subject, from front to back, in acceptably sharp focus. Subjective decisions may need to be made about which parts of the subject need to be in sharp focus and which can be sacrificed. This means that there are great advantages to be had from adopting manual focus for the task. This is where the Live View feature comes into its own.

With Live View, you have the advantage of a large image on the camera's monitor that can be used to check depth of field, with the x5 or x10 magnification function for checking focus in detail. The small white rectangle on the monitor shows the area currently selected for magnification; the grid lines are useful for lining up the camera, but can also be disabled. For more information on Live View, see Chapter 3.

» WORKING DISTANCE

The nature of the subjects you plan to photograph will play a large part in determining the working distance between the camera and subject, which in itself will help to determine the focal length(s) of the lens you use. Inanimate objects can be photographed from mere inches away, whereas live subjects will require a greater distance. If you plan to photograph live subjects that are camera-shy or dangerous, you should opt for a longer focal length to increase the working distance.

Because the camera's sensor is only 22.3 x 14.9mm in size, any lens that is designed for use on a full-frame camera will have its field of view cropped by a factor of 1.6. This means that you can fill the frame from slightly farther away than would be the case with a 35mm or full-frame camera body. This is useful if you plan to use extension tubes on a conventional lens. Extension tubes bring the front element of the lens closer to the subject *(see page 211)*.

GATHERING NECTAR
Your working distance needs to be great enough not to frighten away your subject. Bees are usually so engrossed in collecting nectar that you can get extremely close. A ring flash was used for this shot.

6 » CLOSE-UP ATTACHMENT LENSES

Close-up attachment lenses are one of the easiest routes into close-up photography and screw onto the lens thread just like filters. If you are not planning significant enlargements of your photos, they are good value and can produce great results.

They are best used with prime lenses, such as a 50mm standard lens or a moderate wide-angle with close focusing capability, and work by reducing the minimum focusing distance even farther. Magnification is measured in diopters, generally +1, +2, +3, or +4, and their great advantage for the novice is that all the camera functions are retained. They can also be fitted to some of the so-called macro lenses that offer less than life-size magnification (see page 213).

Close-up attachments can be used two or more at a time—combining a +2 with a +3 attachment to obtain +5 diopters, for example. However, the optical quality will not be of the same standard as your lens, and using two or more attachments will reduce image quality more noticeably. This is another reason to use prime (fixed focal length) lenses—their image quality, despite many advances in zoom lens technology, still tends to be better.

There are some very inexpensive close-up attachment lenses on the market, but as with filters, you will have to pay more for better quality. Canon produces both 2-diopter (Type 500D) and 4-diopter (Type 250D) lenses in both 52mm and 55mm fittings, plus a 2-diopter (Type 500D) lens in both 72mm and 77mm fittings. All are double-element construction for higher quality. The Type number indicates the greatest possible lens-subject distance in millimeters. The 250D is optimized for use with lenses between 50mm and 135mm; the 500D is designed for lenses between 75mm and 300mm.

ISOLATE THE SUBJECT «
One of the easiest ways to make your subject stand out is to isolate it against a plain or diffuse background.

» EXTENSION TUBES

Extension tubes fit between the lens and the camera body, and can be used singly or in combination. Canon produces two: Extension Tube EF 12 II and Extension Tube EF 25 II. The former provides 12mm of extension, and the latter 25mm. By increasing the distance from the lens to the lens mount and thus the focal plane, the minimum focusing distance and the magnification of the image are both increased. Both of Canon's extension tubes retain autofocus capability. They are compatible with most EF and EF-S lenses.

EXTENSION TUBES ☆
Canon extension tubes EF 12 II and EF 25 II.

» BELLOWS

Bellows work on the same principles as extension tubes, but are much more flexible. The basic concept is simplicity itself—a concertina-style lightproof tube mounted on a base that allows minute adjustment. This facilitates better control over the magnification ratio and focusing. Their greatest benefit is that bellows do not employ any glass elements at all and consequently can be used to deliver maximum image quality. The downside is that there is a significant loss of light, resulting in a darker viewfinder image.

Canon no longer produces bellows, but alternatives are available from independent manufacturers, notably Balpro/Novoflex, whose range includes the expensive, but highly versatile tilt-and-shift bellows *(see page 212)*. It is also still possible to find mint-condition examples of Canon's FD bellows, which can be mounted on an EOS body using an adapter.

Canon used to make two such adapters. The first incorporated a lens element to permit focusing to infinity, and was manufactured so that professionals could mount their often extensive range of FD lenses onto EOS bodies when the range was first launched. The second adapter had no such lens element, but could be used for macro work. The former adapter can still occasionally be found for sale, but the latter is now quite rare.

6

The British company SRB-Griturn (www. srb-griturn.com) can provide its own version of either adapter. Autofocus is lost, but metering is still possible. The sharp end of the bellows can be used with FD lenses, or with any brand of lens if reversed. Enlarger lenses, especially reversed, are popular with macro enthusiasts when using a bellows setup. SRB also manufacture adapters for mounting different lenses on the front of a set of bellows, and can manufacture adapters to order.

BALPRO TILT & SHIFT BELLOWS ⌃
The ultimate close-up accessory, this set of bellows features tilt and shift adjustments for maximum control of perspective and depth of field. Metering is still possible with the appropriate adapter.

CANON FD BELLOWS ⌃
Although discontinued, this bellows can still be found regularly in internet auctions.

» REVERSE ADAPTERS

Another simple solution for close-up work involves the use of a reverse adapter, which allows you to mount your lens back-to-front on the camera to increase the possible magnification. The wider the normal focal length of the lens, the greater the magnification will be. (The same is also true when using reversed enlarging lenses with bellows or extension tubes.) With this method, there is no loss of light reaching the sensor. However, as the lens contacts are now at the front of the lens, all the information they normally transmit will no longer be usable unless you use an adapter that is specially designed to transmit that information. One such adapter is produced by Novoflex.

» MACRO LENSES

There are three types of lens that tend to be sold as macro lenses. The first is a specialized lens designed for extremely high magnifications, such as Canon's MP-E65 f/2.8 Macro lens, which has a maximum magnification of an astonishing 5x life-size. The second is a purpose-built conventional macro lens with a maximum reproduction ratio of 1:1, though half life-size is now commonly accepted in this category. These are excellent lenses for everyday use too, often giving crisp and contrasty results in everyday situations. Finally, there are those lenses that boast what they refer to as a "macro setting," which may offer a magnification ratio of up to perhaps 1:3, or one-third life-size.

For close-up photography in general, a dedicated fixed-focal length macro lens is the ideal choice and provides excellent image quality at close focusing distances. Canon manufactures several such lenses.

There are two with shorter focal lengths: the full-frame, but only half life-size EF 50mm f/2.5, which lacks the faster and quieter Ultra Sonic Motor, and the 1:1 true macro EF-S 60mm f/2.8 USM. The 50mm version can achieve 1:1 magnification with the addition of extension tubes or by using the dedicated four-element Life-size Converter. The EF 12 II and EF 25 II extension tubes are also compatible with the 60mm lens to achieve

MP-E65 f/2.8 MACRO LENS ⌃
This Canon lens offers up to 5x magnification without using bellows.

magnifications even greater than life-size. The 60mm lens is the first true macro lens in the EF-S range, designed specifically for digital photography with APS-C sensors, and will focus as close as 8in (20cm).

Two longer close-up lenses are also available from Canon, allowing greater working distances. The longer of the two is the EF 180mm f/3.5L Macro USM. The other, the EF 100mm f/2.8 Macro USM, is still available, but has been superseded by an L-series version with the same focal length and maximum aperture. This lens also sports Image Stabilization.

The 180mm and both versions of the 100mm all provide reproduction ratios of 1:1 and, like Canon's two other conventional macro lenses, have a minimum aperture of f/32. The 180mm and newer 100mm are L-series lenses, with all the build quality you'd expect from that range, though the 180mm version does weigh in at over two pounds (1kg).

SELECTIVE VISION ⌃

Close-up photography is all about your ability to see things more selectively, and to visualize your subject when isolated from its surroundings. Often the subject may be nothing more than a single leaf surrounded by interesting shapes, as in this image. It is the way you arrange the elements of the image that makes it come alive.

Settings
> Aperture-priority (Av)
> ISO 100
> 1/200 sec. at f/5.6
> Evaluative metering
> White balance: 5200ºK
> Picture Style: Landscape
> One Shot AF

Settings
> Aperture-priority (Av)
> ISO 100
> 1/160 sec. at f/6.3
> Evaluative metering
> White balance: 5200°K
> One Shot AF
> Picture Style: Landscape

CONTRE JOUR ☆
In the usual scheme of things, shooting against the light (often known by the French expression *contre jour*) can cause problems with flare and contrast. However, it is a technique that suits close-up photography, allowing you to home in on translucent detail.

Chapter 7
LENSES

7 LENSES

One of the main reasons why photographers choose a manufacturer like Canon is the extensive range of lenses and other accessories available. At the time of writing, Canon offers no fewer than 70 lenses, including specialized items such as tilt-and-shift lenses.

» LENS TYPES

Canon's range includes EF lenses, which fit all EOS cameras; EF-S lenses, which have a smaller image circle and are optimized for APS-C digital bodies; and the renowned L-series lenses, with their rugged design, weatherproofing, and high optical quality. All three feature ultrasonic (USM) motors on most lenses, and Image Stabilization (IS) is slowly being added lens by lens.

EF lenses

This is Canon's standard range. It stretches from a 15mm fisheye up to 400mm and includes the macro lenses, with the exception of the 180mm and 100mm L-series. It also includes two of the four

tilt-and-shift lenses (manual-focus only), and the 1.4x and 2x teleconverters. Zooms range from 16–35mm to 100–400mm. Some EF lenses, such as the EF 70-300mm f/4–5.6 IS USM, use some of the same low-dispersion glass as the L-series and represent excellent value for money.

EF-S lenses

The EF-S lens series was developed to accompany the smaller body of the Digital Rebel/300D and subsequent Rebel models, and the lenses are consequently very light in weight. The "S" designation identifies them as having shorter back focus, a smaller image circle, a specific mount not compatible with a standard EF mount, and a difference in build quality to reduce weight. The EF-S mount was included in addition to the EF mount on the EOS 20D, a feature retained for subsequent updates. The only prime lens in this series is the EF-S 60mm f/2.8 macro. At first, only wide–standard zooms were on offer, but these are now complemented by the superwide 10–22mm and more extensive 55–200mm models.

L-series lenses

These are the cream of the lineup. The L-series prime lenses stretch from 14mm f/2.8 to 800mm. This range includes all the super-fast Canon lenses, such as the 24mm f/1.4, 35mm f/1.4, 50mm f/1.2, 85mm f/1.2, and 200mm f/2. The build quality of the L-series is superb, and later lenses have a rubber skirt on the mount to improve weather- and dustproofing. Longer focal lengths and extended zooms are off-white

in color, allowing the world to see the extent to which Canon is dominant in the fields of news and sports photography. The rest of the lineup has a black finish with a telltale red line.

» IMAGE STABILIZATION (IS)

In 1995, Canon introduced an IS lens design that revolutionized low-light photography: the 75–300mm IS was the world's first interchangeable SLR lens to compensate for camera shake. There are now over 20 IS lenses in the lineup.

Canon's IS system uses tiny gyro sensors to detect lens vibration. They send signals to a microcomputer, which controls a shifting lens group that can compensate

for vertical and lateral movement. With the 200mm f/2 L-series lens, it is possible to shoot at speeds up to five stops slower than would previously have been possible, without loss of image quality, and four-stop IS is now the norm.

To facilitate panning when shooting action, some IS lenses have a second IS setting that disregards lateral movement. While IS lenses are more costly than their non-IS counterparts, the price differential is nowhere near as great as when purchasing very fast lenses.

EF 200mm f/2 L IS «

A sports photographer's dream, this lens has a very fast maximum aperture of f/2 plus a groundbreaking five-stop image stabilizer.

As this book was nearing completion, Canon introduced a new Hybrid IS system on the 100mm f/2.8L Macro lens, which also compensates for rotational movement using a new algorithm that analyzes the combined output from two different sensors—one an angular velocity sensor, the other a completely new acceleration sensor. Low-friction ceramic bearings support the moving elements, providing smooth compensation when camera shake is detected.

» FOCAL LENGTH AND ANGLE OF VIEW

Focal length

When parallel rays of light strike a lens that is focused at infinity, they converge on a single point known as the focal point. The focal length of the lens is defined as the distance from the middle of that lens to the focal point. Photographic lenses are a little more complicated because the lens is comprised of multiple elements, but the principle holds good and the measurement is taken from the effective optical center of the lens group. The focal point is referred to in photography as the "focal plane," and this is the plane on which the sensor lies. Focal length is an absolute characteristic of any lens; it can be measured and replicated in laboratory conditions. The focal length of a lens always remains the same, irrespective of any other factor, such as the type of camera it is mounted on.

Crop factor

This term refers to the digital multiplier that must be used with cameras that have a "less than full-frame" sensor when making comparisons with 35mm/full-frame sensor cameras. The crop factor refers only to the field of view that the sensor covers. Technically speaking, the term should not be applied to the focal length of a lens used with the smaller sensor. Remember, a 300mm lens is always a 300mm lens, no matter what type of camera it is used on.

Field of view

In photographic terms, the field of view of a lens is the arc through which objects are recorded on the sensor (or film). This arc of coverage is measured in degrees (°). Although the image

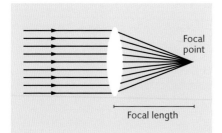

Focal point

Focal length

projected by the lens is circular, we are only really concerned with the usable rectangle within that circle *(see page 33)*, and consequently the field of view of a camera lens is quoted using three figures: horizontal field of view, vertical field of view, and diagonal field of view. If only one figure is quoted, it is generally assumed to be the diagonal field of view.

The field of view of a lens is not an absolute measurement and depends on two factors: the focal length of the lens and the area of the sensor or film that is to record the image.

As the focal length of a lens is fixed, the angle of view should be quoted alongside the image area it is intended for, but unfortunately this practice is not followed by lens manufacturers. Lenses continue to be marketed using the focal-length designation that would be applied to a full-frame (36mm x 24mm) sensor or 35mm film. One reason for this is that lenses designed to fill full-frame sensors can be used on a smaller format too, so at least three sets of figures would need to be given for Canon lenses alone.

Another reason is that different camera manufacturers make their sensors in different sizes, so the angle of view for, say, a 24mm Nikon lens is not exactly the same as that for a 24mm Canon lens when used on their respective "less than full-frame" cameras.

Focal length comparison

When the focal length is doubled, the area covered is one quarter of the previous area. The image below was captured using a lens with a focal length of 20mm. If 40mm (i.e., double the focal length) had been used, the image area would have been that shown by the larger dotted rectangle. Similarly, had an 80mm focal length lens been used, the image area covered would have been that shown by the smaller dotted rectangle. The solid rectangle in the center appears to be a logical progression (i.e., 160mm), but it isn't. It actually represents 320mm in focal length. This is because the numerical difference in the angle of view is reduced as you double the focal length.

7 » STANDARD LENSES

The term "standard lens" dates back to the early days of 35mm photography, long before today's extensive range of prime lenses—and, particularly, zoom lenses—were conceived. A working photographer would generally carry three bodies, equipped with a moderate wide-angle lens of 28mm or 35mm, a 50mm standard lens, and a short telephoto of up to 135mm. The standard 50mm lens was sold with the camera and approximated the field of view of the human eye.

EF 50mm f/1.4 USM lens

With APS-C sensor bodies, because of the crop factor explained on page 220, it is necessary to divide the 50mm focal length by 1.6 in order to arrive at a focal length that may be considered "standard." This gives us a focal length of approximately 30mm. Today, the zoom lenses that are packaged with new cameras instead of the old 50mm prime lens tend to straddle this 30mm figure. Canon's new EF-S 15–85mm lens is a good example.

Historically, the standard lens was always the least expensive in any lineup, unless it was a particularly fast version, because it could be manufactured more cheaply and in greater quantities. But standard zooms have come down in price, size, and weight, and have increased in quality. Add to this the shift toward APS-C bodies by huge numbers of Canon users and it may seem that the 50mm standard lens is turning into a museum piece. Or is it?

Canon still produces 50mm f/1.4 and f/1.2 versions to act as standard lenses for 35mm film and full-frame sensor cameras. For users of APS-C Canon bodies, these serve as really fast portrait lenses, with a field of view similar to an 80mm lens on 35mm, and, in the case of the 50mm f/1.4, for a very competitive price.

» WIDE-ANGLE LENSES

The net effect of using APS-C sensor bodies has been a real boon for telephoto users because the field of view can be reduced by a factor of 1.6—but at the opposite end of the focal-length scale, wide-angle users have suffered. Even a 17–40mm lens provides the field of view of only a 27–64mm equivalent, and 27mm is definitely not considered wide-angle by today's standards.

However, in 2004, Canon introduced the EF-S 10–22mm lens, which, for the first time, meant that there was an affordable Canon option that offered real wide-angle characteristics. Prior to this, the only choice for those determined to stick with Canon lenses was the very expensive

14mm f/2.8L, introduced way back in 1991—a rectilinear lens that gave largely distortion-free images as opposed to a fisheye lens of the same focal length.

Three independent manufacturers (Sigma, Tamron, and Tokina) produce numerous lenses between them that compete with the EF-S 10–22mm. Some of these are full-frame lenses and some have been designed to work with smaller sensors. Their quality varies, but several of these lenses are serious competitors to Canon's own models.

The fast moderate wide-angle—a 35mm f/1.4 on 35mm, for example—always used to be the photojournalist's mainstay, but the chances of an APS-C equivalent of 21mm f/1.4 being brought out are probably slim, so anyone who requires that sort of lens performance will need a full-frame body.

Today's wide zooms are really quite slow: for the best performance it is usually necessary to stop down a couple of stops from the maximum aperture. This means working with an aperture of at least f/5.6, or, more probably, f/8—which places limits on working in low light because the shutter speeds will be very slow, making Image Stabilization an even more desirable feature *(see page 219).*

EF 14mm f/2.8 L II lens

7 » TELEPHOTO LENSES

Telephoto users, whether using prime lenses or zooms, gain hands down from using APS-C sensor bodies because the field of view is reduced by x1.6. My own favorite long lens combination is a 300mm f/2.8 with a 1.4x converter, giving the equivalent field of view on an APS-C body as a 672mm f/4. With a 2x converter instead of the 1.4x, this equates to a staggering 960mm f/5.6, still with AF capability. Such possibilities are incredibly cost-effective.

Telephoto lenses give the appearance of compressing the different planes in an image, making distant subjects look closer than they are. The longer the focal length, the more this is true. However, telephotos also require faster shutter speeds, which is why you will see sports photographers carrying huge lenses along the touchline. It is not the focal length alone that results in such huge lenses so much as the combination of focal length and fast maximum apertures. But doesn't Image Stabilization remove the need for fast maximum apertures? No. Image Stabilization is designed to compensate for camera shake but has no impact on the need for a high shutter speed, and therefore fast maximum aperture, when trying to freeze a moving subject.

One of the bonuses of using longer lenses is the attractive out-of-focus background (known as "bokeh") that can result. This effect is determined to some degree by the number of blades in the diaphragm, and by the extent to which they create a perfect circle when open.

EF 70–300mm IS lens

» PERSPECTIVE

There are several reasons why one might choose a lens of a particular focal length, the most important being angle of view, depth of field, and perspective. Perspective is the term used to describe the relationships between the different elements that comprise an image; in particular, the apparent compression or expansion of planes within the image.

Let's start with the most obvious examples. With a very wide-angle lens, taking a head-and-shoulders portrait will involve a very short camera-to-subject distance, and the nearest facial features will appear quite distorted and overly large. Conversely, try photographing a line of parking meters with a long telephoto lens and the image will give the impression that they are spaced only a couple of feet apart.

Between these two extremes is a host of options, especially if you use zoom lenses. There are no hard-and-fast rules except that if you want natural-looking portraits, it is best to opt for a slightly longer than standard focal length, around 80mm on full-frame, or 50mm on APS-C.

Canon's own prime lenses in this bracket are excellent value for money (not counting the fabulous, but expensive 85mm f/1.2), with wide maximum apertures and superb image quality.

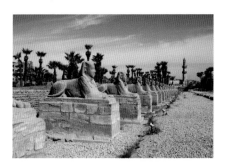

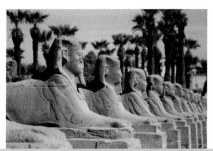

CHANGE OF PERSPECTIVE «
The perspective with any given focal length will change according to the camera-to-subject distance and the viewpoint. The two images here were taken from the same position at 24mm (top) and 105mm (below).

7 » TELECONVERTERS

Canon uses the term "extenders" to describe its two teleconverters. The first is the 1.4x extender, which is fitted between the camera body and the lens to increase the focal length by a factor of 1.4, and which causes the loss of one stop of light. The 2x extender doubles the focal length with a loss of two stops. Both Canon and Sigma manufacture 1.4x and 2x versions.

While teleconverters are an inexpensive way of increasing the pulling power of your telephoto lenses, they will not provide the same quality as a lens of the same focal length, especially a prime lens. Autofocus will also be slower and you may find that the AF will "hunt," unless it can lock onto a suitably contrasty part of the image.

Tip

If you are considering purchasing an extender, it is important to pay attention to the maximum aperture of your lens. If the recalculated maximum aperture with an extender fitted is smaller than f/5.6, you will lose autofocus capability.

Warning!

Only selected lenses can be used with extenders without causing damage to the rear element of the lens. To check which of the current range of lenses can be used, visit the Canon web site and check the specification of the lens concerned.

Extender EF 2x II

Extender EF 1.4x II

» TILT-AND-SHIFT LENSES

One of the main drawbacks of using normal lenses for any architectural subject is that tilting the camera and lens to accommodate the height of the building results in the convergence of vertical lines, usually the sides of the building. You can work around this by finding a viewpoint that is at roughly half the height of the building, but a more satisfactory solution comes in the shape of a tilt-and-shift lens.

Canon manufactures four such lenses—the TS-E 17mm f/4 L, TS-E 24mm f/3.5 II L, TS-E 45mm f/2.8, and TS-E 90mm f/2.8. The latter was the world's first 35mm-format 90mm lens with tilt-and-shift movements. All of these lenses are manual focus only.

They work by allowing the lens to perform three different movements (tilt, shift, and rotate) in relation to the plane of focus, with the added benefit of improving (or reducing) depth of field without

TS-E 17mm f/4 L lens

changing the aperture. Tilt and shift locks on the L-series lenses prevent unwanted slipping.

Both the 17mm and 24mm Mark II versions allow independent rotation of the tilt and shift axes. The earlier versions of the 24mm, the 45mm, and the 90mm could be set up as either parallel or at right angles by a Canon Service Center, but could not be changed in the field. The two new versions also boast a greatly increased image circle.

Lens	Field of view	Tilt	Shift	Rotation	Image circle
TS-E 17mm f/4 L	104° (diag.)	+/- 6.5°	+/-12mm	+/-90°	67.2mm
TS-E 24mm f/3.5 II L	84° (diag.)	+/- 8.5°	+/-12mm	+/-90°	67.2mm
TS-E 45mm f/2.8	51° (diag.)	+/- 8°	+/-12mm		58.6mm
TS-E 90mm f/2.8	27° (diag.)	+/- 8°	+/-12mm		58.6mm

7 » CANON LENS CHART

Lens (USM* = Ring USM)	Construction (elements/ groups)	Diaph. blades	Min. f/no.	Closest focus (m)
Fixed focal length lenses				
EF 14mm f/2.8L II USM*	14/11	6	22	0.20
EF 15mm f/2.8 Fisheye	8/7	5	22	0.20
TS-E 17mm f/4L	18/12	8	22	0.25
EF 20mm f/2.8 USM	11/9	5	22	0.25
EF 24mm f/1.4L II USM*	13/10	8	22	0.25
EF 24mm f/2.8	10/10	6	22	0.25
TS-E 24mm f/3.5L	11/9	8	22	0.30
TS-E 24mm f/3.5L II	16/11	8	22	0.21
EF 28mm f/1.8 USM	10/9	7	22	0.25
EF 28mm f/2.8	5/5	5	22	0.30
EF 35mm f/1.4L USM	11/9	8	22	0.30
EF 35mm f/2	7/5	5	22	0.25
TS-E 45mm f/2.8	10/9	8	22	0.40
EF 50mm f/1.2L USM*	8/6	8	16	0.45
EF 50mm f/1.4 USM	7/6	8	22	0.45
EF 50mm f/1.8 II	6/5	5	22	0.45
EF 50mm f/2.5 Macro	9/8	6	32	0.23
EF-S 60mm f/2.8 Macro USM	12/8	7	32	0.20
MP-E 65mm f/2.8 1–5x Macro	10/8	6	16	0.24
EF 85mm f/1.2L II USM*	8/7	8	16	0.95
EF 85mm f/1.8 USM	9/7	8	22	0.85
TS-E 90mm f/2.8	6/5	8	32	0.50
EF 100mm f/2 USM	8/6	8	22	0.90
EF 100mm f/2.8L Macro IS USM*	15/12	9	32	0.30

Max. mag. (x life size)	Filter (mm) (*drop-in)	Width x Length (mm)	Wgt (g)	Lens hood	Introduced
0.15	n/a	80 x 94	645	Built-in	2007
0.14	n/a	73 x 62	330	Built-in	1987
0.14	77	89 x 107	820	n/a	2009
0.14	72	78 x 71	405	EW-75II	1992
0.17	77	94 x 87	650	EW-83K	1997
0.16	58	68 x 87	270	EW-60II	1988
0.14	72	78 x 87	570	EW-75BII	1991
0.34	82	89 x 107	780	EW-88B	2009
0.18	58	74 x 56	310	EW-63II	1995
0.13	52	67 x 42	185	EW-65II	1987
0.18	72	79 x 86	580	EW-78C	1998
0.23	52	67 x 42	210	EW-65II	1990
0.16	72	81 x 90	645	EW-79BII	1991
0.15	72	86 x 66	580	ES-78	2006
0.15	58	74 x 51	290	ES-71 II	1993
0.15	52	68 x 41	130	ES-62	1990
0.50	52	68 x 63	280	n/a	1987
1.00	52	73 x 70	335	ET-67B	2005
5.00	58	81 x 98	710	n/a	1999
0.11	72	92 x 84	1025	ES-79 II	2006
0.13	58	75 x 72	425	ET-65 III	1992
0.29	58	74 x 88	565	ES-65 III	1991
0.14	58	75 x 74	460	ET-65 III	1991
1.00	67	78 x 123	625	ET-73	2009

Lens (USM* = Ring USM)	Construction (elements /groups)	Diaph. blades	Min. f/no.	Closest focus (m)
EF 100mm f/2.8 Macro USM	12/8	8	32	0.31
EF 135mm f/2L USM	10/8	8	32	0.90
EF 135mm f/2.8 Soft Focus	7/6	6	32	1.30
EF 180mm f/3.5L Macro USM	14/12	8	32	0.48
EF 200mm f/2L IS USM*	17/12	8	32	1.90
EF 200mm f/2.8L II USM	9/7	8	32	1.50
EF 300mm f/2.8L IS USM	17/13	8	32	2.50
EF 300mm f/4L IS USM	15/11	8	32	1.50
EF 400mm f/2.8L IS USM	17/13	8	32	3.00
EF 400mm f/4 DO IS USM	17/13	8	32	3.50
EF 400mm f/5.6L USM	7/6	8	32	3.50
EF 500mm f/4L IS USM	17/13	8	32	4.50
EF 600mm f/4L IS USM	17/13	8	32	5.50
EF 800mm f/5.6L IS USM*	18/14	8	32	6.00
Zoom lenses				
EF-S 10-22mm f/3.5-4.5 USM	13/10	6	22-27	0.24
EF-S 15-85mm f/3.5-5.6 IS	17/12	7	22-38	0.35
EF 16-35mm f/2.8L II USM*	16/12	7	22	0.28
EF 17-40mm f/4L USM	12/9	7	22	0.28
EF-S 17-55mm f/2.8 IS USM*	19/12	7	22	0.35
EF-S 17-85mm f/4-5.6 IS USM	17/12	6	22-32	0.35
EF-S 18-55mm f/3.5-5.6 IS	11/9	6	22-38	0.25
EF-S 18-135mm f/3.5-5.6 IS	16/12	6	22-38	0.45
EF-S 18-200mm f/3.5-5.6 IS	16/12	6	22-38	0.45
EF 20-35mm f/3.5-4.5 USM	12/11	5	22-27	0.34

Max. mag. (x life size)	Filter (mm) (*drop-in)	Width x Length (mm)	Wgt (g)	Lens hood	Introduced
1.00	58	79 x 119	600	ET-67	2000
0.19	72	83 x 112	750	ET-78 II	1996
0.12	52	69 x 98	390	ET-65 III	1987
1.00	72	83 x 187	1090	ET-78 II	1996
0.12	52*	128 x 208	2520	ET-120B	2008
0.16	72	83 x 136	765	ET-83BII	1996
0.13	52*	128 x 252	2550	ET-120	1999
0.24	77	90 x 221	1190	Built-in	1997
0.15	52*	163 x 349	5370	ET-155	1999
0.12	52*	128 x 233	1940	ET-120	2001
0.12	77	90 x 257	1250	Built-in	1993
0.12	52*	146 x 387	3870	ET-138	1999
0.12	52*	168 x 457	5360	ET-160	1999
0.14	52*	163 x 461	4500	ET-155	2008
0.17	77	84 x 90	385	EW-83E	2004
0.21	72	82 x 88	575	EW-78E	2009
0.22	82	89 x 112	635	EW-88	2007
0.24	77	84 x 97	500	EW-83E	2003
0.17	77	84 x 111	645	EW-83J	2006
0.20	67	79 x 92	475	EW-73B	2004
0.34	58	69 x 70	200	EW-60C	2007
0.21	67	75 x 101	455	EW-73B	2009
0.24	72	79 x 102	595	EW-78D	2008
0.13	77	84 x 69	340	EW-83 II	1993

Lens (USM* = Ring USM)	Construction (elements /groups)	Diaph. blades	Min. f/no.	Closest focus (m)
EF 24–70mm f/2.8L USM	16/30	8	22	0.38
EF 24–85mm f/3.5–4.5 USM	15/12	6	22–32	0.50
EF 24–105mm f/4L IS USM*	18/13	8	22	0.45
EF 28–90mm f/4–5.6 III	10/8	5	22–32	0.38
EF 28–105mm f/3.5–4.5 II USM	15/12	7	22–27	0.50
EF 28–135mm f/3.5–5.6 IS USM	16/12	6	22–36	0.50
EF 28–200mm f/3.5–5.6 USM	16/12	6	22–36	0.45
EF 28–300mm f/3.5–5.6L IS USM*	23/16	8	22–40	0.70
EF 55–200mm f/4.5–5.6 II USM	13/13	6	22–27	1.20
EF-S 55–250mm f/4–5.6 IS	12/10	7	22–32	1.10
EF 70–200mm f/2.8L USM	18/15	8	32	1.50
EF 70–200mm f/2.8L IS II USM*	23/19	8	32	1.20
EF 70–200mm f/4L USM	16/13	8	32	1.20
EF 70–200mm f/4L IS USM*	20/15	8	32	1.20
EF 70–300mm f/4.5–5.6 DO IS USM*	18/12	6	32–40	1.40
EF 70–300mm f/4–5.6 IS USM	15/10	8	32–45	1.50
EF 75–300mm f/4–5.6 III USM	13/9	7	32–45	1.50
EF 100–300mm f/4.5–5.6 USM	13/10	8	32–38	1.50
EF 100–400mm f/4.5–5.6L IS USM	17/14	5	32–38	1.80

Max. mag. (x life size)	Filter (mm) (*drop-in)	Width x Length (mm)	Wgt (g)	Lens hood	Introduced
0.29	77	83 x 124	950	EW-83F	2002
0.16	67	73 x 70	380	EW-73 II	1996
0.23	77	84 x 107	670	EW-83H	2005
0.30	58	67 x 71	180	EW-60C	2004
0.19	58	72 x 75	375	EW-63 II	2000
0.19	72	78 x 97	540	EW-78B II	1998
0.28	72	78 x 90	500	EW-78D	2000
0.30	77	92 x 184	1670	ET-83G	2004
0.21	52	70 x 97	310	ET-54	2003
0.31	58	70 x 108	390	ET-60	2007
0.16	77	85 x 194	1310	ET-83 II	1995
0.21	77	89 x 199	1490	ET-87	2010
0.21	67	76 x 172	705	ET-74	1999
0.21	67	76 x 172	760	ET-74	2006
0.19	58	82 x 100	720	ET-65B	2004
0.26	58	77 x 143	630	ET-65B	2005
0.25	58	71 x 122	480	ET-60	1999
0.20	58	73 x 122	540	ET-65 III	1990
0.20	77	92 x 189	1380	ET-83C	1998

Chapter 8
CONNECTION

8 CONNECTION

If you want to organize your images, print them, or share them with others, you need to be able to connect your camera to a variety of other devices— usually a computer, a printer, and a TV. When the EOS 7D is connected to a computer, it is also possible to control shooting remotely from the keyboard.

» VIEWING IMAGES ON TV

Non-HD TV sets

1) Make sure that both the TV and the camera are turned off.

2) Connect the AV cable provided with the camera to the **AV OUT/DIGITAL** terminal on the camera.

3) Connect the AV cable to the television. The yellow plug goes into the TV's **VIDEO IN** terminal, the red plug in the right channel **AUDIO IN**, and the white plug in the left channel **AUDIO IN**.

4) Turn on the television and select the appropriate setting/channel for video input.

5) Turn on the camera and press the ▶ Playback button.

> **Note:**
> For playback controls when viewing movies, see page 156.

HD TV sets

Connecting to an HD TV requires an additional HDMI cable, sold separately.

1) Make sure that both the TV and the camera are turned off.

2) Connect the HDMI cable (sold separately) to the **HDMI OUT** terminal on the camera.

3) Connect the HDMI cable to the television's **HDMI IN** port.

4) Turn on the television and select the appropriate setting for the connected port.

5) Turn on the camera and press the ▶ Playback button.

Common errors

If the video system selected in ŶŶ Set-up menu 2 *(see page 120)* does not match that of the TV, images will not be displayed correctly.

» CONNECTING TO A COMPUTER

Screen calibration

Before manipulating images on your computer, make sure your monitor is calibrated for brightness, contrast, and color, using dedicated software or graphics freely available on the internet. You should be able to discern a good range of tones from pure black to pure white. If the dark gray tones blend into black, the screen is too dark. If the light gray tones blend into white, the screen is too bright.

Correct calibration

Too dark

Too light

Typical color calibration image (courtesy of Digital Masters)

› Installing the software

EOS Digital Solutions Disk

1) Make sure that your camera is NOT connected to your computer.

2) Insert the EOS Digital Solutions Disk provided with the camera.

3) Follow the onscreen prompts through the installation procedure.

4) When installation is completed, you will be prompted to restart the computer. Leave the CD in the drive.

5) When your computer has rebooted, remove the CD from the drive.

EOS Digital Software Instruction Manuals Disk

1) Insert the disc into the CD drive of your computer.

2) Open the CD in **My Computer** (or in the **Finder** if using a Mac).

3) Click on **START.pdf** files. Adobe Reader will display the Instruction Manuals index.

4) Save each PDF file to your computer.

Warning!

Do not connect the camera to your computer before installing the software provided.

› Connecting the camera

1) Make sure the camera is switched off.

2) Connect the USB cable (provided) to the camera's **AV OUT/DIGITAL** terminal with the ⟨⟨ symbol facing the front of the camera. Connect the other end of the cable to a USB port on the computer.

3) On the camera, select any shooting mode except ⦿. Turn the camera's power switch to **ON**. If EOS Utility does not start automatically, select **EOS Utility** from the program selection screen.

4) The EOS Utility screen will be displayed on the computer and the Direct Transfer menu will be shown on the camera's LCD monitor.

Notes:
Software updates for the programs on the EOS Digital Solutions Disk are available to download from Canon's web site *(see page 253)*.

Canon's software manuals are in PDF format, so make sure you have the necessary software installed before you start. Download Adobe Reader free from www.adobe.com.

» CANON SOFTWARE

Canon produces its own software specifically designed to work with its digital cameras. It is largely aimed at digital SLR users but some of it also works with certain PowerShot models. Canon has designed the software so that it is sometimes possible to launch one program from within another. Due to the complexity of this integration, and because programs like Digital Photo Professional and Picture Style Editor now represent significant pieces of software in their own right, only a brief outline of their capabilities can be given here. For detailed information, refer to the instruction manuals on the CD provided with your camera.

› Digital Photo Professional

Digital Photo Professional (DPP) is designed as a stand-alone RAW workflow tool that links with or incorporates other Canon software, such as PhotoStitch and Picture Style Editor. DPP can be used to adjust RAW images, apply Picture Styles, and convert RAW to JPEG or TIFF formats, both singly and via batch processing. It also supports the use of JPEG and TIFF files as base images with which to work. It features sophisticated color management techniques, including CMYK simulation.

› Picture Style Editor

Picture Style Editor can apply six preset Picture Styles to base images, saving you from repeatedly making the same adjustments to each one. Each Picture Style can be customized and registered in order to fine-tune the desired results. Changes to color tone, saturation, contrast, sharpness, and gamma characteristics can all be applied. Picture Styles that have been defined in-camera can also be saved onto the computer. Picture Styles can even be applied to images shot previously on cameras that do not support Picture Styles. See pages 95–100 for more information on using Picture Styles with the EOS 7D.

› EOS Utility

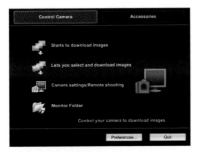

› ZoomBrowser EX

EOS Utility facilitates batch downloading of your images from the camera to the computer, also allowing you to only download selected images. It enables you to capture images remotely by controlling the camera from the computer, including the use of Live View. EOS Utility links with Digital Photo Professional in order to view and work with remotely captured images. It also links with the Wireless File Transfer software and Original Data Security Tools.

ZoomBrowser EX is used for viewing, assessing, and organizing images. It also facilitates the printing of images with Canon inkjet printers. Secondary software such as Camera Window and Raw Image Task may be started from within ZoomBrowser. The programme's editing suite supports adjustments to brightness, color, cropping, sharpness, red-eye correction, adding images to e-mails or using them as wallpaper or screensavers, and the insertion of text into images. It also facilitates the transfer of images to Canon iMAGE Gateway. Limited editing and arranging of movie clips is also possible.

› Canon iMAGE Gateway

Canon iMAGE Gateway provides 100 MB of web space, allowing you to share photos with friends and family by creating online albums. It even supports the customization of your camera by adding startup images and sound effects, as well as downloadable Picture Styles.

› PhotoStitch

PhotoStitch permits the opening and arranging of images to be merged, saved, and printed. However, you are limited to working with JPEG files only.

» USING A PRINTER

You can connect the EOS 7D directly to a printer and print the images, including RAW files, held on the memory card. You can also preselect the images you wish to print. The camera is compatible with PictBridge. The printing procedure is controlled directly from the camera using the LCD monitor to view the operation. If your printer has slots for memory cards, you may be able to insert your memory card into the printer without connecting the camera.

› Connecting to a printer

1) Check that the camera's battery is fully charged. Even better, attach the AC Adapter Kit ACK-E6 (sold separately) to use AC power.

2) Make sure that the camera and printer are switched off.

Canon PIXMA iP4600 printer ⌃

3) Connect the USB cable provided with the camera to the camera's ⟷ USB terminal. The ⟷ symbol must face the front of the camera.

4) Connect the cable to the printer according to the printer's manual.

5) Turn on the printer.

6) Turn the camera's power switch to **ON**.

7) Press the ▶ button. The ʳⁱ symbol will be shown on the monitor at top left, indicating camera/printer connection.

At this point some printers may emit a beep. If this beep is prolonged, there is a problem with the printer. To discover the error, press the ▶ playback button on the camera. When the image is played back, press **SET**. On the Print Setting screen, select **Print**. The error message should be displayed on the LCD monitor. Error messages include Paper Error, Ink Error, Hardware Error, and File Error.

> **Note:**
> Any default settings referred to are the printer's default settings and not those of the camera.

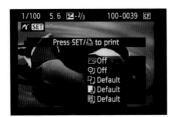

The instructions below are a general indication of what to expect, but note that actual displays and available functions will depend on the printer used.

1) Press the ▶ Playback button to bring up the first image.

2) If this is not the image you wish to print, rotate the ◌ Quick Control dial to select the image to be printed.

3) Press **SET**. The camera's LCD monitor will display the image with a list of settings overlaying the image. Press **SET**.

4) The **Print setting** screen will be displayed with a thumbnail image and a list of settings covering printing effects, date, file number, quantity, trimming, paper size, and layout. Rotate the ◌ Quick Control dial to select a setting to change, and press **SET**. For some settings, ◄► arrows are added to the screen to indicate the need to scroll with the ◌ Quick Control dial to amend the setting.

Other settings go to a submenu. The **Trimming** option goes straight to the Trimming frame, which you can adjust using the ✳/🔲•◎ and ⊟/◎ buttons and ✳ Multi-controller. *(Full details of all the printing options available are given on pages 243–6.)*

5) When you are ready to print, rotate the ◌ Quick Control dial to highlight **Print**.

6) Press **SET**.

7) While **Stop** is displayed, you can stop printing by pressing **SET** and then **OK**.

8) To print additional images using the same settings, select the first image to be printed and press the 🖨 Direct Print button. Repeat as necessary. Note: with the **Easy printing** option, you can't set the number of copies, and trimming cannot be applied.

9) When you've finished printing, turn off the camera and the printer.

10) Disconnect the cable.

› Print settings

During the following procedures, pay attention to options at the bottom of the screen, such as **INFO**. These will sometimes provide access to further settings.

Paper settings

1) From the **Print setting** screen you reached in step 4 on the previous page, rotate the ⊙ Quick Control dial to select **Paper settings** and press **SET**.

2) The **Paper size** screen will be displayed. Rotate the ⊙ Quick Control dial to select the dimensions of the paper to be used and press **SET**. (If you are intending to trim the image, choose an appropriate ratio.)

3) The **Paper type** screen will be displayed. Rotate the ⊙ Quick Control dial to select the type of paper to be used for printing and press **SET**.

4) The **Page layout** screen will appear. Rotate the ⊙ Quick Control dial to select the **Page layout** and press **SET**.

5) The display will now revert to the **Print setting** screen.

> **Note:**
> The extent to which your printer supports different functions will determine whether or not some functions can be performed.

Print settings	
Bordered	The print will have a white border along each edge.
Borderless	The print will have no white borders. (If your printer cannot print borderless prints, the print will still have borders.)
Bordered ℹ	The shooting information will be imprinted on the border of prints that are 3½ x 5in (9 x 13cm) or larger.
xx-up	Option to print 2, 4, 8, 9, 16, or 20 images on one print.
20-up/35-up	On Letter/A4 size paper, 20 or 35 thumbnails of DPOF ordered images will be printed.
20-up ℹ	Shooting information will be printed on the border.
Default	Page layout will depend on the printer type and its default settings.

Shooting information from the Exif data will include camera name, lens, shooting mode, shutter speed, aperture, exposure compensation, ISO speed, and white balance.

8 Printing effects

1) From the **Print setting** screen, rotate the ⊙ Quick Control dial to select the option on the upper right and press **SET**.

2) The **Printing effects** screen will be displayed. Use the ⊙ Quick Control dial to select each item to change and press **SET**. Refer to the table below for information on the options available. The actual display will depend on the printer being used. The table is based on the assumption that the full list of effects is available.

3) If the ⊞ icon is displayed next to **INFO** on the **Printing effects** screen, additional options are available if you press the **INFO** button. The options available will depend on the choices you made from the table below. If no options are available, skip this step.

Preset printing effects

Item	Description
⊠ Off	No automatic correction will be performed.
⊠ On	The image will be printed according to the printer's standard colors. The image's Exif data is used to make automatic corrections.
⊠ Vivid	The image will be printed with higher saturation to produce more vivid blues and greens.
⊠ NR	Image noise is reduced before printing.
B/W B/W	Prints in black and white with true blacks.
B/W Cool tone	Prints in black and white with cool, bluish blacks.
B/W Warm tone	Prints in black and white with warm, yellowish blacks.
🖸 Natural	Prints the image in the actual colors and contrast. No automatic color adjustments will be applied.
🖸 Natural M	The printing characteristics are the same as the **Natural** setting. However, this setting enables finer printing adjustments than with the **Natural** setting.
⊠ Default	Printing will differ depending on the printer. For details, see the printer's instruction manual.

The screen display may differ depending on the printer.

When the printing effects are changed, the changes will be reflected on the screen. However, the actual result of the printing effects may look different than what you see on screen. The screen only shows an approximate rendition.

Adjustable printing effects

Brightness	The image brightness can be adjusted.
Adjust levels	When you select **Manual**, you can change the histogram's distribution and adjust the image's brightness and contrast. With the **Adjust Levels** screen displayed, press the **INFO** button to change the position of the indicator. Turn the Quick Control dial to freely adjust the shadow level (0–127) or highlight level (128–255).
Brightener	Effective in backlit conditions that can make the subject's face look dark. When **On** is selected, the face will be brightened for printing.
Red-eye corr.	Effective in flash images where the subject has red-eye. When **On** is selected, the red-eye will be corrected for printing.

The **Brightener** and **Red-eye corr.** effects will not show up on the screen.

When you select **Detail set.**, you can adjust the **Contrast**, **Saturation**, **Color tone**, and **Color balance**.

When you select **Clear all**, all the printing effects will revert to the default settings.

Date/Time/File Number

1) Rotate the Quick Control dial to select ⊙, then press **SET**.

2) Use the ⊙ Quick Control dial to choose the desired setting and press **SET**.

Number of copies

1) Rotate the Quick Control dial to select ⊡, then press **SET**. Use the ⊙ Quick Control dial to choose the desired setting and press **SET**.

2) If you want to trim your images, go to Trimming the image *(right)*. To print without trimming, go back to step 5 on page 242.

Trimming the image

1) On the **Print setting** screen, select **Trimming**. Use the ⊟/⊕ Enlarge and ⋇/⊞•⊖ Reduce buttons to adjust the size of the trimming frame, and the ⋇ Multi-controller to move the frame.

2) Press the **INFO** button to rotate the image through 90°. Use the ⊙ Quick Control dial to rotate the image by up

to +/-10°. It is also possible to adjust the tilt correction by rotating the ⟲ Quick Control dial. Up to +/-10° in ½° increments can be adjusted. The onscreen tilt icon turns blue while adjustments are made. Press **SET** to exit the Trimming function and go back to step 5 on page 242 to start printing.

› Digital Print Order Format

Commonly abbreviated to DPOF, this is a system for recording printing instructions to the memory card. The DPOF system is managed through the **Print order** option in ▶ Playback menu 1. With the camera connected to a compatible printer, use the Print Order menu to manage the direct printing of your images from the camera's memory card. DPOF settings can be applied to all JPEG images (though not RAW images or movies) on the memory card, or to selected images. However, different settings cannot be applied to individual images. The same print type, date, and file number settings will be applied to all print-ordered images.

Print ordering

Before printing with DPOF, you will need to select the image(s) you wish to print. You can do this with either one image at a time displayed on the monitor, or a group of three images. Use the ✱/⊟ •⊖ Reduce button and the ⊟/⊕ Enlarge button to toggle between the two different display formats. Press **INFO** to save the print order to the memory card.

When you have decided which image(s) to print, press **SET**. This will automatically order a single print of that image. If you require more than one, rotate the ⟲ Quick Control dial to set the desired number of copies, up to a maximum of 99. The number of copies selected for the current image will be shown top left, next to the PictBridge symbol. The number of images selected so far is displayed to the right of the **SET** icon.

You can create an index sheet from the menu, or select **All images**, which will add all the photos on the memory card to the print order. Press **SET**. The displayed image will be included in the index print and a tick will appear next to the PictBridge symbol. The index icon will be shown to the right of **SET**.

You can also select images by folder ◼. A print order will be created for one copy of each image in the folder selected. If you select **Clear all** and choose a folder, the print order for that folder and all the images in it will be canceled.

To use DPOF, you must use a memory card for which DPOF specifications have been set. Do not use a memory card for which DPOF specifications have been set on a different camera body.

Common errors

Date and file number printing is dependent on the **Print type** setting and printer model.

RAW, MRAW, and SRAW images cannot be selected for DPOF.

Setting the printing options

1) Press the **INFO** button and use the 🔄 Main dial to scroll through the menus until you reach Playback menu 1.

2) Rotate the ◯ Quick Control dial to select **Print order** and press **SET**.

3) Rotate the ◯ Quick Control dial to select **Set up** and press **SET**.

4) To set a particular item, rotate the ◯ Quick Control dial to select the item. Press **SET**.

5) Set all the print type, date, and file number options as desired *(see table below)*.

6) Press **INFO** and the Print order screen will reappear. Choose **Select image**, ◼, or **All images** to order printing.

Printing options

Print type	⬤ Standard	Prints one image on one sheet.
	🔲 Index	Multiple thumbnail images are printed on one sheet.
	⬤ 🔲 Both	Prints both the standard and index prints.
Date	On Off	**On** imprints the recorded date on the print.
File number	On Off	**On** imprints the file number on the print.

›› GLOSSARY

Aberration An imperfection in the image caused by the optics of a lens.

AE (Auto Exposure) lock A camera control that locks in the exposure value, allowing an image to be recomposed before shooting.

Angle of view The area of a scene that a lens can take in, measured in degrees.

Aperture The opening in a camera lens through which light passes to expose the CMOS sensor. The relative size of the aperture is denoted by f-stops.

Autofocus (AF) A through-the-lens focusing system that allows you to focus accurately without manually rotating the focusing ring.

Bounce flash A flash technique that involves directing the flash beam at a reflective surface, which indirectly illuminates the subject.

Bracketing Taking a series of three identical pictures at, above, and below the nominal exposure you have set.

Buffer Temporary memory that stores image data while it is written to the memory card.

Built-in flash The flash unit incorporated into the camera.

Burst size The maximum number of frames that a digital camera can shoot before its buffer becomes full.

Cable release A device used to trigger the shutter of a tripod-mounted camera at a distance, to avoid camera shake.

Center-weighted average metering A metering mode that takes into account the whole image area but places greater importance on the central area.

Channel When using wireless flash, both master and slave units can be set to one of four channels (frequencies) to reduce the possibility of being affected by another Canon photographer using wireless flash in the immediate vicinity.

Chromatic aberration The inability of a lens to bring spectrum colors into focus at one point.

CMOS (Complementary Metal Oxide Semiconductor) A type of image sensor that converts an optical image into an electrical signal, as opposed to the CCD (Charge Coupled Device) used in earlier models.

Color temperature The color of a light source expressed in degrees Kelvin (°K).

CompactFlash card A safe and reliable digital storage medium.

Compression The process by which digital files are reduced in size.

Contrast The range between the highlight and shadow areas of an image, or a marked difference in illumination between colors or adjacent areas.

Custom Functions User-selectable options that affect the camera's operation. External flash units have their own Custom Functions, some of which can be selected via the camera's menu system as well as on the flash unit.

Depth of field (DOF) The amount of an image that will appear acceptably sharp. This is controlled by the aperture: the smaller the aperture, the greater the depth of field.

Diffuser Any translucent material that interrupts the light from a flash beam before it illuminates the subject, softening it by effectively enlarging the light source.

Diopter Unit expressing the power of a lens.

Direct flash When the light from the flash illuminates the subject without any diffuser or bounce technique being used.

dpi (dots per inch) Measure of the resolution of a printer or a scanner. The more dots per inch, the higher the resolution.

Dynamic range The ability of the camera's sensor to capture a full range of shadows and highlights.

EF (Extended Focus) lenses Canon's range of fast, ultra-quiet autofocus lenses.

E-TTL Evaluative through-the-lens flash metering system that does not incorporate distance information.

E-TTL II Canon's current evaluative through-the-lens flash metering system, which makes use of distance information, the camera's multizone metering system, and a preflash burst of light that illuminates the subject prior to the actual exposure. This data is analyzed to calculate the correct exposure.

Evaluative metering A metering system that uses algorithms to calculate exposure, based on light reflected from several different subject areas.

Exposure The amount of light allowed to hit the CMOS sensor; controlled by aperture, shutter speed, and ISO. Also the act of taking a photograph, as in "making an exposure."

Exposure compensation A camera function that allows intentional over- or underexposure relative to the meter reading.

Extension tubes Hollow spacers that fit between the camera body and the lens, typically used for close-up work. The tubes increase the focal length of the lens.

External flash Any EX Speedlite, whether mounted on the camera's hotshoe, attached to the hotshoe using an OC-E3 Off-camera Shoe Cord, or connected to the camera wirelessly.

Fill-in flash Flash combined with daylight in an exposure. Used with naturally backlit or harshly side-lit or top-lit subjects to prevent silhouettes forming, or to add extra light to the shadow areas of a well-lit scene.

Filter A piece of colored, or coated, glass or plastic placed in front of the lens.

Firing group Slave units can be designated as belonging to one of three firing groups: A, B, or C. The master unit always belongs to group A. Multiple slave units can be assigned to a single group. A firing group may contain only one flash unit.

Flash exposure compensation
A means of reducing or increasing the flash output by a specified amount measured in whole stops, ½ stops or ⅓ stops. If you are combining flash illumination and ambient lighting, only the flash output is adjusted, and the shutter speed and aperture remain the same. Usually used to compensate for an abnormally bright or dark background, or bright backlighting. If flash exposure compensation is accidentally set separately on both camera and EX Speedlite, the flash unit's setting is used.

Flash mode The 7D's flash modes are as follows: E-TTL or E-TTL II (evaluative through-the-lens metering, as used on EX Speedlites), which can be set to either Average or Evaluative; Manual flash, with settings of between 1/1 and 1/128; and MULTI flash (this refers to the number of flash bursts fired, not the number of flash units in use).

Flash output The amount of power used for the flash beam, usually expressed as a fraction (e.g., 1/4, 1/8, 1/16).

Flash range With the EOS 7D, wireless flash can be used outdoors with a maximum of around 23ft (7m) between the master unit and any slave unit, with the latter inside an 80° arc centered on the master unit's sensor. Indoors, this figure will be reduced to approximately 16ft (5m).

Flash ratio A means of controlling the relative outputs of different firing groups automatically. If you want group A to be twice as powerful as group B, you set the A:B ratio as 2:1, regardless of how many flash units are in each firing group.

Focal length The distance, usually in millimeters, from the optical center point of a lens element to its focal point.

Focal length and multiplication factor
The CMOS sensor of the Canon EOS 7D measures 22.3 x 14.9mm, which is 1.6x smaller than a full-frame sensor. The angle of view of any full-frame lens is reduced by the same factor.

fps (frames per second) The speed at which a digital camera can process one image and be ready to shoot the next.

f-stop Number assigned to a particular lens aperture. Wide apertures are denoted by small numbers such as f/2, and small apertures by large numbers such as f/22.

Histogram A graph used to represent the distribution of tones in an image.

Hotshoe An accessory shoe with electrical contacts that allows synchronization between the camera and a flashgun.

Hotspot A light area with a loss of detail in the highlights. This is a common problem in flash photography.

Incident-light reading Meter reading based on the light falling on the subject.

Interpolation A way of increasing the file size of a digital image by adding pixels, thereby increasing its resolution.

ISO (International Organization for Standardization) The sensitivity of the CMOS sensor measured in terms equivalent to the ISO rating of a film.

JPEG (Joint Photographic Experts Group) A compressed file format. JPEG compression can reduce file sizes to about 5% of their original size.

LCD (Liquid Crystal Display) The flat screen on a digital camera that allows the user to preview digital images.

Macro A term used to describe close focusing and the close-focusing ability of a lens.

Master The master flash unit controls which slave units fire, synchronizing and regulating their output both in conjunction with each other and with the camera. The only EX Speedlites that can perform this function are the 550EX, 580EX (both now discontinued), and the 580EX II. In addition, the Speedlite Transmitter ST-E2 acts as a master, but lacks a flash head. The EOS 7D's built-in flash also acts as a master unit for wireless flash, whether it actually fires or not. Any 550EX, 580EX, or 580EX II acting as the master unit can be disabled while still being able to control the slave units.

Megapixel One million pixels equals one megapixel.

Memory card A removable storage device for digital cameras.

Microdrive Small hard disk that fits into a CompactFlash slot, resulting in larger storage capabilities.

Mirror lockup A function that allows the reflex mirror of an SLR to be raised and held in the up position, before the exposure is made.

Off-camera Shoe Cord OC-E3 A 2ft (60cm) cord connecting the camera hotshoe to a flash unit, maintaining full E-TTL II compatibility. Can be used to connect a 550EX, 580EX, or 580EXII as a master unit in a wireless flash setup.

Pixel Short for "picture element"—the smallest bits of information in a digital image.

Predictive autofocus An autofocus system that can continuously track a moving subject.

Noise Colored image interference caused by stray electrical signals.

Partial metering A system unique to Canon that meters a relatively small area at the center of the frame.

PictBridge The industry standard for sending information directly from a camera to a printer, without having to connect it to a computer.

Red-eye reduction A system that causes the pupils of a subject to shrink by shining a light toward them prior to taking the flash photograph.

RAW File format in which the raw data from the sensor is stored without permanent alteration being made.

Resolution The number of pixels used to capture or display an image. The higher the resolution, the finer the detail.

RGB (Red, Green, Blue) Computers and other digital devices understand color information as combinations of red, green, and blue.

Rule of thirds A compositional rule of thumb that places the key elements of a picture at points along imagined lines that divide the frame into thirds.

Shading The effect of light striking a photographic sensor at anything other than right angles, incurring a loss of resolution.

Shutter The mechanism that opens and closes to control the amount of light reaching the sensor.

Slave Any flash unit that is triggered by the master unit. Multiple slave units can be used, in which case they can be treated as a single flash unit or divided into slave groups (*see* Firing group). The way in which they are physically arranged around the subject does not determine how they are grouped.

Slave ID The firing group to which each flash unit is assigned (A, B, or C).

SLR (Single Lens Reflex) A type of camera (such as the EOS 7D) that allows the user to view the scene through the lens, using a reflex mirror.

Speedlite transmitter ST-E2 A lightweight hotshoe-mounted master unit that does not have a flash head and is restricted to two firing groups when ratio control is applied.

Spot metering A metering system that places importance on the intensity of light reflected by a very small portion of the scene.

Swivel The ability of the flash head to rotate while the body of the flash unit, which incorporates its sensor, remains fixed. Usually employed to bounce light off a reflective surface.

Teleconverter A lens that is inserted between the camera body and main lens, increasing the effective focal length.

Telephoto lens A lens with a large focal length and a narrow angle of view.

Test flash Usually achieved by pressing a designated button on the flash unit to test whether the subject will be adequately illuminated. When using wireless flash with the EOS 7D, the test flash is indicated within the menu system and activated by pressing the ✛ Picture Style button.

Tilt The ability of the flash head to be pointed upward, usually incorporated with the swivel function when bouncing flash off a reflective surface.

TTL (Through The Lens) metering A metering system built into the camera that measures light passing through the lens at the time of shooting.

TIFF (Tagged Image File Format) A universal file format supported by virtually all relevant software applications. TIFFs are uncompressed digital files.

USB (Universal Serial Bus) A data transfer standard, used by the EOS 7D when connecting to a computer.

Viewfinder An optical system used for composing and focusing the photograph.

White balance A function that allows the correct color balance to be recorded for any given lighting situation.

Wide-angle lens A lens with a short focal length and consequently a wide angle of view.

» USEFUL WEB SITES

CANON

Worldwide Canon Gateway
www.canon.com

Canon USA
www.usa.canon.com

Canon UK
www.canon.co.uk

Canon Europe
www.canon-europe.com

Canon Oceania
www.canon.com.au

Canon EOS
Site dedicated to the EOS range
of cameras and accessories.
www.canoneos.com

Canon Camera Museum
Online history of Canon cameras and
their technology and design.
www.canon.com/camera-museum

Canon Enjoy Digital SLR Cameras
A web site from Canon with advice on how
to use digital SLRs.
web.canon.jp/Imaging/enjoydslr/index.html

GENERAL SITES

Photonet
Photography discussion forum.
www.photo.net

The EOS Experience
EOS-related seminars.
www.eos-experience.co.uk

Bureau of Freelance Photographers
Expert advice and tuition for freelance and
aspiring freelance photographers.
www.thebfp.com

ePHOTOzine
Online magazine with a photographic
forum, features, and monthly competitions.
www.ephotozine.co.uk

SOFTWARE

Adobe USA
www.adobe.com

Adobe UK
www.adobe.co.uk

EQUIPMENT

SanDisk
CompactFlash cards.
www.sandisk.com

Speedgraphic
Mail-order dealers in photographic
equipment and materials.
www.speedgraphic.co.uk

PHOTOGRAPHY PUBLICATIONS

Photography books
www.pipress.com

Black & White Photography magazine
Outdoor Photography magazine
www.thegmcgroup.com

EOS magazine
www.eos-magazine.com

» INDEX

Contact us for a complete catalog or visit our web site:
Ammonite Press, 166 High Street, Lewes, East Sussex, BN7 1XU, United Kingdom
Tel: +44 (0)1273 488006 Fax: +44 (0)1273 472418
www.ammonitepress.com